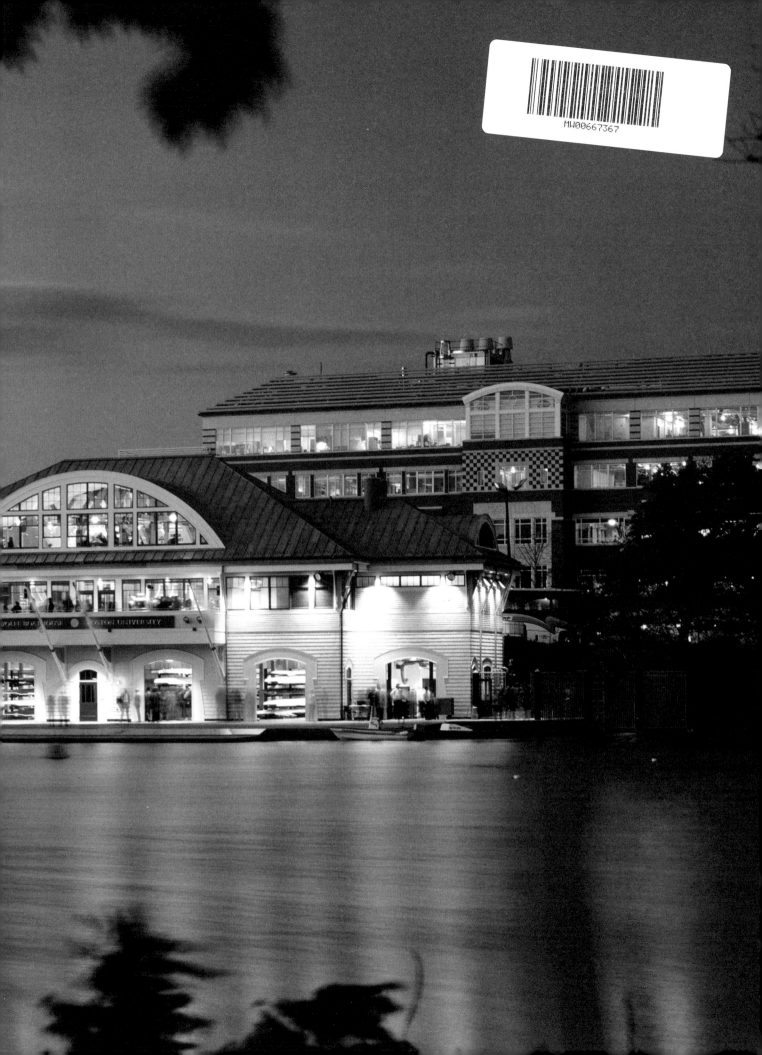

Boathouses
Architecture at the Water's Edge

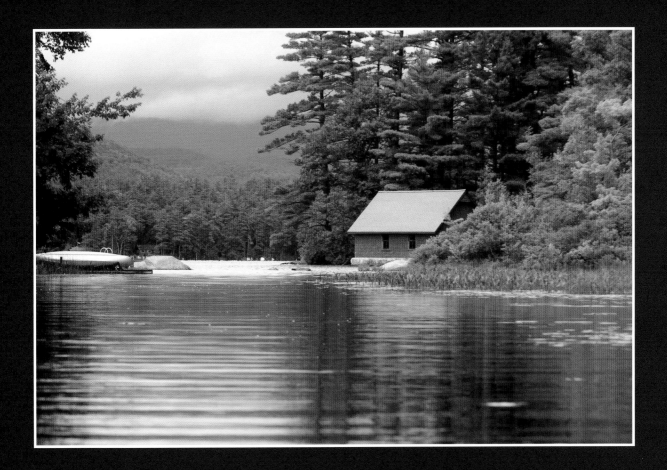

E. Ashley Rooney

With a foreword
by Jeffrey D. Peterson

Schiffer Publishing Ltd

4880 Lower Valley Road Atglen, Pennsylvania 19310

Front cover photos *courtesy of D. Peter Lundy and Ed Burtynsky*
Back cover photos *courtesy of Frances Loeb Library, Harvard Graduate School of Design: Nick Wheeler photographer; and Peter Paige, photographer*
Spine photo *courtesy of Peter Paige, photographer*
Contents page photo *courtesy of Michael Moore*
Acknowledgments page photo *courtesy of Harrison Design Associates*

Title page photo. *Courtesy of Neil Tischler*

Other Schiffer Books by E. Ashley Rooney

Waterfront Homes: from Castles to Cottages.
 0-7643-1893-4 $34.95
Cliffhangers and Hillside Homes: Views from the Treetops
 0-7643-2387-3 $39.95
Shingle Style Homes: Past & Present, with contributions by John C. McConnell AIA
 978-0-7643-2554-0 $39.95
Green Homes: Dwellings for the 21st Century
 978-0-7643-3033-9 $39.99

Copyright © 2009 by E. Ashley Rooney
Library of Congress Control Number: 2008938355

Designed by "Sue"
Type set in American Typewriter Medium/Zurich BT
ISBN: 978-0-7643-3190-9
Printed in China

Contents

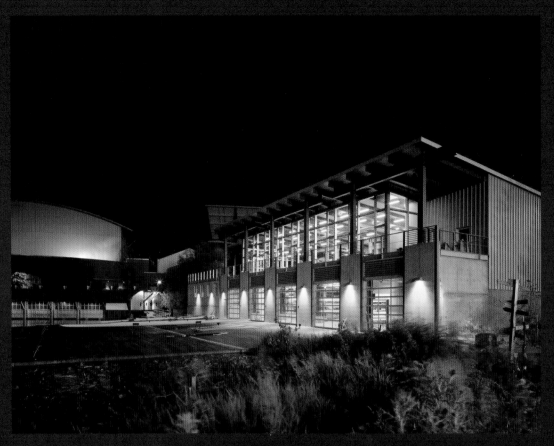

Photo *courtesy of Nic Lehoux*

Acknowledgments

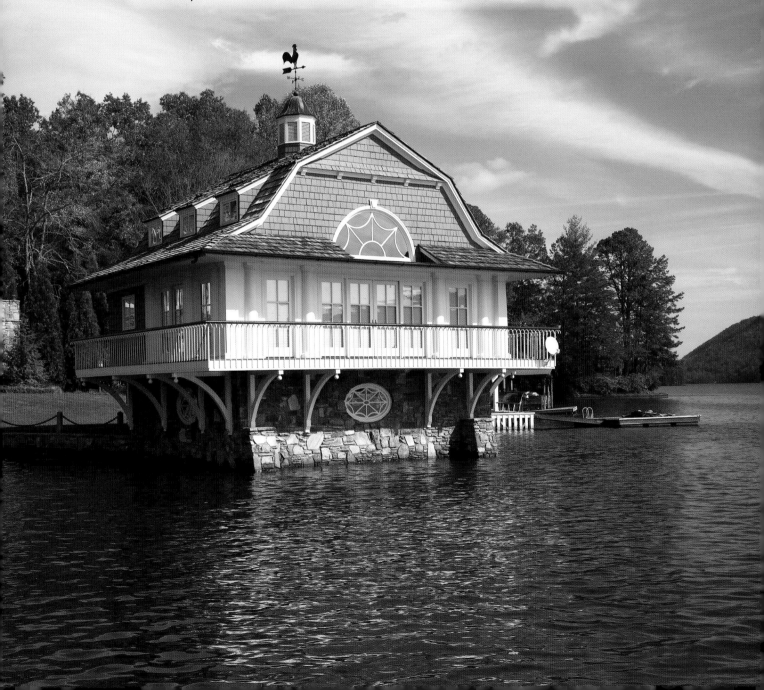

Jeff Peterson knows his boathouses! A member of the rowing fraternity, he has designed boathouses in the United States and elsewhere: he brings that knowledge to this foreword. I also must thank Harold and Priscilla Galberg who looked at many boathouses with us; Norm and Kay Ricker who showed us Boathouse Row; Norma Osborn, who introduced us to the Cambridge Boat Club; Bruce Livingston, who led us on a tour of boathouses in Jamestown, Rhode Island; Johnny Rickard of Lake Placid, and the Porcupine Inn at Lake Saranac for all the good boathouse sleuthing tips.

D. Peter Lund is responsible for all images without a credit line. There are many.

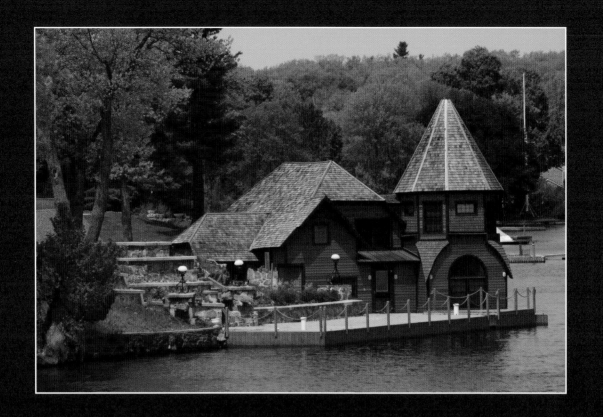

Boathouses: Buildings for Re-creation

Jeffrey D. Peterson, AIA, LEED AP

The experience of being in a boat on the water is exhilarating and slightly unsettling. We float, not quite so in control of ourselves as we are accustomed to being. We are isolated. Our perspective is low and the world we experience becomes flatter, with horizon lines echoed by tree lines above. Our view is broad and the water is undifferentiated. The sun pervades unimpeded by trees or other obstructions. The world is doubled by reflections in still water; down becomes up. As a portal to these unique experiences, boathouses capture our imagination.

Boathouses are unusual because they are located at the intersection of water, earth, and sky. They are vertical objects that interrupt the flatness of the water and the horizon beyond. Boathouses are also signposts, helping to define location in the sameness of the water all around. As a gateway, they are ambiguous; which side of the building is its front?

Boathouses can also appeal to our sense of culture and history. They create nostalgia in connecting us to an era of social elitism: the realm of wealthy recreation and the private club.

Yet, most importantly, a boathouse is a building with a function: a structure on or near the water, built to store and protect a boat or boats when not in use. When stored in a boathouse, a boat may be completely removed from the water, so that it is protected from the action of tides or waves, from saturation or rot, or from barnacles, worms, or other degradation. Such boathouses also protect their contents from sun, rain, and snow. Boathouses built on the water often protect a boat as it floats and allow use without the need to put the boat in and out of the water. Many of these structures are used seasonally.

Boathouses have certainly been in use for thousands of years and in thousands of ways. Most of them have been built either on freshwater lakes and rivers or in sheltered saltwater locations; boats that are large enough and rugged enough to weather the open ocean do not generally need protection from rain or snow. Further, the larger the boat that needs to be protected, the larger and more expensive the structure needs to be to do so.

Economy and the nature of the boats themselves have constrained the kinds of boathouses that have been built.

Rowing and Recreation

Although the variety of boathouses is nearly endless, those presented in this book fall essentially into two categories. First, there are residential boathouses that serve to shelter privately owned boats. Second, there are boathouses that accommodate rowing shells and the equipment and activities related to the sport of rowing. Beyond the obvious similarity that both of these kinds of boathouses house and protect boats near or on bodies of water, there are also considerable differences.

Private boathouses frequently house a small boat or boats used by an individual or just a few people. The boats they protect range from canoes to rowboats, "guideboats" to small motorboats. They are generally small structures, although some contain secondary functions often related to their role as the arrival point on wilderness lakes. These buildings are generally pastoral and private. Indeed, the boats they shelter are used by people who want isolation, whether they are fishing, hunting, or exploring the wilderness.

Rowing boathouses, in contrast, are often both collegial and collegiate. They are typically much larger and house a number of rowing shells. Most of these shells are designed for four or eight rowers and a coxswain; the activity they serve generally requires active engagement with others. In many ways, rowing is the ultimate team activity; other than the single scull, rowing demands unparalleled synchrony amongst teammates. As they serve large numbers of people, these boathouses are typically easily accessible and often located in urban areas or affiliated with clubs or educational institutions. As meeting places for large groups of people, frequently with views of and over the water, institutional boathouses often contain spaces that complement the boat storage functions. These additional spaces can range from locker rooms to training spaces to meeting spaces. The most elaborate and impressive of these contain

magnificent "Club Rooms" with fine finishes, trophy cases, and memorabilia acknowledging the grand history of that institution's rowing program.

Despite the substantial differences between these structures, both private and institutional boathouses as building types became prominent in the nineteenth century and continue, within modern constraints, to this day. These buildings trace their history back to reactions against changes brought on by the Industrial Revolution.

Nineteenth Century Urban Life

Industrialization caused continuous and profound change in the American culture throughout the nineteenth century. Early in the century, mechanization began to supplant physical labor as a means of production. The changes were incremental at first, but in the second half of the century, and particularly after the Civil War, they became rapid and dramatic. Among other things, they led to the rise of recreational activities.

Cities in the nineteenth century were difficult places. As mechanization vastly improved agricultural efficiency, a smaller proportion of the population was necessary to work in agricultural production. At the same time, manufacturing processes evolved from cottage industries to factories. These factories, which required people to work in assembly lines or sweatshops, were located in population centers. The resultant redistribution of the population from rural to urban areas, also fueled by a steady influx of immigrants, created cities of staggering density.

The rookeries and tenements that housed much of the urban population were built amongst unpaved streets filled with potholes, sewage, and garbage. Horses and free-roaming pigs also contributed to the filth. Disease was rampant and spread easily amongst the closely packed citizens. Coal use jumped dramatically, first in the production of metal goods, and then as the power source for the steam engine, which powered industrial machinery as well as steamboats and trains. This new widespread use of coal coated industrial cities in soot. Chemicals also found new uses in metallurgy, fabric dyeing, and leather tanning and as pharmaceuticals, explosives, and fertilizers. There was no understanding of their toxicity and no means of appropriately disposing of chemical waste; it was often dumped in the open where it contributed to the city's pollution.

Dirty, smelly, noisy, and fostering disease, the city, originally the seat of humane civilization, became, in many cases, a dangerous place from which escape, both physically and spiritually, was desirable. Spiritual escape sometimes took place with intense physical activity that required focus and exertion that forced one to forget the oppressive forces of the city. This activity led to the development of rowing as a sport and the need to build boathouses to facilitate the activity. The other desire, to physically leave the city behind, spurred the ultimate development of private rural boathouses as part of a new interest in recreational vacations. The boathouses shown in this book were built as a result of these two different means of finding an escape from the difficulty of urban life.

Leisure and the Vacation from Urban Stress

The increased efficiency of industrial production, combined with the number of immigrants who could do the more difficult or dirty work, created an expanded upper class that was now able to spend time in activities not related to industrial or agricultural production. This new freedom, along with the oppressive urban conditions, created a powerful desire to reconnect with things that were missing in their lives — most notably, clean air and the natural world. Many Americans, especially the upper class, now sought out nature as a desirable experience, as opposed to the longstanding attitude that its rigors were something to be endured rather than enjoyed.

This desire was reflected in the development and expansion of urban parks, the migration of the upper class to the fringes or other undeveloped parts of the city and eventually in the creation of residential suburbs, particularly along rail lines. Central Park was established as the first landscaped urban park in 1857. In 1871, the first public playgrounds were built there (Mumford, p. 429). Further from the city, the movement to protect natural resources began to pick up speed. In 1864, Yosemite was set aside for preservation; in 1872, Yellowstone became the first national park. Concurrently, resort hotels were developed in remote locations (but near enough to cities) to entice wealthy city dwellers to visit the countryside, such as the Adirondacks in upstate New York.

Transportation allowed reconnection with nature in different ways. The proximity of the Adirondacks to New York and Boston made them an appealing destination. In the first half of the nineteenth century, however, access was not easy. The stagecoach was the main means of access to the central Adirondacks (Kaiser, p. 34), and small parties or individual hunters were the most typical visitors to make the journey. In the middle and latter half of the century, Thomas Durant and others oversaw the extension of rail lines throughout the

Adirondacks. In 1869, William Murray published *Adventures in the Wilderness; or Camp-Life in the Adirondacks.* This book, which became incredibly popular, caused a dramatic increase in visitors to the Adirondacks.

Adirondack Camps: A Rural Escape

This new access and popularity led to the establishment of a number of Adirondack hotels specifically intended to cater to the new "leisure class." Eventually, some wealthy families felt that buying or leasing their own land would provide them with a better wilderness experience. The hotels, with their guides and package trips (including tents and all other necessary equipment) could no longer provide them with the solitude they sought. In many cases, the sheer numbers of people taking advantage of the opportunity simply convinced the wealthiest families that this vacation routine had become too pedestrian. The incredible Prospect House hotel, built on Blue Mountain Lake, illustrated the problem perfectly. It had over 300 rooms, with electric lights, running water, and steam heat. It also had its own fenced-in deer corral. For some, this was not a satisfactory wilderness adventure.

Although the primary motivation for purchasing remote property was often to ensure a more authentic backwoods vacation, accommodations were made to facilitate the process; tent platforms and other minor amenities were often constructed on these wooded sites. Some families grouped together to form clubs or associations. In a variety of ways, the wilderness experience and the social aspects of vacations in the Adirondacks began to merge. As houses and support buildings became part of the vacation lifestyle, so did social visits and teas. The trips became more and more complex, involving large numbers of people and huge quantities of equipment and provisions.

Never to be outdone when it came to spending, the wealthiest Adirondack vacationers, including such families as the Vanderbilts, Whitneys, Carnegies, and Morgans, began to build increasingly larger estates, complete with hunting lodges, ice houses, carriage houses, work shops, and, of course, boathouses. These estates were less palatial than those of, for example, Newport or Southampton. The buildings themselves tended to be more rustic in appearance. Additionally, functions were often broken out of the main house and accommodated in separate outbuildings, thus reducing the scale and even the formality of the main structure. To reinforce the rustic impression, the owners called these estates "camps."

Adirondack architecture was based on indigenous log construction, but also drew on styles found in other alpine areas; Swiss chalets were a prominent source, but aspects of Japanese, Bavarian, Russian, and Scandinavian design were present as well. Elements such as broad roof overhangs to protect the building below from snow were drawn from these styles. Ideas and craftsmanship drawn from rustic furniture making were extended to provide decoration of many Adirondack structures. These designs used materials endemic to the regions— stone and wood—in new and creative ways.

Boathouses were frequent and important components of Adirondack camps. Indeed, the region is noted for its collection of unique waterfront structures. These buildings were often the first point of arrival for guests who arrived by boat. As such, they were required to make a favorable first impression on the guests, and many directly faced the water in a formal manner. As time passed, some

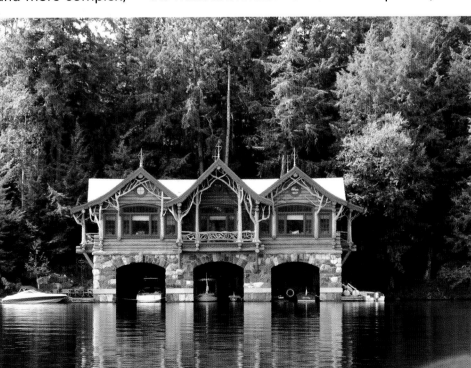

The second boathouse at Topridge features a stone base, log construction and ornate decoration of woven branches and stumps. *Courtesy of Doug Shick*

of these boathouses became more sophisticated, adding fancy game rooms, club rooms or other functions that might complement their roles as gateways to the estates. Many of these structures manage to be simultaneously rustic and elaborate. Two of the most striking examples are at the camp called Topridge, where the boathouses feature incredible detailing fashioned from tree roots and branches, forming brackets and ornate friezes that are essentially woven stick work. This later structure represents the culmination of the style that had evolved over the previous fifty years or so.

A similar pattern of leisure resort development followed in other wilderness areas with reasonable proximity to urban centers. The developments in the Muskoka region in Canada mirrored the Adirondack development. Resort hotels were built there too, with its own Prospect House, Royal Muskoka Hotel, and Deerhurst Inn. Ultimately, grand residences with outbuildings appeared, again following the pattern in the Adirondacks. The Muskoka region also became particularly known for its numerous and unique boathouses.

Leisure resorts of varying styles and with varying features developed throughout much of the settled area of the country. Grand hotels were built in many of these resorts, in such places as the White Mountains, on Lake Champlain, and along the St. Lawrence River. Spas opened in central Pennsylvania, Saratoga, New York, West Virginia, and Arkansas. Although these regions may not be known for boathouses in the way that Muskoka and the Adirondacks are, boathouses could be found in most places where there was water and were built with frequency until the onset of the Depression.

As rural development gave birth to a number of remarkable private boathouses, in the cities people found different ways to escape the burdens of nineteenth century life. Another group of people, generally much less wealthy—at least initially—found relief through physical activity.

Rowing: A Physical Outlet

With increased efficiency and reduced physical labor, industrialization provided people with both leisure time and the energy to engage in physical activity during that time. Athletic endeavors became more popular early in the nineteenth century and grew exponentially in the latter half of the century. During this time, a number of new sports were invented or formalized, including baseball, basketball and volleyball in the United States and soccer (football) in England. The Modern Olympics were established in 1896.

The nature of nineteenth century athletic activities was limited by access to the space necessary for those activities. In urban areas, without expansive open land available for games, boxing grew in popularity as did sandlot baseball. At the same time, huge numbers of people made their living on the water, fishing, shipping, or ferrying passengers across rivers. Races between ferrymen were common, generally accompanied by betting. Other rowing races took place between crews of ships moored in New York Harbor (Miller, *"The Wild and Crazy Professionals"*). Many of the successful rowers, and even their boats, became famous. Some rowers were so successful that they no longer needed to work outside of their competitive rowing: they were some of the earliest modern professional athletes.

The upper class, both in England and the United States, initially perceived rowing as a social activity: a boat trip with lunch. Upper class rowing activity was centered on universities and social clubs. Eventually, the competitive activity became the central focus for the universities and the social clubs. In 1829, Oxford raced Cambridge in the first of what is now the longest running athletic event. The first Henley regatta was held 10 years later. In the United States, 1852 marked the first race between Harvard and Yale, the longest continuous United States collegiate competition. Yet as collegiate rowing grew, much of the interest remained focused on professional rowing. Even Henley, originally intended as a wholly amateur event, was quickly marked by prize money and substantial betting even amongst the competitors (Dodd, p. 53).

Thousands watched rowing races, and certainly thousands gambled on them as well. Rowers became local heroes and legends followed by many avid fans. By the 1860s, rowing had exhibited spectacular growth; in 1869, Oxford defeated Harvard in front of an enormous crowd, variously estimated from 500,000 to 750,000 spectators, along the Thames River (Weil, *"Brief Timeline: 1850-1899,"* and Miller, *"The Great International Boat Race"*)! This must have been one of the largest spectator events up to that time. The popularity of collegiate rowing exploded soon after; within two years, the Rowing Association of American Colleges was formed, and rowing became the first organized collegiate sport in the United States.

The growth of the sport also meant that more structures were necessary to house the boats. Many of the early boathouses were simple sheds, doing nothing more than protecting boats from snow and rain. The first boathouse for the Undine Barge

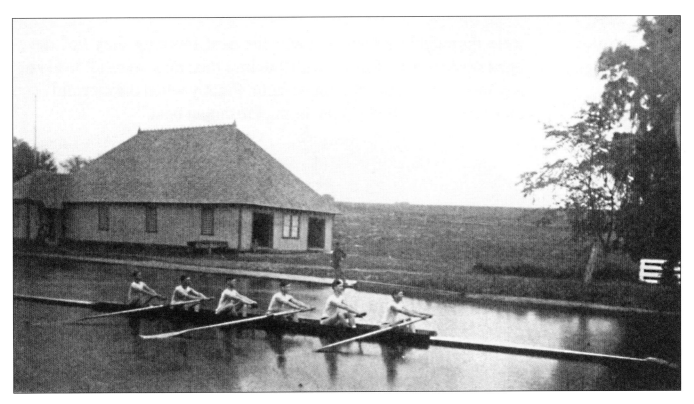

The original Princeton University boathouse was a simple two-bay shed on the Delaware and Raritan Canal. *Courtesy of the Princeton University Rowing Association*

Club, built in 1856, was "a shed, fifty feet long, by eight feet wide, costing one hundred dollars" (http://www.undine.com/about.php). A number of clubs and colleges built boathouses in the next forty years or so. Many of these were quite simple, as well: Princeton University's first boathouse, built in 1874 on the Delaware and Raritan Canal, was a 70-foot by 30-foot single story structure with few adornments. (Presby, p. 19).

In some circles, rowing boathouses became more than functional. In Philadelphia, the Fairmount Park Commission was established in 1867 to regulate the property around the city's water works. The commission, influenced by city leaders, promoted the idea that the sport represented a moral ideal that should be encouraged. It also felt that the architecture of the boathouses should reflect that moral rectitude, and they required that all existing clubs dismantle their buildings and rebuild them in a proper style (Beischer, p. 300). What this meant varied over the years, although strict spacing, orientation to the water, and dimensional requirements were enforced. Ultimately, the competition between the clubs extended to the architecture of their buildings, resulting in a forty-year period of architectural one-upsmanship. Many consider the high-point of the architectural battle to be the construction of the new Undine Barge Club boathouse in 1888. Designed by noted

architect Frank Furness, the boathouse pushed the picturesque qualities of its Boathouse Row neighbors to new limits, using different materials to house different functions, while still responding to Fairmount Park Commission's strictures. In a sense, by its own boldness, the design of the Undine Barge Club opened the door to consider boathouse design as a serious pursuit.

The first decade of the twentieth century saw a flourish of boathouse construction; as the new century dawned, many of the earlier boathouses were ready for a new generation of buildings to replace them. Given the Boathouse Row precedent demonstrating that boathouse design was a worthy architectural endeavor, leading architects of the time designed many of these new buildings, at some of the finest colleges. At Harvard, the prominent firm of Peabody and Stearns designed both the Newell (1900) and Weld Boathouses (1906). Five years later, they designed a grand structure for archrival Yale: the Adee Boathouse, which opened in 1911. (Unfortunately for Yale, the water of New Haven Harbor proved to be congested and dangerous, forcing the university to build elsewhere some two decades later.)

Some of these second generation boathouses were more ambitious as projects than they were successful as works of architecture. Princeton's Class of 1887 Boathouse, completed in 1913,

was an unusual collegiate gothic stucco structure with Craftsman Style proportions, designed by Pennington Satterthwaite. A bit ungainly but not without charm, it was a sprawling structure with seven bays, a huge club room and balcony, lockers, showers, kitchenette, and director's room. At Yale, James Gamble Rogers designed the replacement for the Adee Boathouse in 1923. Not fully completed, the resulting building was a lukewarm stucco structure that seemed out of place in Derby, Connecticut. The Gould Boathouse at Columbia, occupied in 1920, is a plain and undistinguished colonial block.

After the Wars

As was the case with leisure boathouses, the Depression and World War II slowed the construction of rowing boathouses. After the war, as modernism continued to gain prominence in the architectural realm, it was slow to take hold in the conservative rowing world. Even so, modernist boathouses were constructed for two of the nation's

most storied rowing programs. The University of Washington, who had rowed out of a lighthouse-like structure early in the century, then a rebuilt hangar, opened the Conibear boathouse in 1949, a large, blocky, flat-roofed structure. Cornell built the Collyer Boathouse in 1958, a three-bay structure with a broad low-pitched gable roof. One of the most notable modernist boathouses, MIT's Pierce boathouse was built in 1966. A floating, flat roofed structure, it is infamous in that the oars did not fit in the boatbays, requiring that holes be cut into the first floor to accommodate them.

Beginning in the 1980s, the nostalgia inherent in a postmodern approach to design fit the conservative rowing community well. In 1986, the Friends of Dartmouth Rowing Boathouse opened on the Connecticut River, with arched boatbay doors and a large "Palladian" second floor window. Two other historic boathouses were built on one of rowing world's most hallowed rivers, the Charles. First, Northeastern was able to move out of its long time home at Riverside Boat Club, when they opened

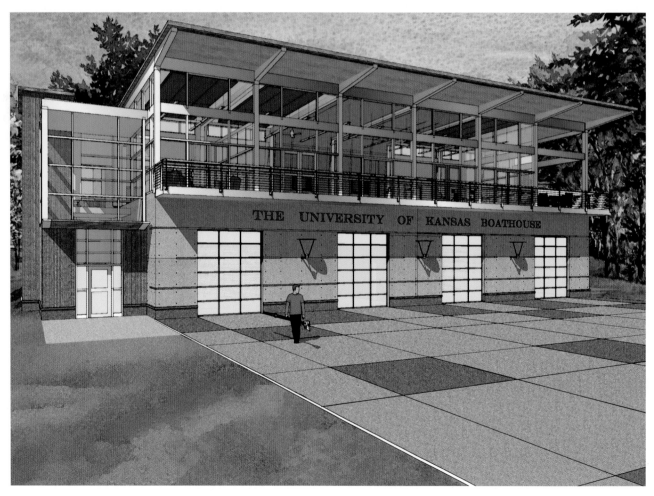

The proposed new boathouse (Design Architect: Peterson Architects. Architect of Record: Treanor Architects) at the University of Kansas features a flood-proof lower level and a second floor with a glass-enclosed club room. *Courtesy of Peterson Architects*

the Henderson Boathouse (which recalls Harvard's Newell Boathouse a few miles downstream) in 1989. Boston University opened the DeWolfe boathouse (which recalls its predecessor building on the site) a decade later.

Although federal gender-equity legislation called Title IX was passed in 1972, the growth in collegiate rowing has been most dramatic in the twenty-first century. Refreshingly, this growth has been reflected in a substantial wave of bold new boathouses. Many of these new modern structures have moved past the bland functionalism of their early modern predecessors; they combine bold forms, simple and elegant detailing, and thoughtful response to their sites. Many also provide cross-sectional excitement by including dramatic vertical spaces to serve as counterpoints to the horizontality of the on-the-water experience. Structures such as those at the University of Wisconsin, Tufts University, the University of Washington, and the proposed boathouse at the University of Kansas illustrate the new vigor of the sport.

Boathouses and the Environment

Environmental issues have influenced both private and institutional boathouse design even prior to the current interest in "green" design. For example, FEMA regulations have affected what can be constructed in a 100-year flood plain. Boat storage is generally allowed within this zone, but many of the support functions, such as lockers and showers, are not. These support components can be built above the boats (at a floor level above the flood elevation), but, for institutional buildings, this solution can be complicated by the need to provide handicap access, generally with an elevator, within that same flood area.

Conservation laws have also had a direct impact on boathouse design. Historically, most rowing boathouses were configured with their storage bays perpendicular to the water. The boathouse thus formally addressed the water and defined its own space between the building and the shore. Often this space was a vast inclined pier, providing a sloping apron from building to dock. In many states, current conservation regulations require setbacks from the water's edge and also protect plants within those zones. The traditional perpendicular configuration does not work with these regulations; the aprons put shore plants in shade and violate setbacks. One solution to these issues is to set the building back farther from the water or to locate and orient the building so that boat maneuvering within the sensitive zones is minimized.

In many states, the same setback requirements have made the private boathouses at the water's edge nearly impossible to build. Some states have effectively banned them. For example, in New Hampshire, regulations state that "no person shall excavate, remove, fill, dredge or construct any structures in or on any bank, flat, marsh, or swamp in and adjacent to any waters of the state without a permit from [Department of Environmental Services]" (New Hampshire Legislation RSA 482-A:3).

In some states, on-the-water structures have historically been allowed if they either float or are built completely over the water. The flooding in the Midwest in 2007 called the allowance of these boathouses into question. After some boathouses were torn loose in the high water, the Iowa Department of Natural Resources ordered floating boathouses removed, stating that dock structures were not allowed with roofs and side walls. The argument that floating boathouses were actually boats themselves was not accepted. It would be premature to state that residential boathouses are a thing of the past, but it is certainly true that these water-side structures command more attention than they have previously.

Back to Nature Again

Environmental sensitivity need not prevent the construction of boathouses for rowing. However, with the greater awareness of the possible impacts of building on the water's edge comes a greater responsibility to do it well.

Probably the most critical issue one considers when designing a building with the environment in mind is how the building is sited. By their nature, boathouses are dependent on proximity to water. Not surprisingly, building construction is not considered to be an optimal environmental use of delicate waterfront property. Rowing, however, can be a net benefit to this habitat. Such use is generally non-polluting and not otherwise detrimental, and creates a new group of people to whom the well-being of the water is important. Urban infill and brownfield sites should be favored for boathouse construction if possible. These sites should then be carefully designed to consider how stormwater retention, "heat-island" effects, shoreline preservation, plant retention and other environmental issues can be dealt with in ways that will mitigate the impact the building will have on its site.

A boathouse on an urban or brownfield site can create a new appreciation and connection between a community and its waterfront. Such a reconnection has, in fact, occurred at the newly constructed Tufts boathouse in Massachusetts. In a letter to *Rowing News* Magazine titled "Boathouses

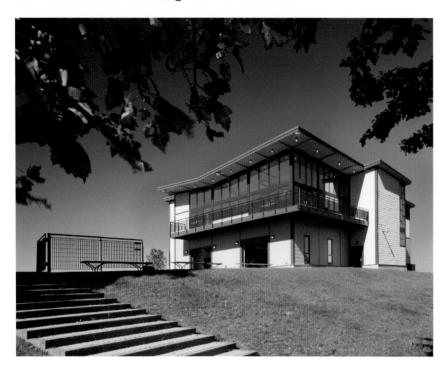

The Shoemaker Boathouse at Tufts University was constructed on remediated brownfield land. The project has allowed the neighboring community to rediscover its waterfront. *Photo by Edua Wilde*

Helping the Environment," Tufts' Director of Rowing Gary Caldwell noted, "Our new boathouse has been a catalyst for redevelopment and reconnecting the Malden River to the surrounding community," as part of a broad effort to "reclaim an urban wasteland and cesspool and return it to beauty and usefulness" (Caldwell, p. 17).

Caldwell's letter highlights the joy of a community finding new appreciation of its long-abused waterfront. This observation brings us full circle to the very point for which boathouses were first built in the Adirondacks and for competitive rowing: to provide for people a way to "re-create" themselves in a setting apart from the stresses of everyday life. As such, boathouses are gateways to a new life, one in which nature has the upper hand, where wind and waves alter our absolute control over ourselves and our surroundings.

Jeff Peterson is both an award-winning architect and a part of the rowing community. He rowed at Simsbury High School, Princeton University and on the US Lightweight team. He coached at Princeton and at the University of Virginia. Jeff received his B.A. from Princeton University and his Master of Architecture from the University of Virginia. With 20 years of experience, he is also one of the world's most accomplished architects and planners of rowing facilities. Jeff was an associate at ARC/Architectural Resources Cambridge, where he worked on a number of boathouse projects. In 2001, he started his own firm, Peterson Architects, in Cambridge, Massachusetts, which has designed boathouses and rowing tanks from Florida to the state of Washington and in several foreign countries.

Works Cited

Beischer, Thomas. "Control and Competition: The Architecture of Boathouse Row." *Pennsylvania Magazine of History and Biography*. July 2006

Caldwell, Gary. "Boathouses Helping the Environment," Letter to *Rowing News*. August 2008, p. 17

Dodd, Christopher. *Henley Royal Regatta*. London: Stanley Paul, 1987

Kaiser, Harvey. *Great Camps of the Adirondacks*. Jaffrey, New Hampshire: David R. Godine, 2003

Miller, Bill. "The Great International Boat Race." http://www.rowinghistory.net/1869.htm: 2006, accessed July 2008

Miller, Bill, "The Wild and Crazy Professionals." http://www.rowinghistory.net/professionals. htm: 2003, accessed July 2008

Mumford, Lewis. *The Culture of Cities*. New York: Harcourt Brace Jovanovich, 1970

New Hampshire Statute RSA 482: "Fill and Dredge in Wetlands"

Presby, Frank. Excerpted in "Ready All Row," *Rowing at Princeton*. Princeton, N.J.: Princeton University Rowing Association, 2002

Undine Barge Club Website: http://www.undine. com/about.php. Accessed 2 July, 2008

Weil, Thomas E., "Brief Time Line 1850-1899." http://www.rowinghistory.net/Time%20Line/ TL%201850-1850-1899im.htm: 2005. Accessed July 2008

Introduction

So we beat on, boats against the current, borne back ceaselessly into the past.

—F. Scott Fitzgerald, *The Great Gatsby*

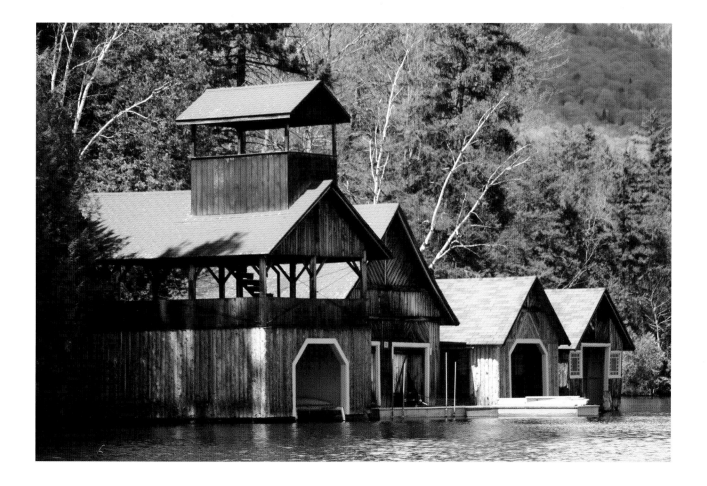

Boathouses...just saying the word evokes memories of a long-gone time of wealth and privilege. Boathouses are often associated with boat or rowing clubs and evoke magazine ads of prep schoolers, beautiful people, and sun-kissed decks. Generally people who own a boathouse will house their boat rather than leaving their boat moored or tied up. Many Americans on the Eastern Seaboard immediately refer to Boathouse Row on the Schuykill River in Philadelphia. Some may think of the Loeb Boathouse, which contains the Boathouse Restaurant in New York's Central Park, or a rustic Adirondack boathouse from their youth.

Boathouses can be considered a symbol of wealth. They belong to a period, when people had the wherewithal to build housing for their boats and the time to enjoy the rivers and lakes. In those pre-income tax years, people could afford houses for their boats!

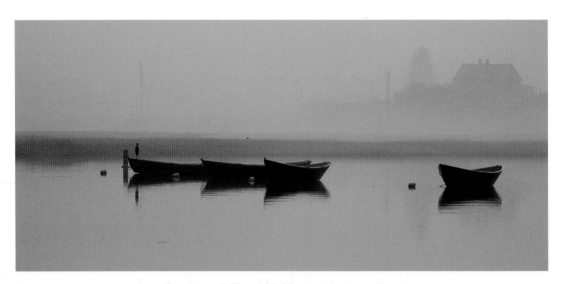

Courtesy of Aimee McMaster photographer

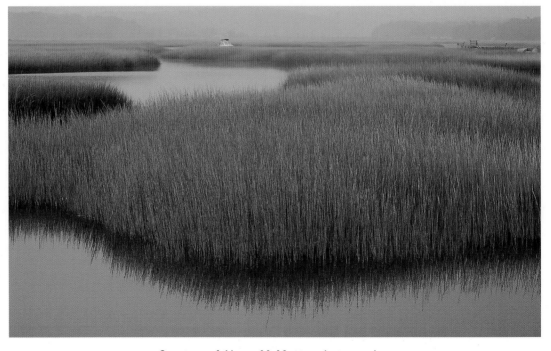

Courtesy of Aimee McMaster photographer

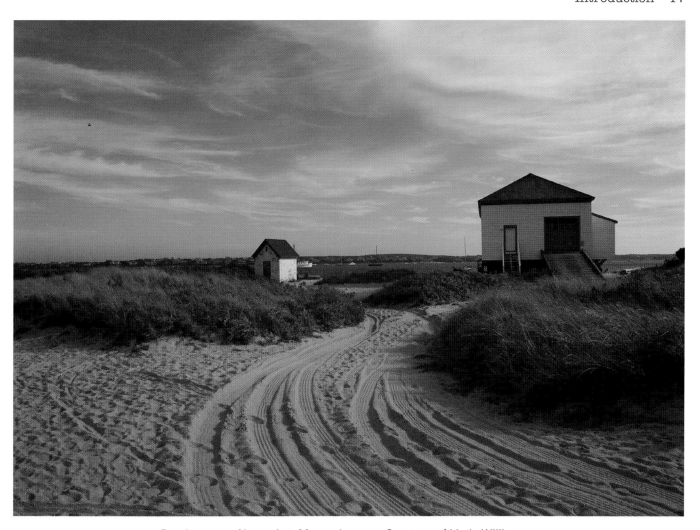

Boathouse on Nantucket, Massachusetts. *Courtesy of Linda Williamson*

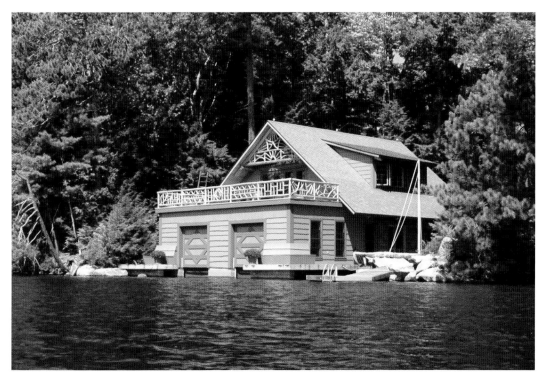

Boathouse on Squam Lake, New Hampshire. *Courtesy of Neil Tischler*

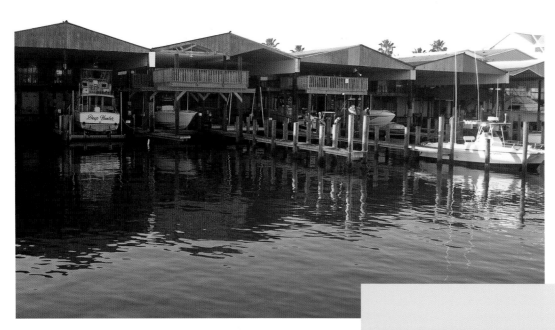

Boathouse in Texas. *Courtesy of Eleanor Lund*

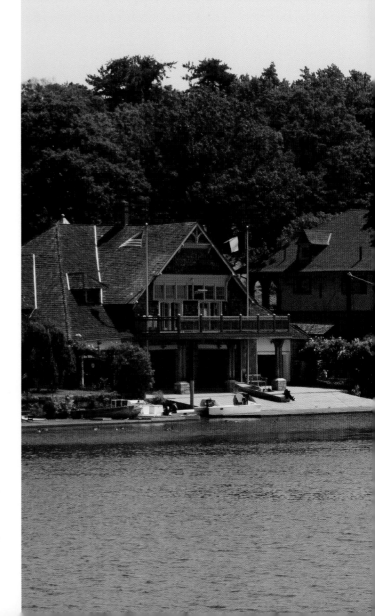

Boathouse Row, Philadelphia

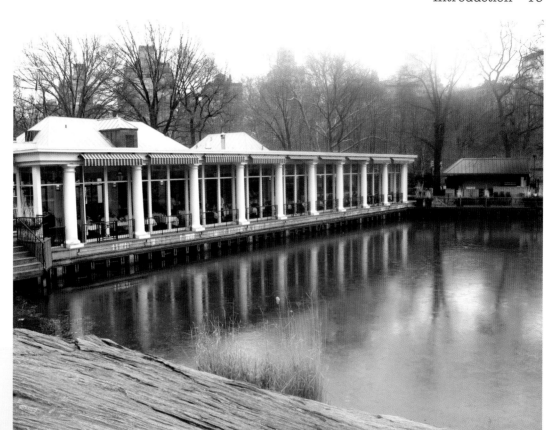

Loeb Boathouse,
New York City

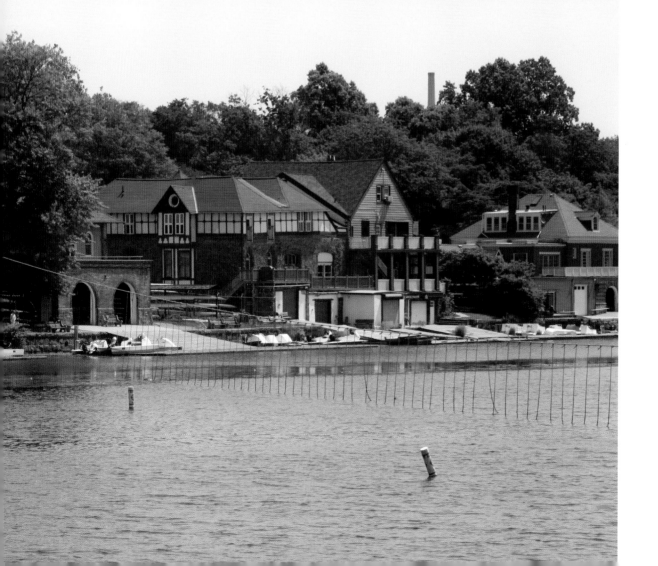

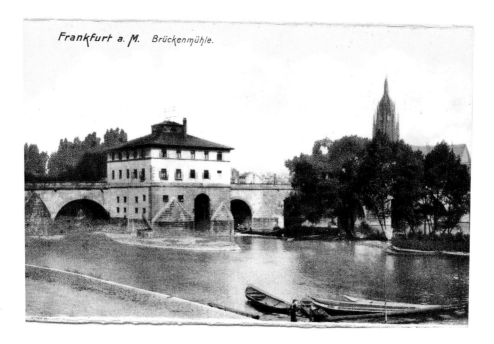

Frankfurt a. M. Brückenmühle.

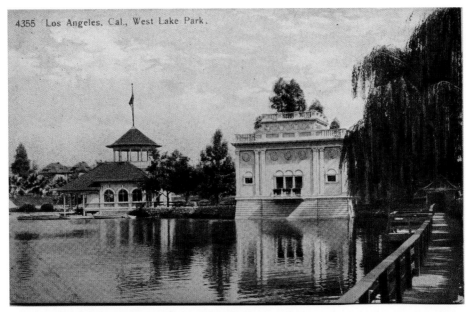

4355 Los Angeles, Cal., West Lake Park.

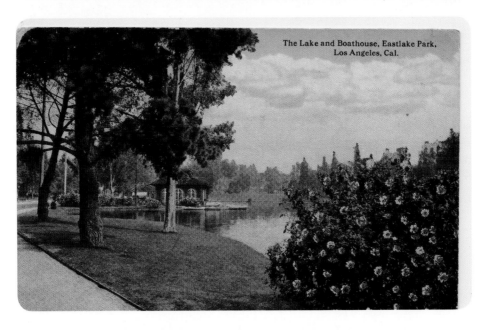

The Lake and Boathouse, Eastlake Park,
Los Angeles, Cal.

Boathouses were fashionable during the Gilded Age (1880-1920). The American aristocracy of the time flocked to regions like Newport, Rhode Island, Thousand Islands, and the Adirondacks, New York, to erect massive estates or large "camps" with beautiful vistas and expansive lawns. Natural resources, labor, production, and transportation were accessible to meet their needs. They traveled by boat, coach, and later by train, bringing their household servants with them—the butler, cook and, perhaps, a lady's maid. They hired natives to mow acres of lawns, to take care of the boats, and to guide the fishermen. They were the bankers, the heads of industry, and the politicians; they were the ones with the next daring idea, the next new product, and the next great invention that would help transform the country to an industrialized nation of international standing.

They all took their leisure very seriously. They came to attend the house parties, the balls, and the horse shows; to play golf, tennis, and croquet; to fish and hunt; to dance, to dine, and to flirt. They came to compete, to impress, and to enjoy this luxurious life of entertainment. They came to do business in a more relaxed environment and to spend time with their families. After six weeks, they would leave, draping the white sheets over the furniture, shutting the blinds, and putting the boats away in a boathouse until next year.

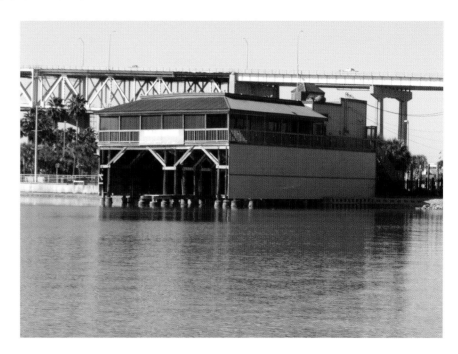

Courtesy of Eleanor Lund

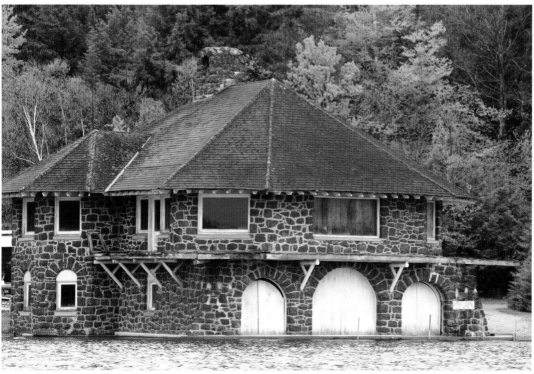

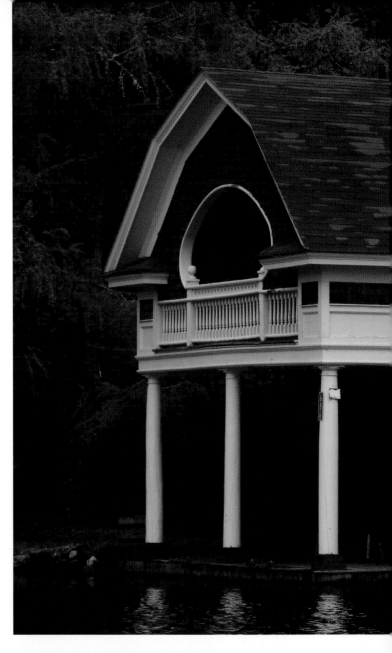

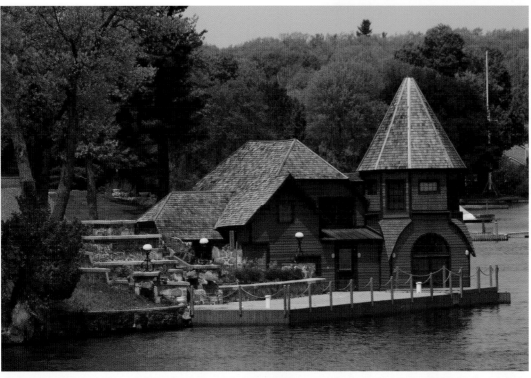

Boathouses can be
very elaborate

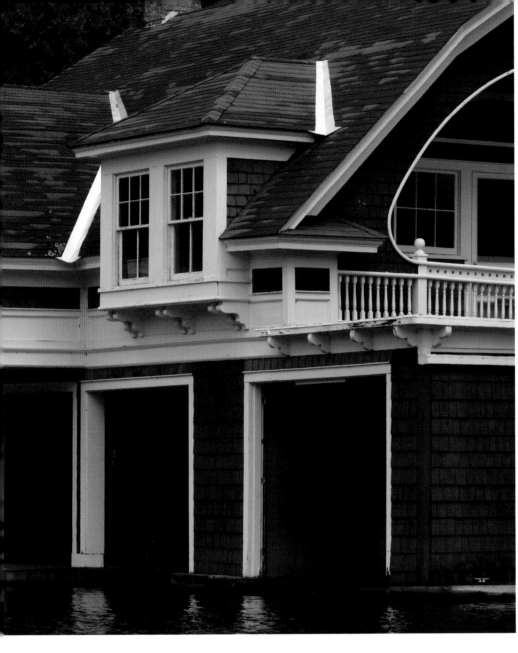

Left and below:
Many are quite large

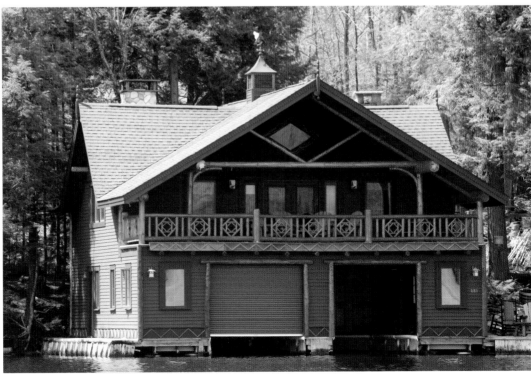

There are private boathouses and rowing club and university boathouses. Boathouses are sometimes modified to include living quarters, or the whole structure may be used as temporary or permanent housing. Club or institutional boathouses contain racing boats together with beginner's equipment and racking for private craft.

Many people confuse the word boathouse with a houseboat. A boathouse is a permanent enclosed structure intended to store watercraft and associated materials. Typically, boathouses are found near water, such as a lake or river. The open sea is generally too rough for a boathouse.

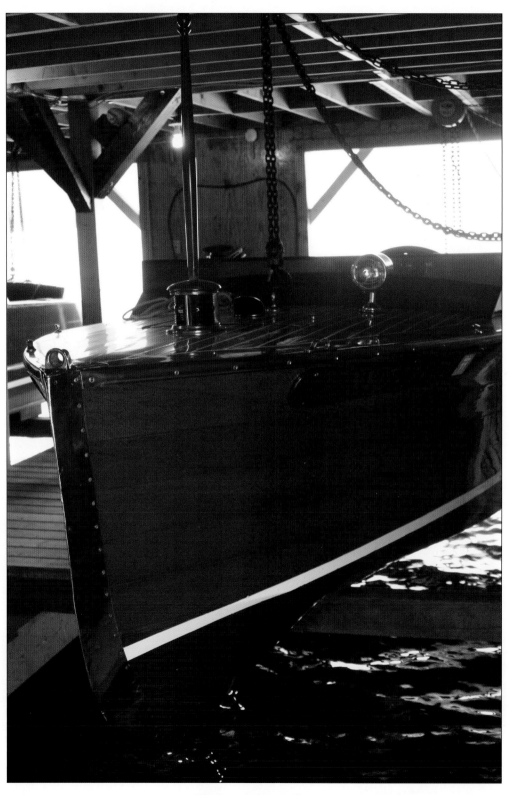

The boat in its cradle.

The interior of the Cambridge Boat Club.

Detail from the entrance oar gate at Yale University's
Gilder boathouse. *Courtesy of Michael Marsland*

Many of these boathouses are unique, using local resources and materials in their construction. Unfortunately, whether they are small architectural masterpieces or quaint nostalgic structures, boathouses are expensive and hard to maintain. They can be easily destroyed by weather, neglect, fire, and vandalism. As the population increases and our waterfront becomes even more popular, we will continue to lose these ties to the past. Boathouses that once housed magnificent motor craft, sailboats, or small rowboats will be only a memory.

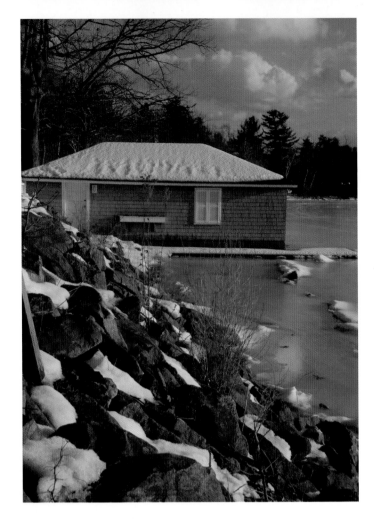

A rural escape.
Courtesy of Linda Williamson

Boston University's boathouse.
Courtesy of Janet Smith Photography

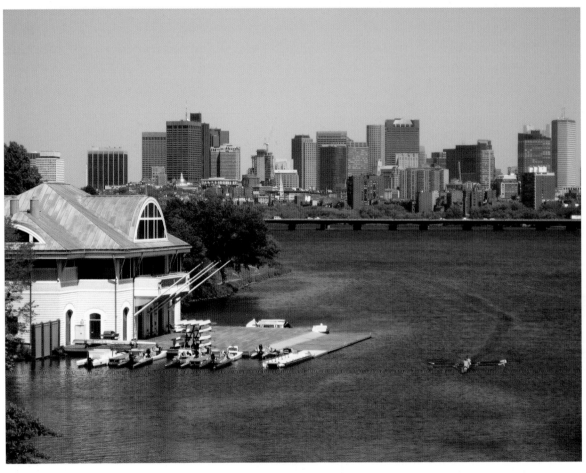

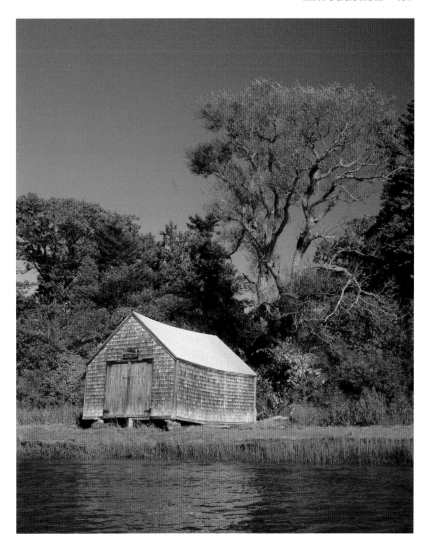

Thoreau idyll.
*Courtesy of Neil
Tischler*

Peace in the wilderness.
*Courtesy of Linda
Williamson*

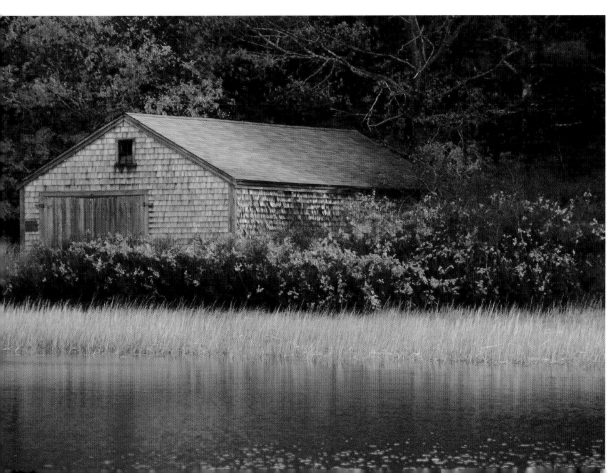

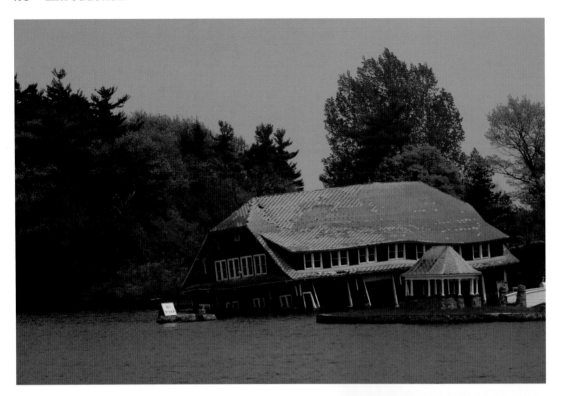

Weather, fire, and even desertion can destroy boathouses.

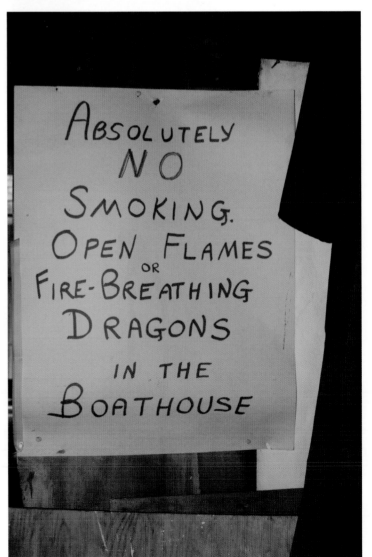

Already, in many areas, boathouses are becoming extinct. Weather and fire have destroyed many. Building codes have hampered their restoration or construction. Environmentalists point out that boathouses can disturb the near-shore habitat, increase the levels of runoff pollution by increasing the degree of impervious surface area and interfere with natural shoreline beauty. Some areas frown on having anything other than boat equipment (i.e., no living quarters) on the second floor of a boathouse. Other areas have such a large variation in water levels that stationary boathouses are no longer possible. Some regions no longer permit new boathouses.

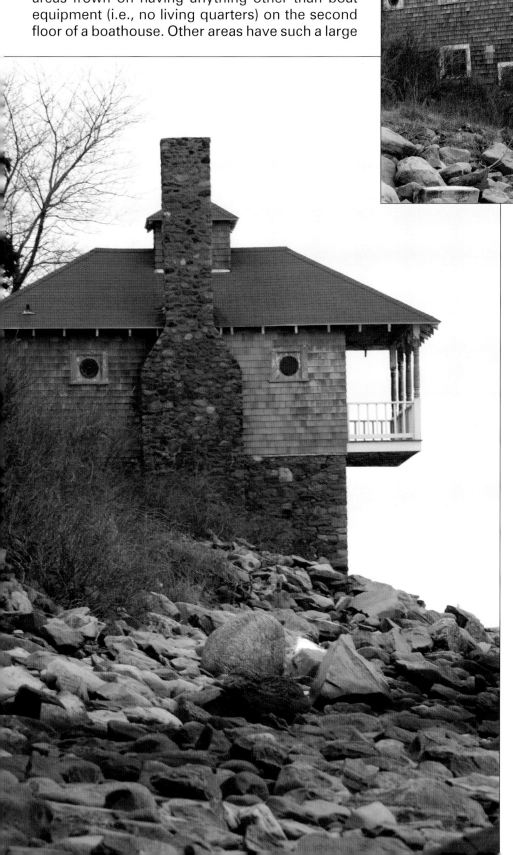

In its heyday, this Jamestown, Rhode Island, boathouse was a lovely shingled boathouse.

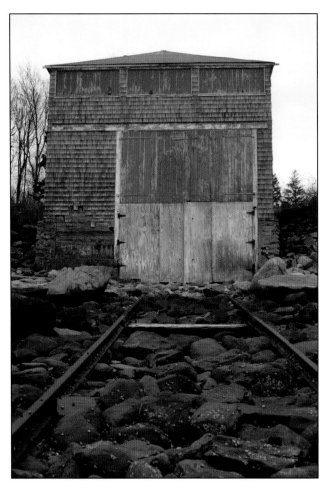

These tracks were used to bring the boat in and out of the water.

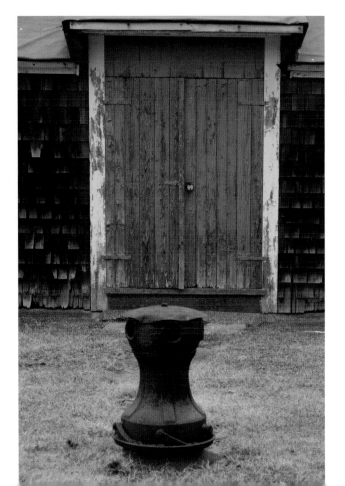

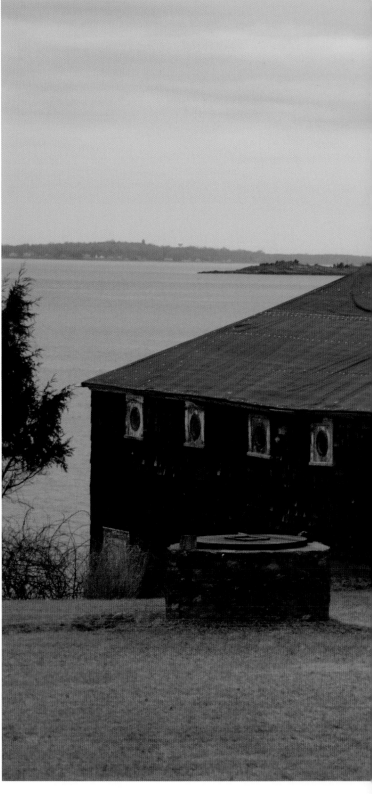

The rope used to pull the boat out of the water was wrapped around this vintage capstan.

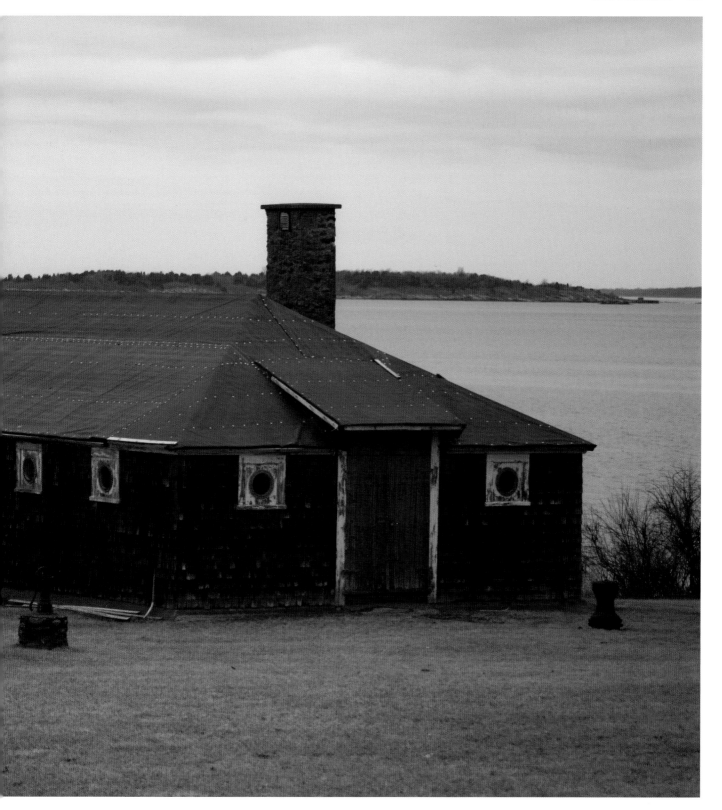

Overlooking Rhode Island's scenic Narragansett Bay, this boathouse is no longer used.

Boathouses do not have the same problems in the institutional arena. Rowing is one of the oldest Olympic sports and can be traced back to the ancient Greeks. Long before football and baseball, rowing was the first organized collegiate sport in the United States, complete with its own governing body. The Yale-Harvard Regatta, or the "Race," began in 1852, making it the oldest competitive sports challenge at the college level. Today, thousands come to Cambridge for the Head of the Charles Regatta. Rowing is becoming an increasingly popular sport at preparatory and college levels and in clubs. In turn, clubs and educational institutions are building and renovating boathouses.

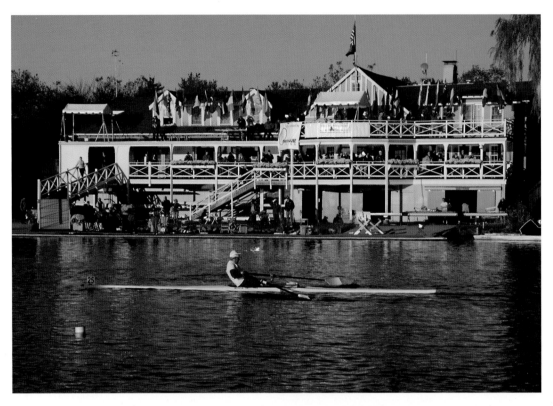

Head of the Charles Regatta® attracts up to 300,000 spectators during the October weekend. *Courtesy of Joan Bowhers*

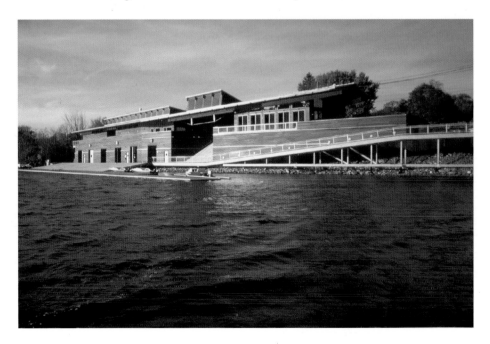

Turner Brooks Architects designed Yale University's Gilder Boathouse. *Courtesy of Richard Cadan*

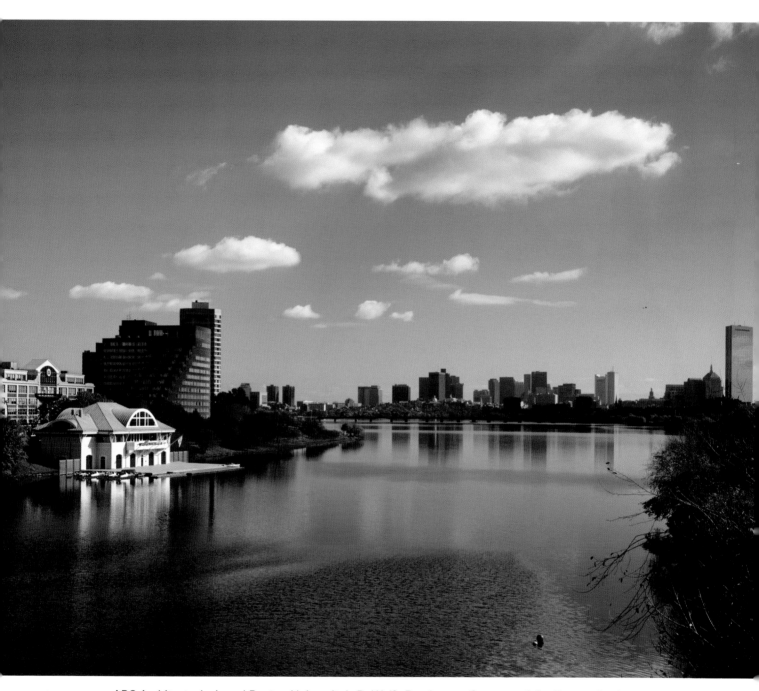

ARC Architects designed Boston University's DeWolfe Boathouse. *Courtesy of the Frances Loeb Library, Harvard Graduate School of Design: Nick Wheeler photographer*

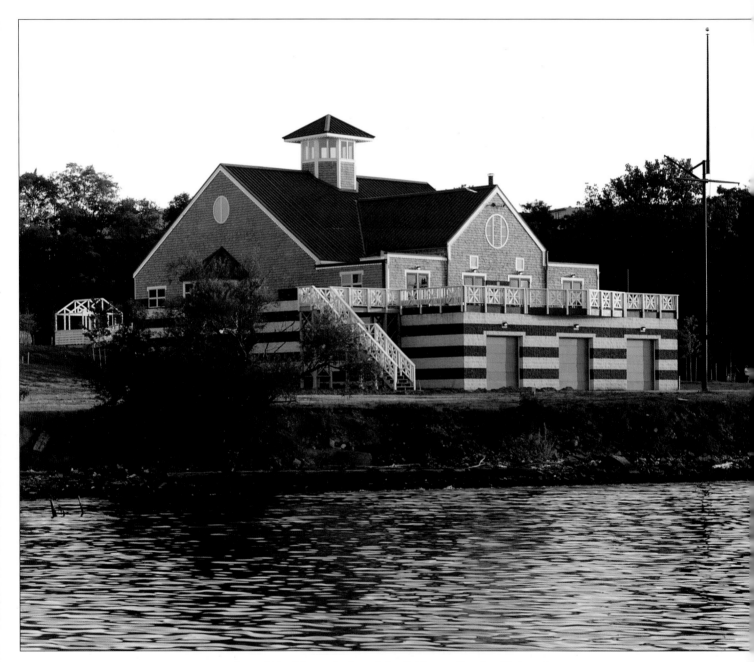

Ayers/Saint/Gross designed the Baltimore Rowing Club and
Water Resource Center. *Courtesy of Ayers/Saint/Gross*

Today, if you're planning a home on a lake or river and if the regulations permit, a well-designed boathouse provides both a convenient place for storing the boat and a spot for hosting a party or entertaining friends. It can be located directly on the bank or out in the water, connected to the shore with a bridge or walkway. It can be a closed or open boathouse, with only a roof to give some shelter against rain and sun. The former protects against the elements and provides more security, but it is more expensive to build. With either type of boathouse, a powered hoist system is normally used to lift the boat out of the water and store it.

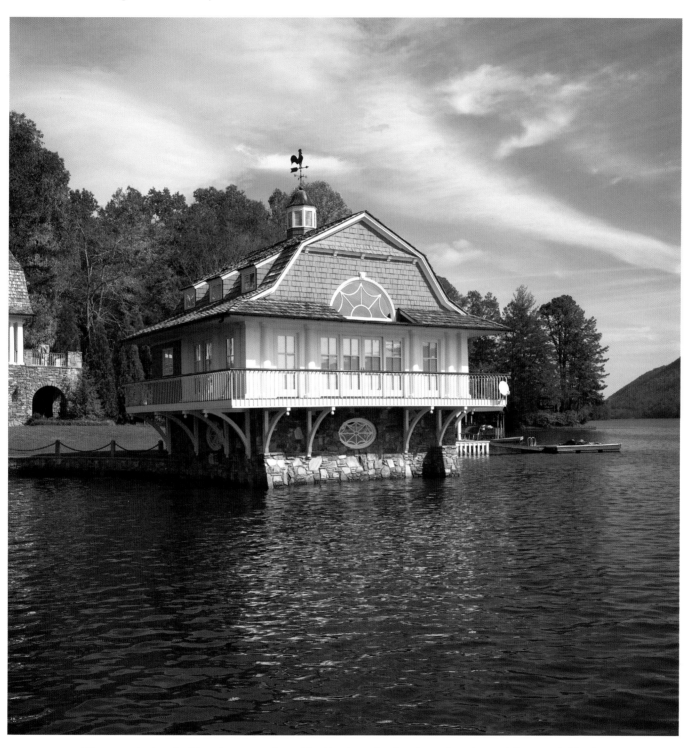

The smartly detailed boathouse designed by Harrison Design Associates is reminiscent of shingle-style homes found along the New England coastline. Matching materials and design features create a visual connection with the main house, while a stonewall bordering the lake further bonds the structures with the landscaping. Repeating elements of note are the gambrel roofs, stone bases, and shingle siding and roofing. *Courtesy of Harrison Design Associates*

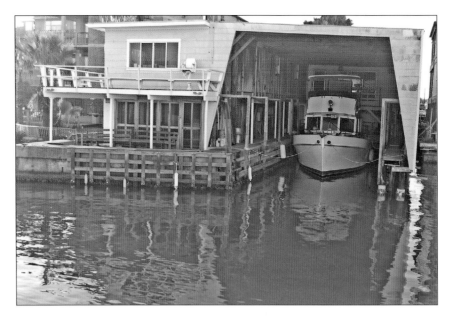

This simple boathouse provides a safe haven from
Gulf of Mexico storms. *Courtesy of Eleanor Lund*

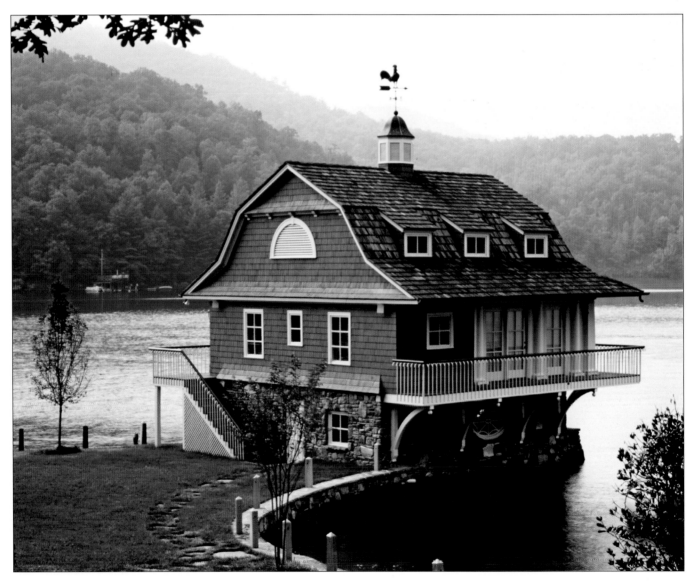

This cottage-style boathouse is as charming as it is functional. *Courtesy of Harrison Design Associates*

In the following pages, we will look at private boathouses from two famous regions: the Thousand Islands Region and the Adirondacks. We then review some recently designed boathouses for private use. We then look at club and institutional boathouses.

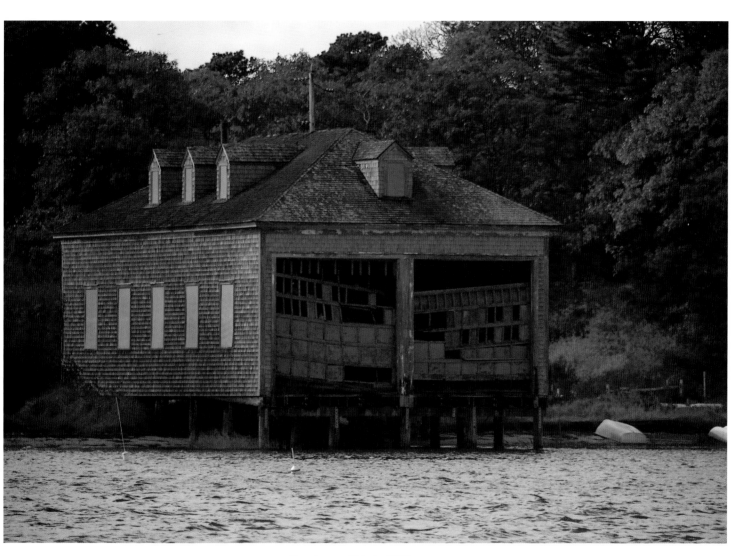

Courtesy of Linda Williamson

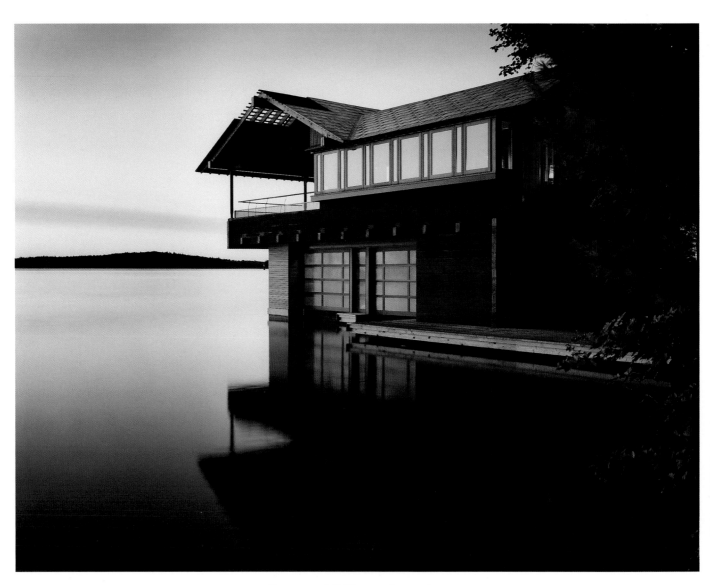

Courtesy of Ed Burtynsky, et al.

I. Residential Boathouses: Old and New

There is nothing—absolutely nothing—half so much worth doing as simply messing about in boats.
—Kenneth Grahame,
The Wind in the Willows

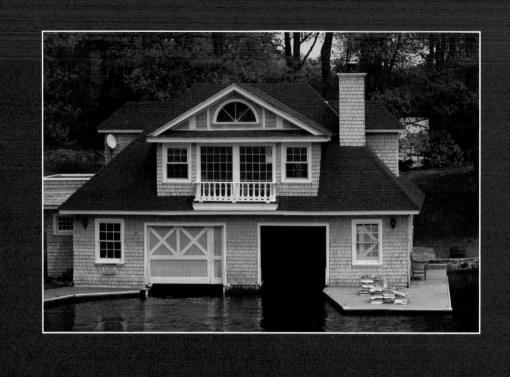

Thousand Islands

When people think of boathouses, they automatically mention Thousand Islands, a pristine resort community, encompassing communities on both sides of the American and Canadian border along the St. Lawrence River and the eastern shores of Lake Ontario. The Native Americans called the region "Manatoana" or Garden of the Great Spirit. Today, it is named for the many more than thousand islands that line this international waterway.

Both the Iroquois and Algonquin traveled to this area for hunting and fishing. After the Native Americans came the squatters, smugglers, lumbermen, and then the shipbuilders. The French explorers named the region. Soon after the Civil War, as transportation developed, sportsmen began to travel to Alexandria Bay, New York, located in the heart of the area for the fishing. Ultimately, wealthy vacationers from New York City, Chicago, and other American and Canadian cities discovered the region in that opulent, pre-income tax period, 1874-1912.

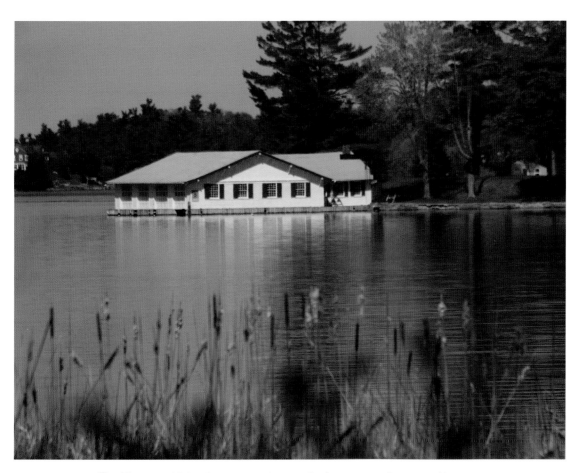

The Thousand Islands region is known for its spectacular natural beauty.

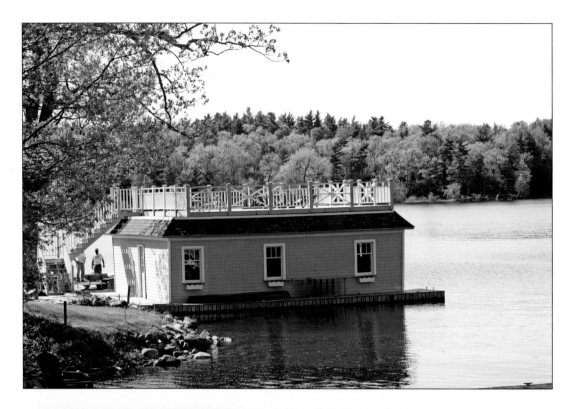

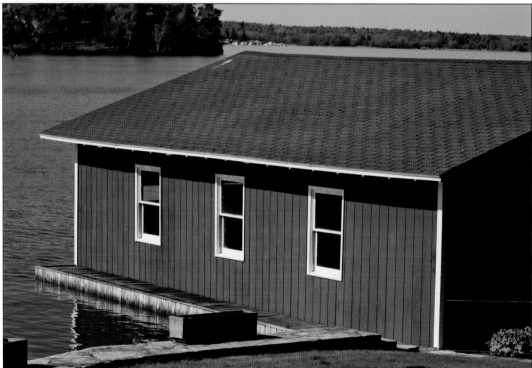

In the seventeenth century, the French explorer Count Frontenac described Alexandria Bay as "A Fairyland, that neither pen nor tongue of man may even attempt to describe."

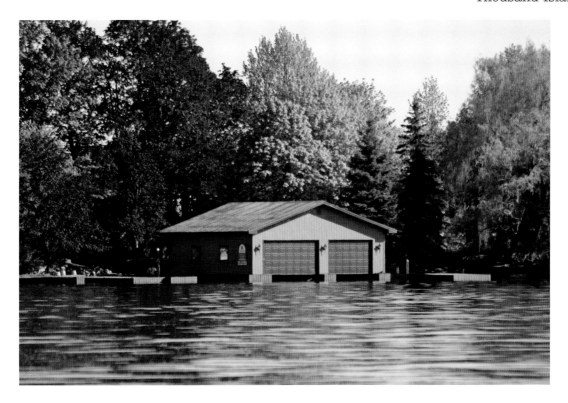

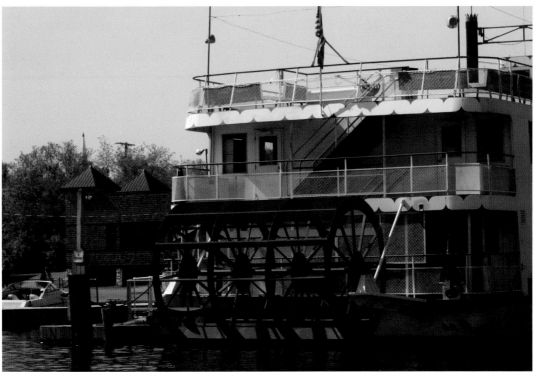

The ferryboats today offer a pleasant scenic trip.

Known for inventing railroad sleeping cars, George M. Pullman invited General Grant to his Thousand Islands home in 1872. The media traveled with Grant, who was running for President of the United States, Once the press began writing articles about this hunting and fishing paradise, people wanted to visit. As many as twenty trains a day would come and go at the village stations. Passengers and their many trunks (no carry ons in those days!) would transfer from train to steamship to their island destinations. The city servants would bring the family's trunks and luggage, and

local summer help would be hired. Recreational excursion vessels and local steamboat lines were introduced to the area. The large vessels served not merely transient tourists, but also gave access to many new island and mainland resort communities.

The small communities along the United States and Canadian shores supplied labor to build new hotels and grandiose summer "cottages." Horse drawn carts transported building materials over the ice in the winter. Owners housed their large island staffs often in boathouses. Sometimes boathouses would be several stories high. Hotels were built, and bankers, heads of industry, lawyers, robber barons, and social leaders built many fabulous summer homes on the Thousand Islands. Several still exist.

One of the most famous is Boldt Castle, which is ranked by *Almanac of Architecture and Design* as the fourteenth most popular historic house museum. At the turn-of-the-century, George C. Boldt, who had immigrated to the United States as a boy and worked his way up to become the millionaire proprietor of the celebrated Waldorf Astoria Hotel in New York

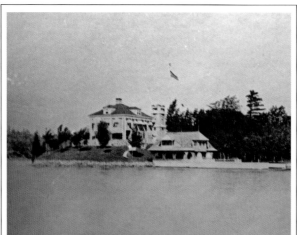

Elizer Hart, a newspaperman and New York State senator, built a river cottage on Hart Island. From there, he could see Alexandria Bay and its promenade of boats on the St. Lawrence River. When George Boldt purchased the island, the original home was moved across the frozen St. Lawrence, expanded and re-designed as the Thousand Islands Club. Now, renamed Hart House in honor of the original owners, it is a lovely B&B.
Courtesy of Jo Morgan and Art Mook

City, decided to build a castle as beautiful as the Rhineland castles, as a monument to his love for his wife Louise. He and his wife chose Hart Island as the perfect setting for his dream castle. In 1900, George renamed it Heart Island and molded the island into the shape of a heart. No small feat. Three hundred workers began to build the six-story, 120-room castle, Italian gardens, drawbridge, and a dovecote. Not a single detail or expense was spared. The remote area was humming with workmen.

One day in 1904, George wired the workers to immediately "stop all construction," as Louise had died suddenly. George never returned to the island, leaving behind the unfinished structure as a monument of his love. For 73 years, the castle was left to the vandals and the wind, snow, and ice. In 1977, The Thousand Islands Bridge Authority acquired the property and decided to rehabilitate, restore, and improve Boldt castle and its structures. Since then George's architectural dream has attracted over 5 million visitors and 700 weddings to the region.

The 90-foot Alster Tower is also known as the Playhouse – perhaps because it has a billiard room, bowling alley, a Roman swimming pool and a room for dancing. Opened in 1899, this building, which resembles a German defense tower, was intended for guests. The Boldt family lived here for four years while the castle was being built.

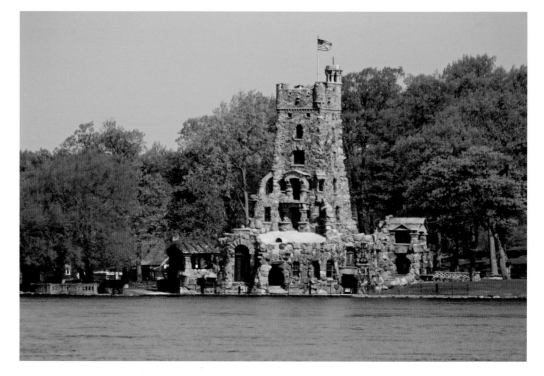

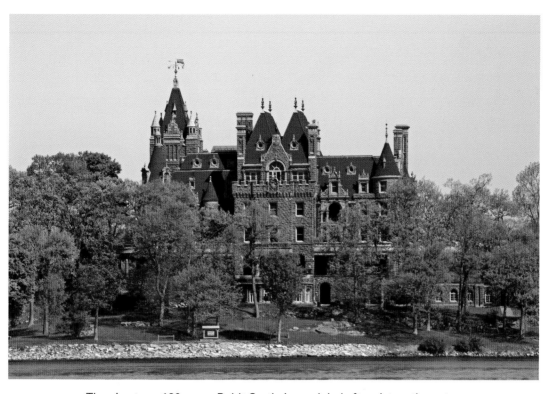

The six-story, 120-room Boldt Castle is modeled after sixteenth century buildings. It combines the beauty of medieval towers with large, plate glass windows, wrap-around porches, an elevator, and fireproof construction.

The castle was a symbol of George's love for Louise. Hearts can be found throughout the building such as in this stained glass window.

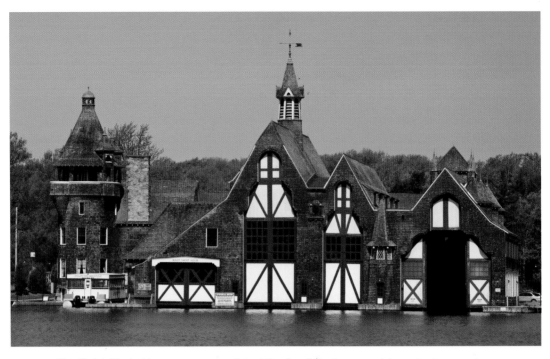

The Boldt Yacht House accommodated the family's three yachts and a tremendous houseboat in its 128-foot-long slips. The 64-foot-high building also housed a shop to build racing launches and staff quarters. The heavy doors require an engine to open and shut them.

Today, the building houses a collection of antique wooden boats from the original Boldt fleet. The Yacht House is listed on the National Register of Historic Places.

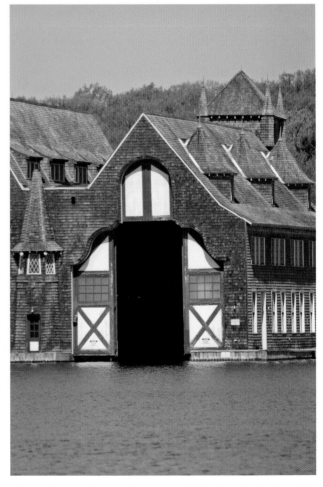

Boat tours to the Castle are available from both Canada and the United States. A shuttle from Heart Island provides access to the Boldt Yacht House.

As a vacation spot, the region is world-renowned. The river runs 1,900 miles from its furthest headwater in Minnesota to its mouth. According to the Official Tourism Board of the Thousand Islands Region, there are 1,964 islands in the region. The islands vary from mere points of rock to several square miles and extend from Cape Vincent to Ogdensburg, a distance of fifty miles. To become a part of this count, any island must be above water level throughout the year and support at least one living tree. The Canadian islands are in Ontario; the American islands are in New York State.

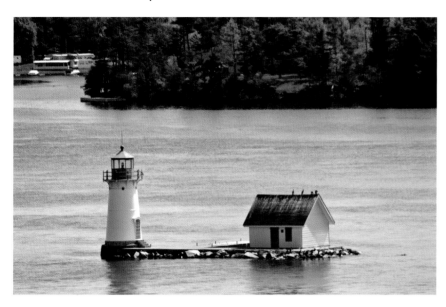

Thousand Islands is also famous because, at the beginning of the twentieth century, Sophie LaLonde of Clayton, New York, served her salad dressing to guests of her husband, a popular fishing guide. With that, she began a new trend in salad dressings. One guest shared the recipe for Thousand Islands dressing with hotel magnate George C. Boldt.

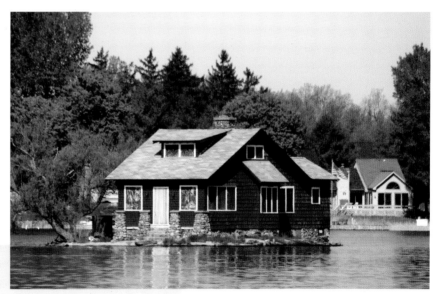

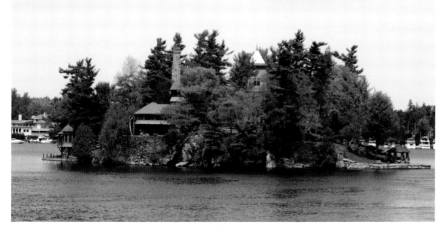

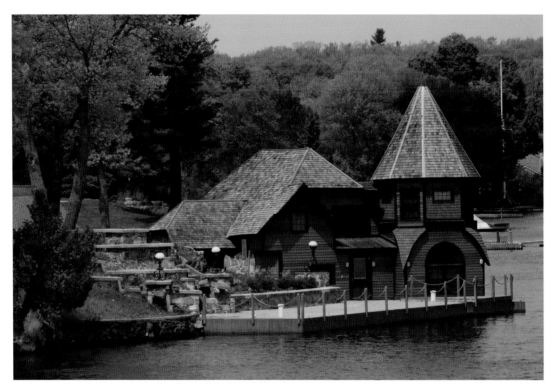

Vacationers, campers, and boaters enjoy the region, which
they call the "fresh water boating capital of the world."

The boater-friendly area has a long history of recreational boating. Previously, large steam
yachts, many requiring distinctive boathouses, sailed here. The Gold Cup Races of the
American Power Boat Association have been held here. The Antique Boat Museum of Clayton,
New York, retains one of the world's major collections of recreational freshwater boats.

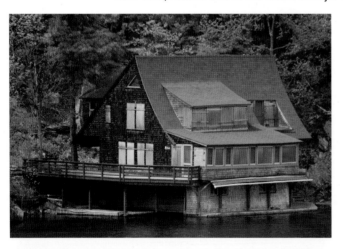

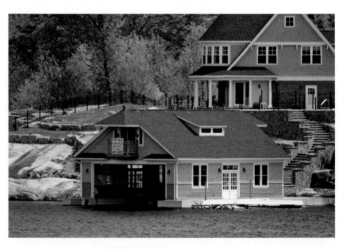

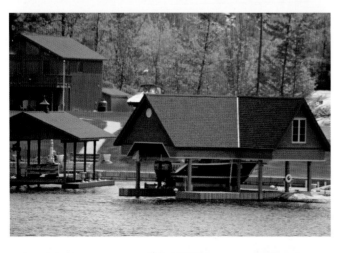

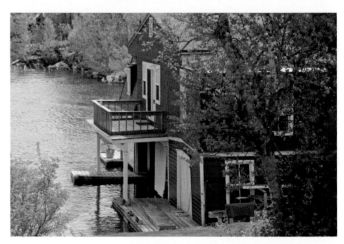

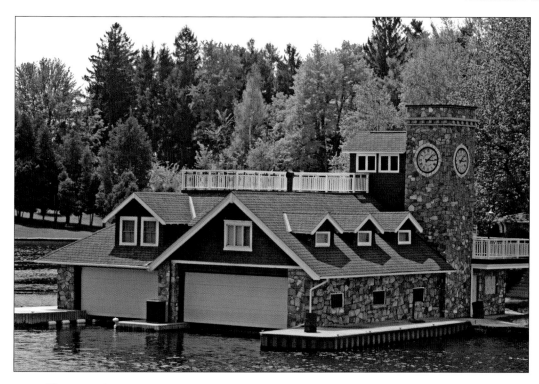

The water is so clear that the river's rocky bottom can be seen at 80 feet. Divers and underwater photographers enjoy the clear river, which contains several shipwrecks.

The islands vary in size, geology, and their distribution. In 1816, a British surveyor recognized and named eight clusters. The islands in the Navy Group, for instance, are named after Royal Navy officers. Those in the Lake Fleet are named after Royal Navy ships, e.g., "Deathdealer" and "Bloodletter." They are part of a granite formation that extends from New York's Adirondack Mountains northwest to Georgian Bay in Lake Huron. Where it crosses the St. Lawrence River, the narrow link of exposed granite seen crossing the river is known as the Frontenac Arch.

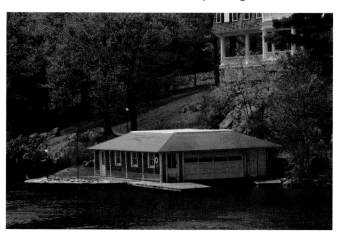

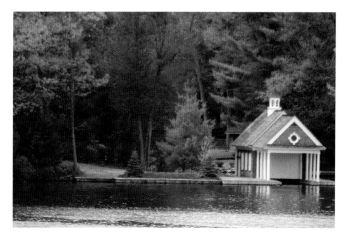

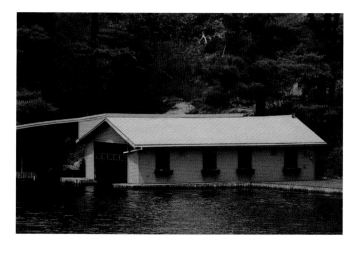

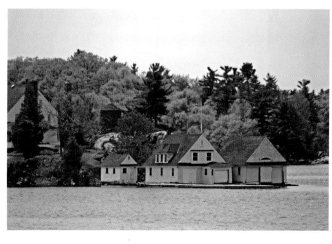

Originally a sportsman's resort, the Thousand Islands continue to boast excellent golf and sport fishing opportunities year-round. Trophy-size bass, northern pike, trout, walleye, and perch abound in the upper St. Lawrence. Novices and expert fishermen find success here. The dedicated sports anglers concentrate on the sharp-nosed muskellunge, or "muskie." They get out early to see if they too can catch one of those mammoth muskies of 39 -50 pounds.

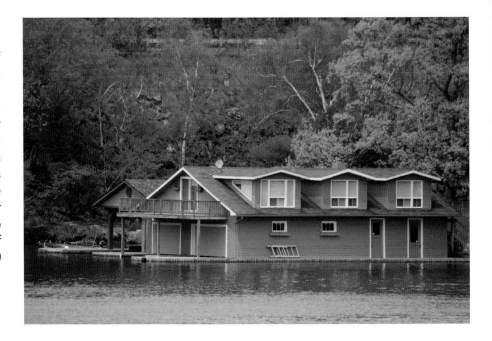

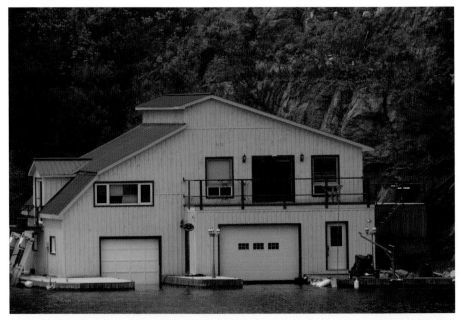

The St. Lawrence River has long been a major transportation route in North America. Cartier named the river in 1535; Samuel de Champlain, followed by many Jesuit missionaries, sailed it in the sixteenth century. The British arrived in the late 1700s. Once the Lachine Canal was completed in 1824, people began to push for further expansion. As industry boomed in North America, more canals around the rapids upstream eventually facilitated river traffic. The demand for an effective seaway by both Americans and Canadians led to the establishment of the International Joint Commission in 1909. In 1959, Queen Elizabeth and President Dwight Eisenhower opened the St. Lawrence Seaway.

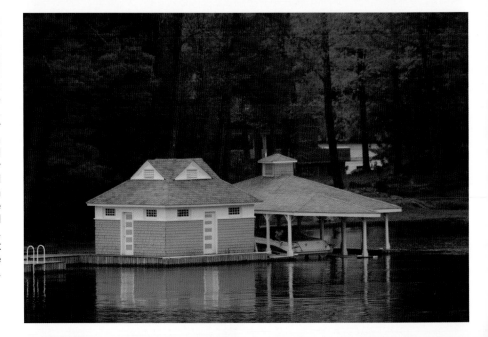

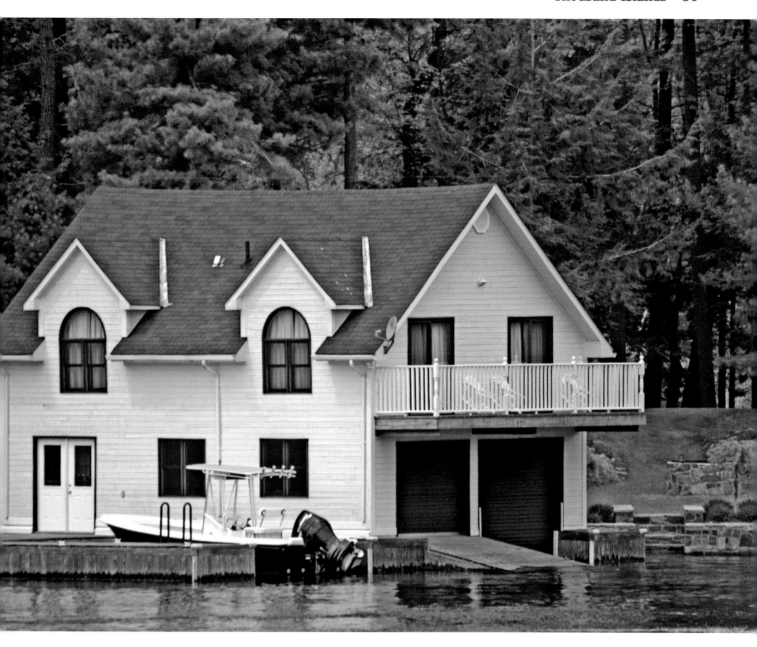

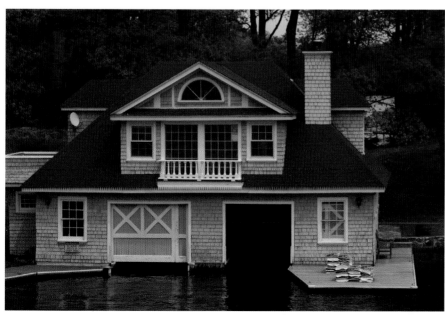

In the Thousand Islands region, Lake Ontario narrows to become the St. Lawrence River. The Great Lakes water flows through these islands. Together, they and the 1,900-mile river connect North America with the Atlantic Ocean, making the largest inland navigation system in the world.

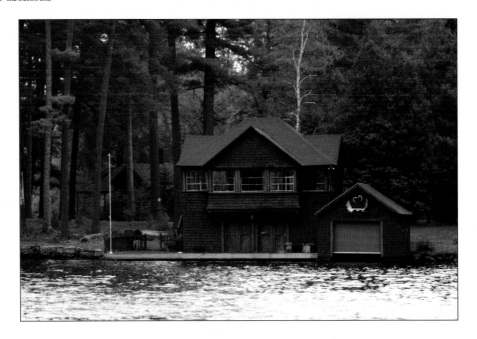

The Thousand Islands Bridge connects New York State and Ontario by traversing Wellesley Island at the northernmost point of U.S. Interstate 81 in Jefferson County, New York. The Thousand Islands Parkway provides a scenic view of many of the islands.

Internally, you experience rowing as a graphic microcosm of life—solitude, learning, work, rest, nourishment, sharing and ultimately challenge.
—Allen Rosenberg

The Adirondacks

Today, at 6 million acres, The Adirondack Park and Forest Preserve in New York State is the largest park in the nation outside of Alaska. This first great preserved wilderness area is greater in size than Yellowstone, Yosemite, Grand Canyon, Great Smoky, and Everglades National Parks combined. The park is particularly interesting because of the patchwork pattern of land ownership between state and private interests. The state owns approximately 48 percent of the land; the remaining land is owned privately. It includes farms, camps, businesses, homes, and timberlands.

A 1761 English map called the area "Deer Hunting Country." Both Mohawk and Algonquin tribes hunted in the region, but they did not settle in the area. Jesuit missionaries and French trappers were the first Europeans to visit the region. During the French and Indian War, the British built Fort William Henry and the French built Fort Carillon (later renamed Fort Ticonderoga by the British) on Lake George.

By the end of the eighteenth century, loggers were active in the area, and rich iron deposits were discovered in the Champlain Valley. In the early 1800s, the vast timber resources and iron ore deposits spurred the development of such towns as St. Regis, Paul Smiths, and Old Forge. Logging, mining, farming, and tourism have influenced the region's growth. In 1837, the area was formally named the *Adirondacks*. The word "Adirondacks" is a derogatory name used by the Mohawk in referring to Algonquian-speaking tribes. When food was scarce, the Algonquians would eat the inside of the bark of the white pine.

Logging continued slowly but steadily throughout the nineteenth century. Farm communities developed in many of the river valleys, but serious exploration of the interior did not occur until after 1870.

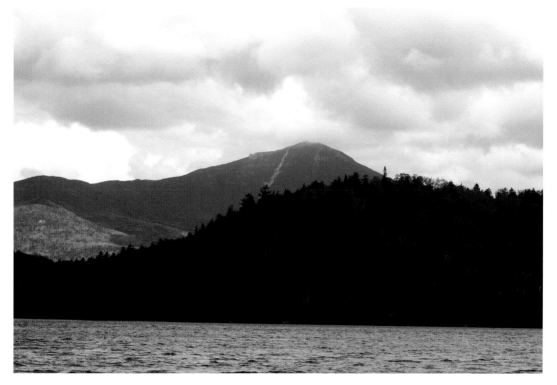

The Adirondacks contains over 100 summits, ranging from under 1,200 to over 5,000 feet in altitude and 2,000 miles of hiking trails.

The Adirondacks has over 2,300 lakes and ponds and 1,500 miles of rivers.

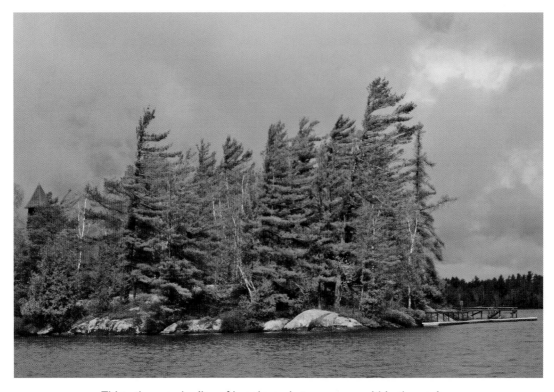

Thirty thousand miles of brooks and streams run within the region.

After the War between the States, many people were stimulated to explore unknown areas. Once fishermen and hunters learned about the Adirondacks, the rich and famous flocked in, leading to the development of stagecoach and then railroad lines and the building of hotels. By 1875, developers had built more than two hundred hotels, some of them with several hundred rooms. Wealthy families built summer homes, where they could enjoy the wilderness and entertain their friends. Built from native timber and indigenous rock, many of these camps have additional shingled roofed buildings for sleeping, cooking, and entertaining. In the Adirondacks, a camp can mean a single-family residential compound as well as a recreational center for an organized group.

In 1873, Verplanck Colvin, a lawyer and topographical engineer, urged the creation of a state forest preserve covering the entire Adirondack region to preserve the watershed as a source for the then-vital Erie Canal. By 1885, the Adirondack Forest Preserve was created, followed by the Adirondack Park in 1892. Concurrently, timber and tourism interests were lobbying to reverse these decisions. In 1894, the state adopted the Article VII, Section 7, which reads in part:

> The lands of the State...shall be forever kept as wild forest lands. They shall not be leased, sold, or exchanged, nor shall the timber thereon be sold, removed or destroyed.

This article is said to be the basis of the U.S. National Wilderness Act of 1964 (Pub. L. 88-577) signed into law by President Johnson. Consequently, many areas of the original Adirondacks forest are *old growth* and have never been logged.

The New York State Legislature created the Adirondack Park Agency ("APA") in 1971 to develop rangeland use plans for both public and private lands within the Park's boundaries. The APA tries to conserve the Park's natural resources and to ensure that development is well planned. The shorelines along the lakes, rivers, and streams are among its most valuable resources. If a resident is contemplating building or adding to a current dock or boathouse, a permit or variance may be required.

Saranac Lake

In 1819, Saranac Lake was first settled. The village formed around an 1827 logging facility, dam, and sawmill. The first industry was logging, which left the area almost tree-less. In 1849, the Saranac Lake House, one of the first major hotels in the region, was built. Increasingly, sportsmen came for the excellent fishing and hunting. Soon they brought their families with them. Once rail service came to the area, several entrepreneurs built hotels. By the 1890s, Saranac Lake was a popular destination.

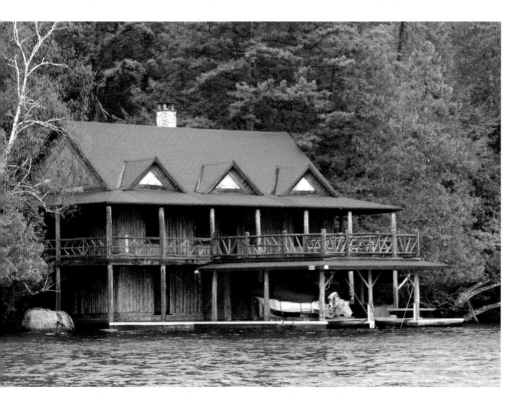

Boathouses permit the great escape from civilization.

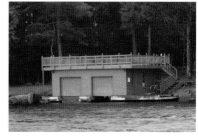

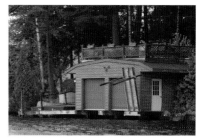

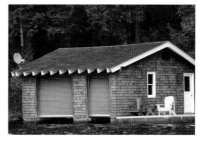

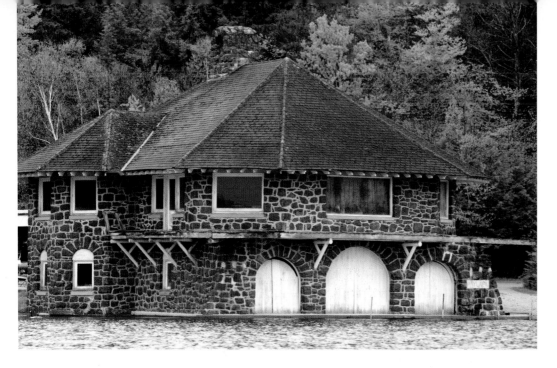

Boathouses range from small to large, wood to stone.

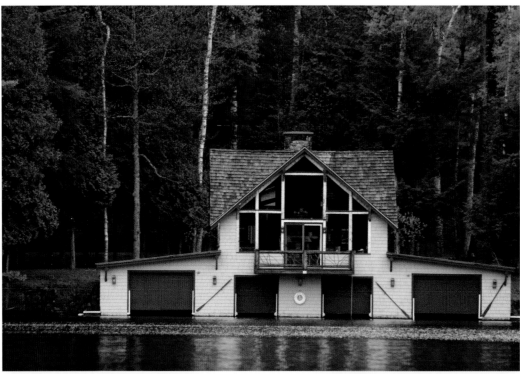

This large boathouse has room for several boats.

The famous Adirondack fencing decorates the balcony.

This close up shows the birchbark and fencing details.

In 1876, Dr. Edward Livingston Trudeau, who had had tuberculosis (TB), moved to Saranac Lake and established a medical practice among the sportsmen, guides and loggers. After learning about the successful results of "rest cures" in cold, clear mountain air for TB patients, Trudeau founded the Adirondack Cottage Sanatorium (renamed the Trudeau Sanatorium) in February 1885. The need for fresh air for the treatment caused Trudeau to avoid institutional settings and to utilize more cottage-like settings, which emphasized fresh air and light. "Little Red," his first sanatorium, was the first "cure cottage" on Mount Pisgah. Large boarding houses sporting several wide porches or "cure cottages" sprang up all over town, as the success of his treatment became known. As more and more patients visited the region, including author Robert Louis Stevenson in 1887, the village grew into a thriving community, home to many bustling hotels and cure cottages.

For the next sixty years, Saranac Lake was considered one of the foremost centers for the treatment of pulmonary tuberculosis. Sanatorium treatment for TB was over by 1954; however, the small sleepy village was changed forever by its dominance in the field of TB care. Many prominent people came from all over the world to be treated or to accompany family members during their treatment. Many handsome private cure cottages were built and are listed on the National Register of Historic Places.

The 100 Best Small Towns in America ranked Saranac Lake as the eleventh "best small town" in the United States in 1995. In 1998, the National Civic League named Saranac Lake an All-American City; in 2006, the National Trust for Historic Preservation awarded the village one of the "Dozen Distinctive Destinations. "

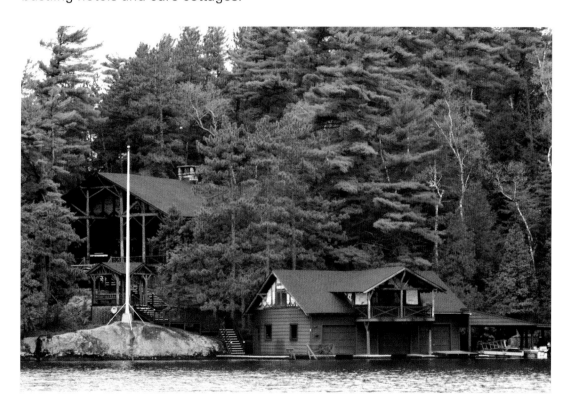

Many Adirondack camps are comprised of several buildings, divided more or less according to function: there are the living quarters, the lodge for dining and gathering, guest quarters, and recreational use.

Below, left:
Resort architecture in the Adirondacks does possess distinctive architectural characteristics that have become closely associated with a regional rustic style.

Below:
The modern log cabin style

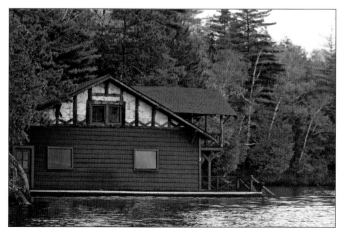

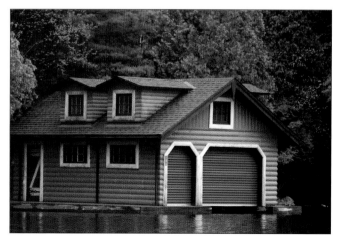

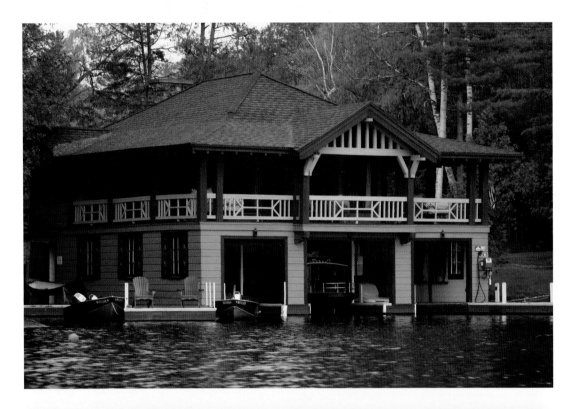

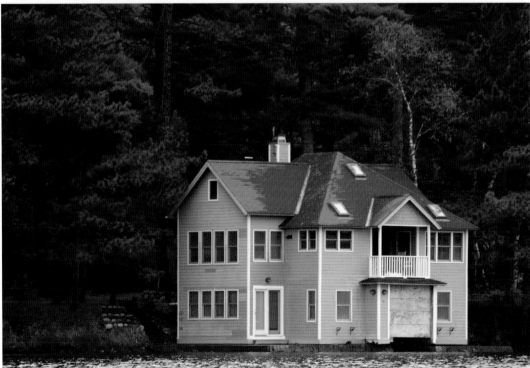

The traditional house with a boathouse inside

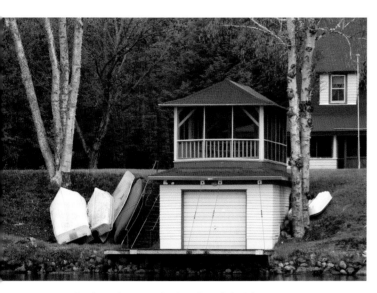

In the winter, only the deer inhabit
the shores of the frozen lake.

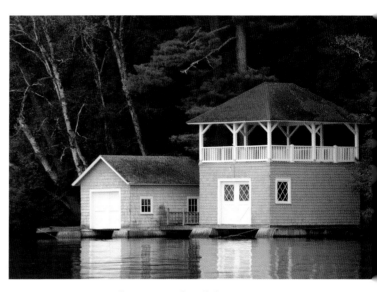

Consequently, all the greenery
is clipped uniformly.

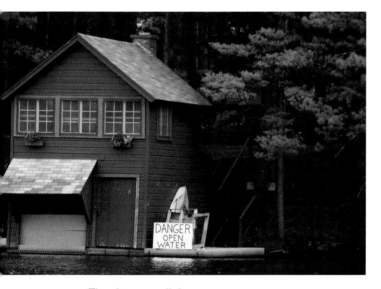

The deer eat all the greenery
up to a certain height.

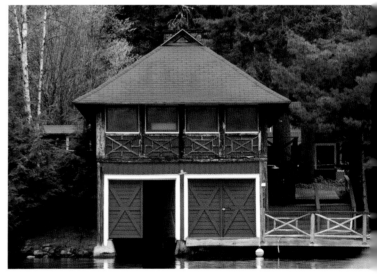

Adirondack camp buildings use a variety of
native materials such as stone, logs, bark,
wood shingles, and other ornaments.

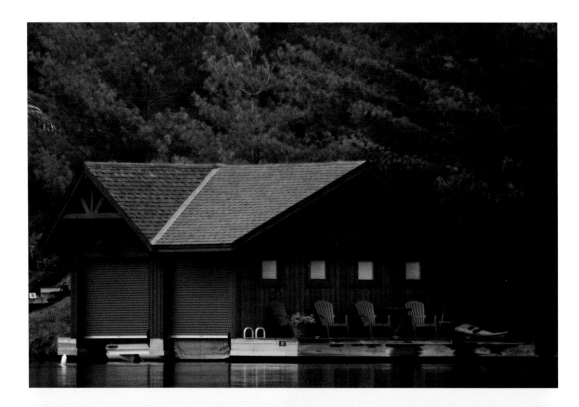

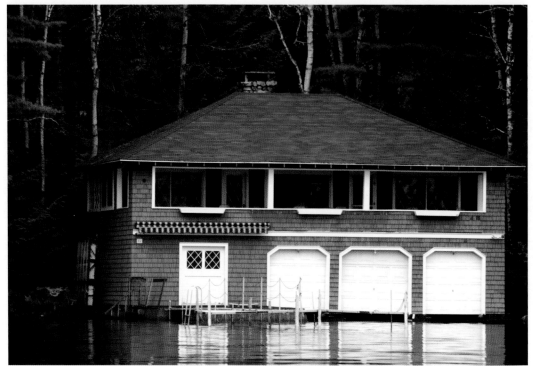

This is lake country.

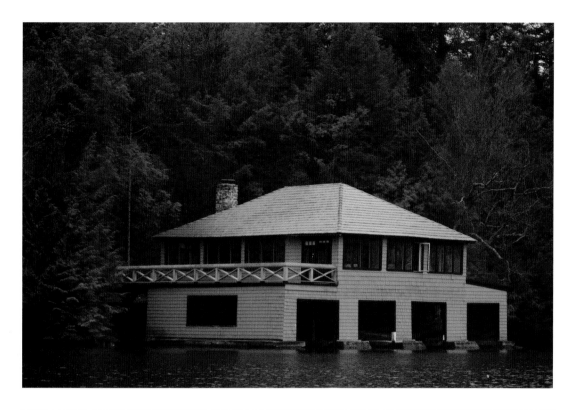

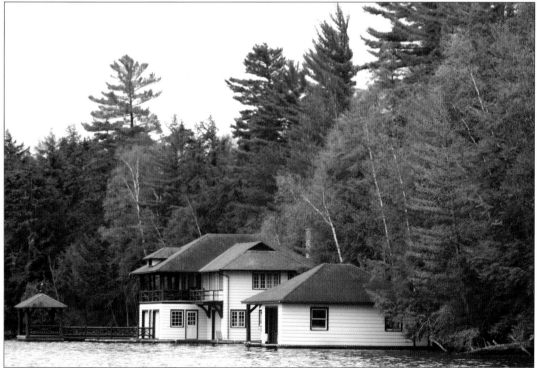

Often the buildings fade into the forest background.

Lake Placid

Lake Placid lies among the peaks of the Adirondack Mountains in Essex County, New York. This famous small town was founded in the early 1800s when iron ore was discovered nearby. In 1845, wealthy abolitionist Gerrit Smith sold tracts of land in North Elba, New York, to fugitive blacks for the nominal fee of $1. The hardships of farming in the area, coupled with the settlers' lack of experience in homebuilding and the bigotry of white neighbors, caused the experiment to fail. In 1849, learning of this experiment, John Brown moved with his family to North Elba, hoping to assist the free blacks in the area adjust to the pitfalls of farming. Before his execution, John Brown asked to be buried on his farm, which is now known as the John Brown Farm State Historic Site.

The Adirondack Protection Association is a group of concerned citizens, who wish to defend and protect the unique character and quality of the Lake Placid community and its fragile environment.

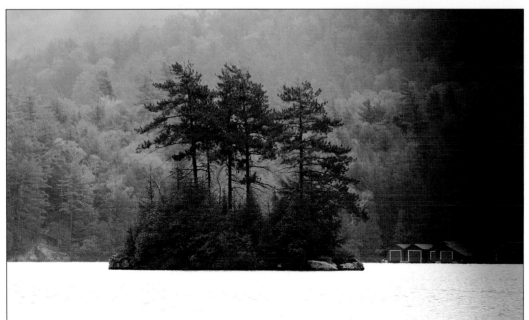

They are concerned about the impact of overdevelopment.

In 1895, Melvil Dewey, the inventor of the Dewey Decimal System, founded the Lake Placid Club. He and his wife had been searching for a resort where they might be free from hay fever and the common cold, and they believed they had located it in Lake Placid. He bought the land and began the club with no bar, no gambling, and no late hours. Amazingly, it was a grand success, inspiring the village to change its name to Lake Placid. Dewey kept the club open through the winter in 1905, which helped it earn a reputation as the national center for winter sports. Drawn to the fashionable Lake Placid Club,

the rich and famous began to come to Lake Placid. By 1921, the area could boast a ski jump, speed skating venue, and ski association. The 1932 and 1980 Winter Olympics were held in Lake Placid.

Fame came to Lake Placid when a team of American college students and amateurs beat the Soviet national ice hockey team, believed to be the best in the world, and won the gold medal during the 1980 Winter Olympics. The victory, often referred to as "Miracle on Ice," is often ranked as one of the greatest in American sports history.

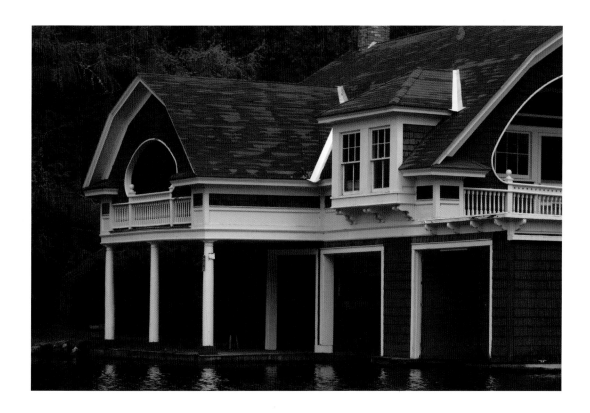

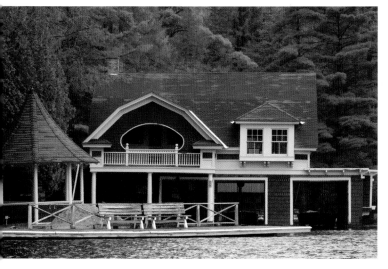

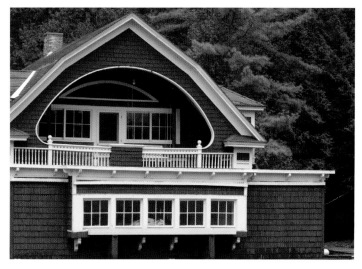

An impressive boathouse—complete with gazebo.

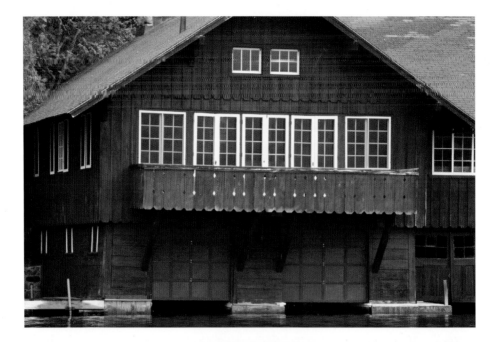

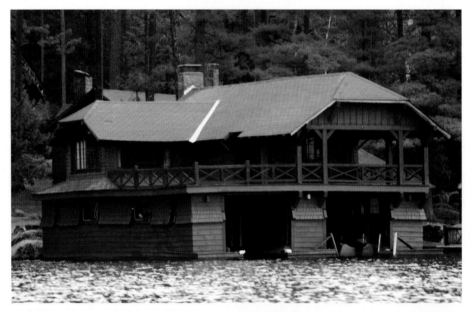

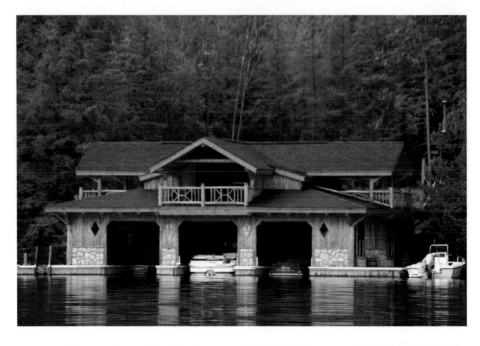

Lord Byron said, "There is pleasure in the in the pathless woods...

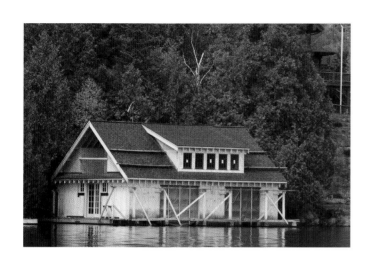

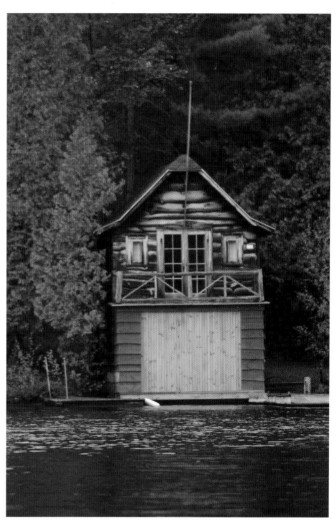

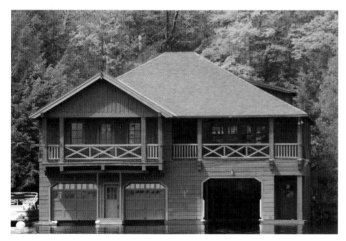

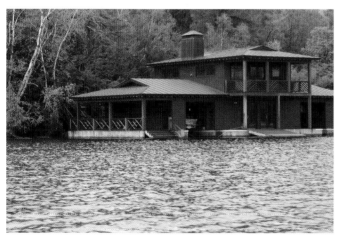

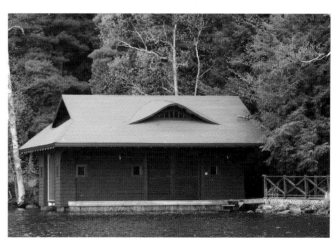

...There is a rapture on the lonely shore."'

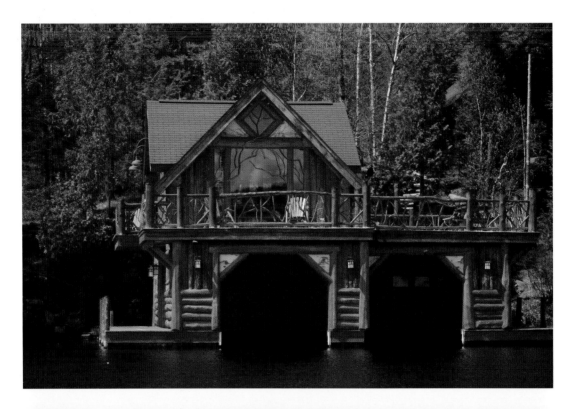

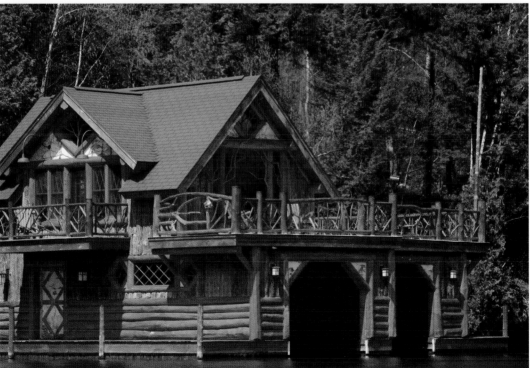

This comparatively new boathouse is designed in the Adirondack style.

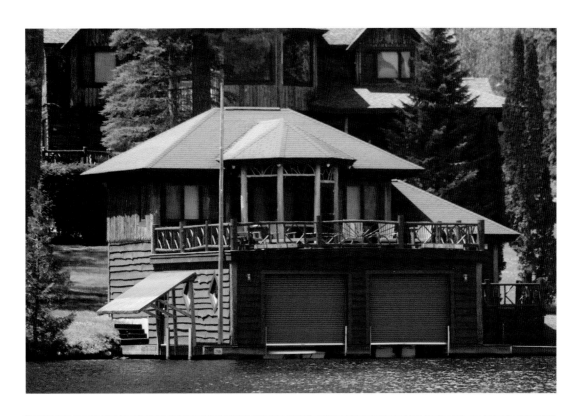

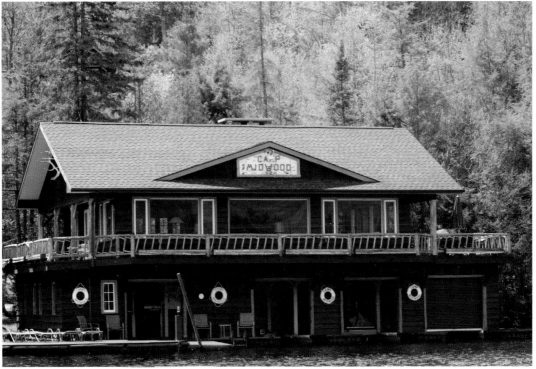

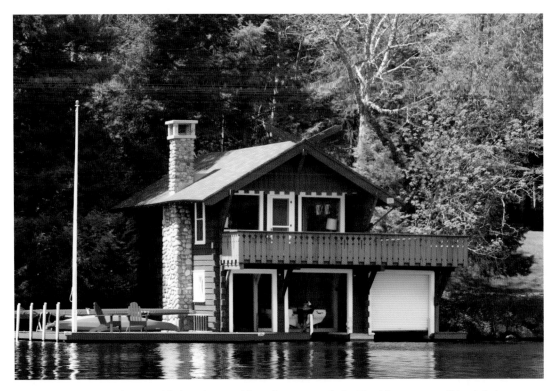

Note the house number on this boathouse. Many houses on Lake Placid are accessible only by water.

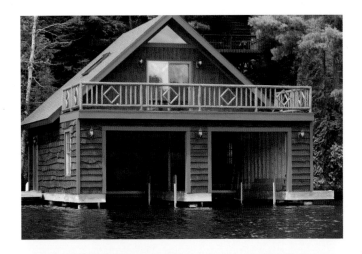

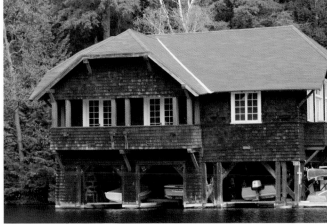

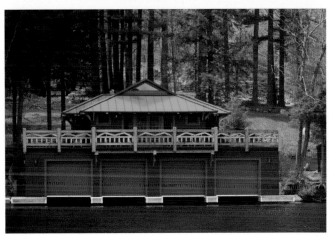

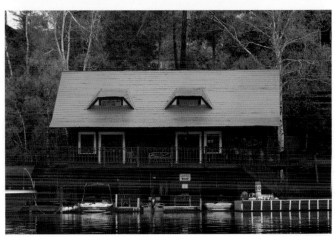

The boathouses seem to grow out of the forest. A chorus of geese
and the haunting sounds of the loons are the music of the lake.

Well known for its alpine and cross country skiing, Lake Placid was the first location in North America to host two Olympic games. The 4,867-foot Whiteface Mountain, about 13 miles from Lake Placid, offers skiing, hiking, gondola rides, and mountain biking and is the only one of the High Peaks that can be reached by an auto road. The area, which has one of only three bobsled rides in the western hemisphere, offers dogsled and sleigh rides. Many people use Lake Placid as a base from which to climb the forty-six high peaks in the Adirondack Mountains. The Adirondack Forty-Sixers is a club open to all who have climbed, or intend to climb, all the peaks. Many alpine lakes, wetlands, streams, and forests are located in this region.

In 1898, Lake Placid built a golf course, one of the first in the United States. This area of the Adirondacks resembles the area in Scotland where golf was invented. Consequently, many famous golf course architects have designed courses for the area.

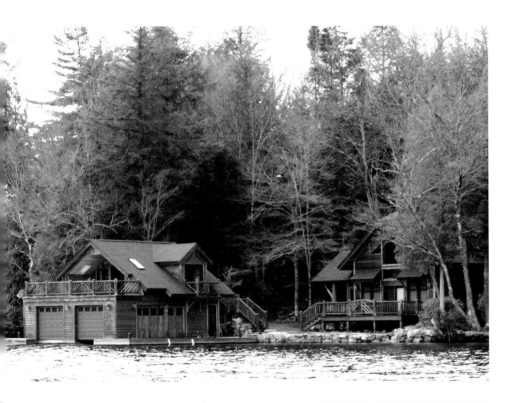

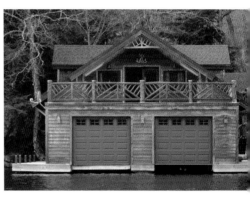

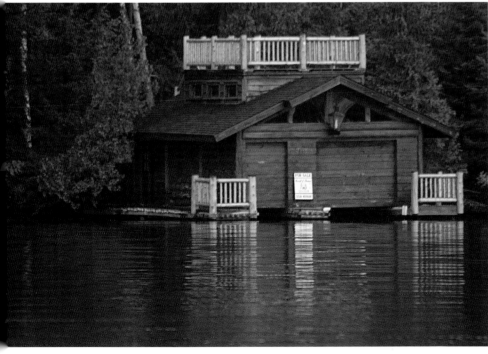

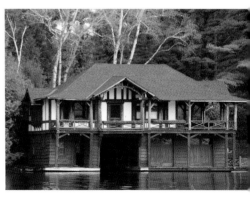

Fishing or boating—your dreams can be fulfilled.

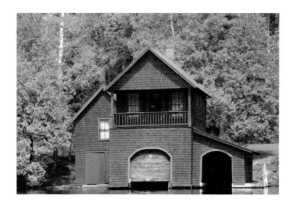

If you use your magnifying glass, you will see that the door is posted "no trespassing." Some believe that if a boathouse has a second floor it should be only for boats – not living quarters for people.

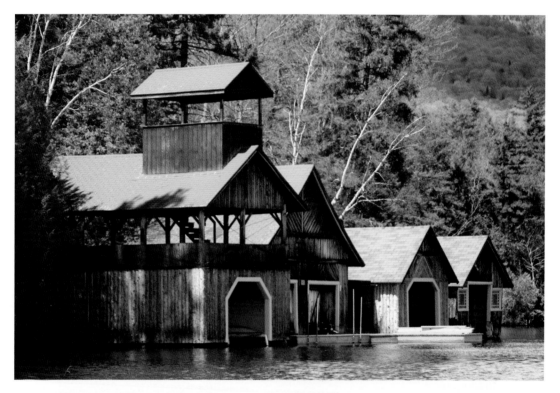

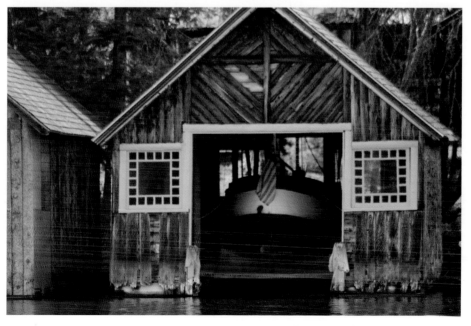

The lake water laps with low sounds by the shore.

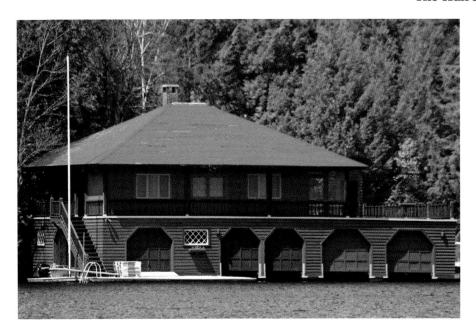

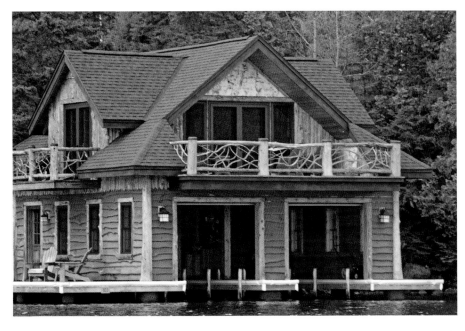

Imagine a summer
spent as a child here.

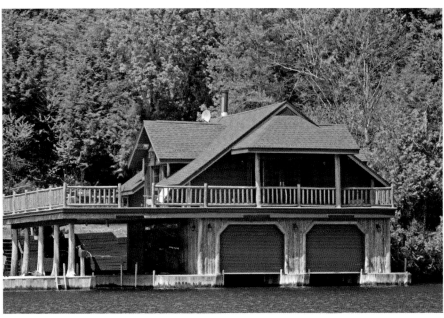

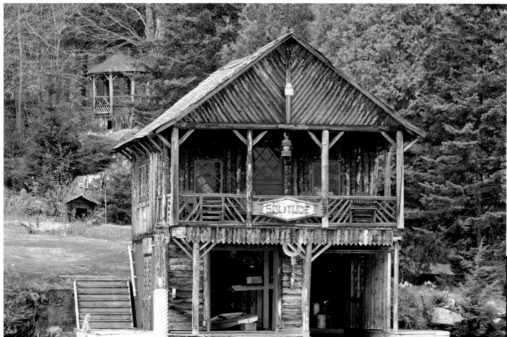

The sound of summer is the gentle
music of the lake and the breeze
through the pines.

The tracks used by
the boat to enter
the boathouse are
visible here.

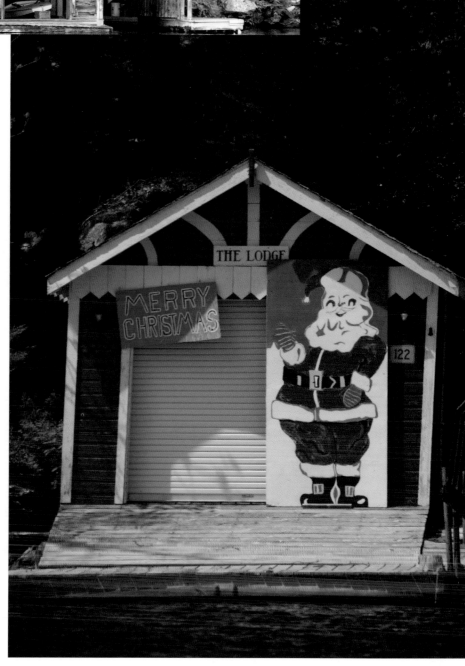

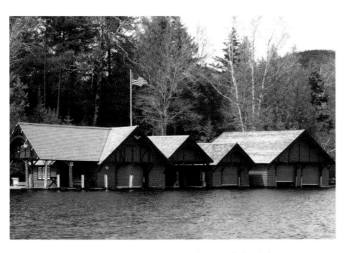
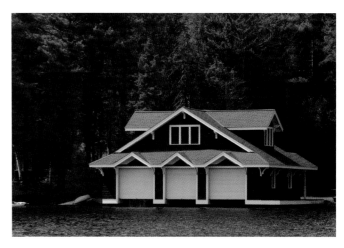

Around the lake, you can see shadows on the rocks, hear
the wind in the trees, and the call of the Canada geese.

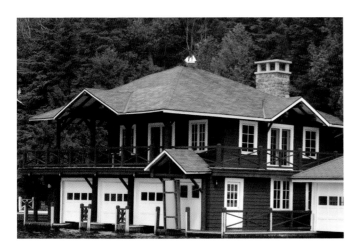
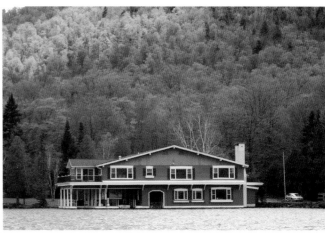

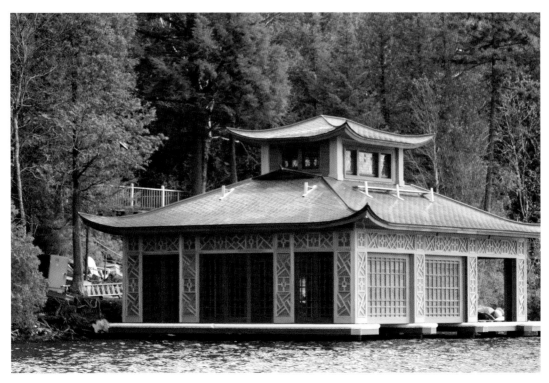

When the copper roof was installed on this pagoda-style
boathouse, the sun was blinding at certain times of the day.

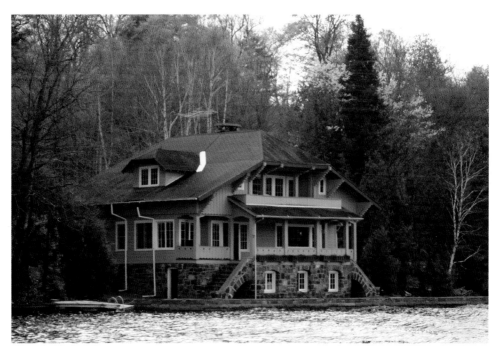

So much of the beauty of this region is within the trees.

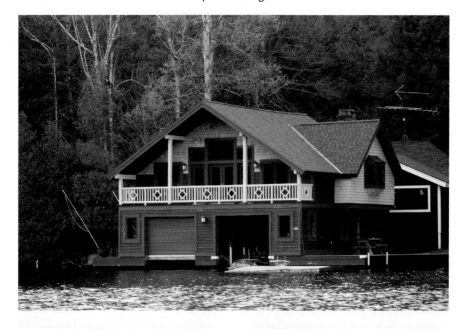

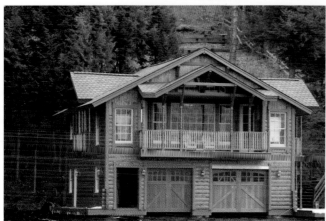

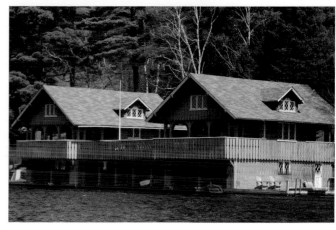

Summer at the lake.

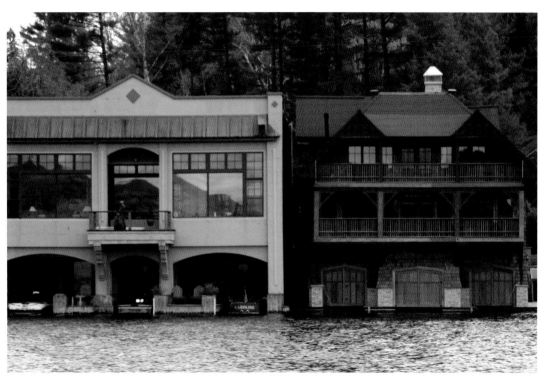

Look at the proximity of these two massive boathouses.

Help thy brother's boat across, and lo! thine own has reached the shore.
—Hindu Proverb

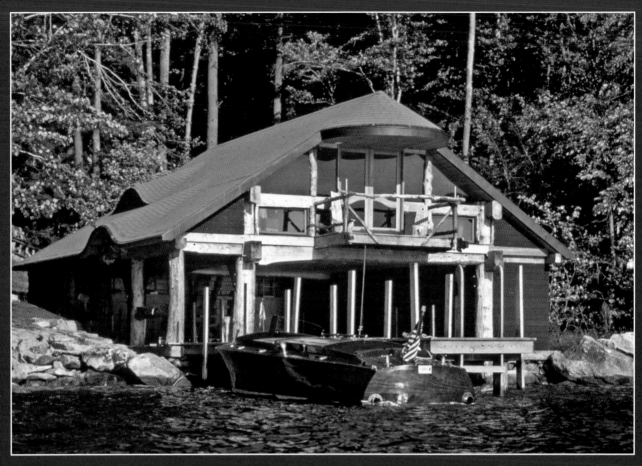

Courtesy of Dave Sellers.

Recently Designed Boathouses

Lake Muskoka Boathouse

One of the most well known boathouses is this beauty designed by Shim-Sutcliffe.

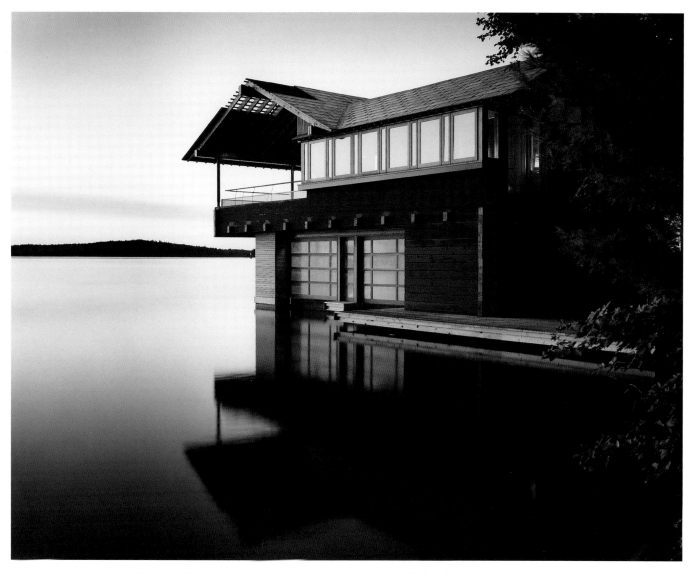

This boathouse located on the southwest shore of Lake Muskoka won the 2004 Governor General's Medal in Architecture. *Courtesy of Ed Burtynsky*

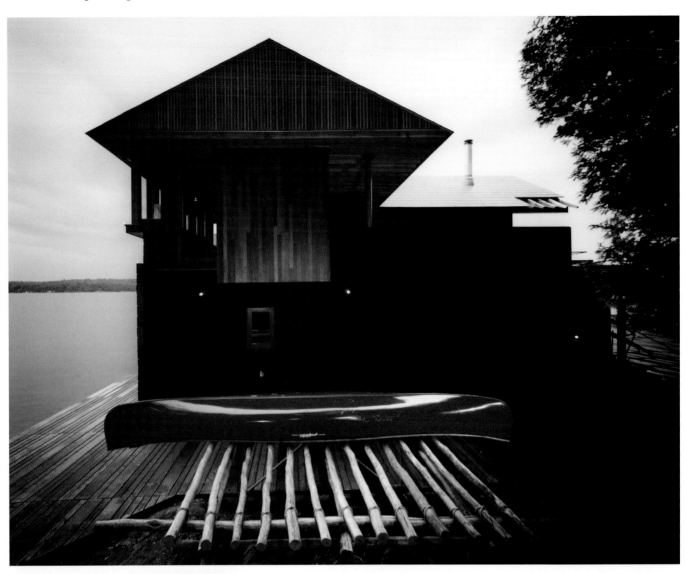

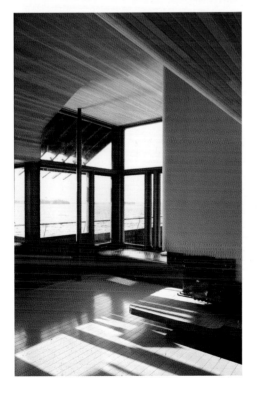

Construction began in the winter, when the lake was still frozen. The layout of the dock was drawn on the ice to locate the cribs. Holes were cut into the ice, and sleepers were laid across the holes to support the crib assembly. As each crib was completed, the ends of the sleepers were cut, and the cribs were lowered through the ice to settle on the lakebed. Granite rocks were then dropped into the cribs for ballast. This submerged structure provided the foundation for the heavy timber outer walls of the boathouse. The timbers are reclaimed industrial beams, assembled using traditional log cabin methods. *Courtesy of Ed Burtynsky*

This heavy, rustic exterior wraps around the intricately crafted sleeping cabin. The interior finishes combine ordinary and sophisticated features, including Douglas fir plywood cabinets and mahogany windows, all detailed to allow for settlement in the crib foundations. Victorian beadboard ceilings merge into a shaped Douglas fir ceiling in the main room of the sleeping cabin, while mahogany duckboards in the bathroom recall a typical Muskokan boat deck. *Courtesy of James Dow*

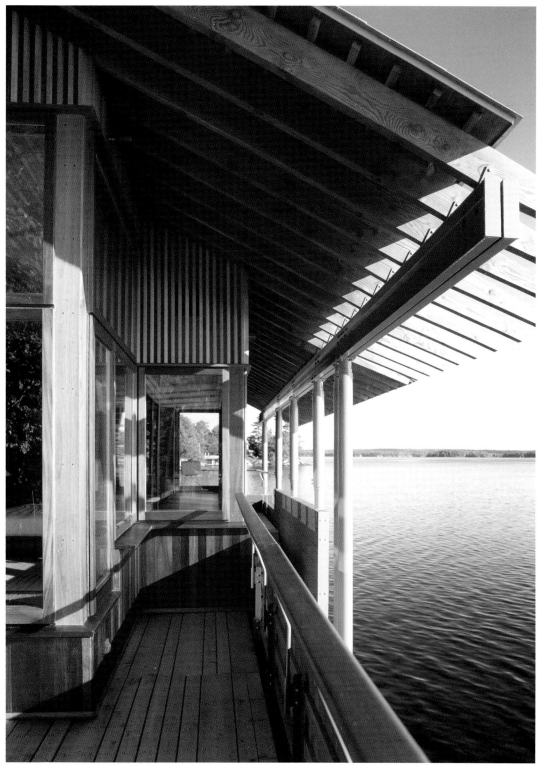

The boathouse includes two indoor boat slips, a covered outdoor boat slip, storage for marine equipment; a sleeping cabin with kitchenette, shower and bath area, bedroom-sitting room; and several outdoor porches and terraces, with a moss garden and local plant species. The materials, spatial layers, and framed views throughout the boathouse and its surroundings are experienced as a series of juxtapositions: exterior and interior, forest and lake, building and nature, tradition and innovation – characteristics of building in the modern Canadian landscape. *Courtesy of James Dow*

Open Air Retreat

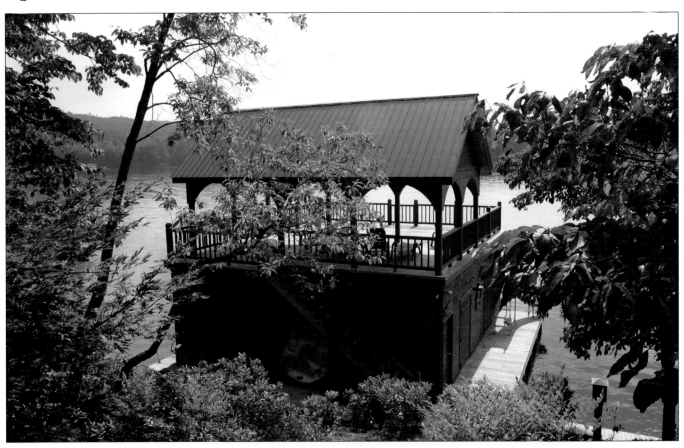

Designed by Harrison Design Associates, this boathouse incorporates arched openings and patterned stick work on the central gable. *Courtesy of Harrison Design Associates*

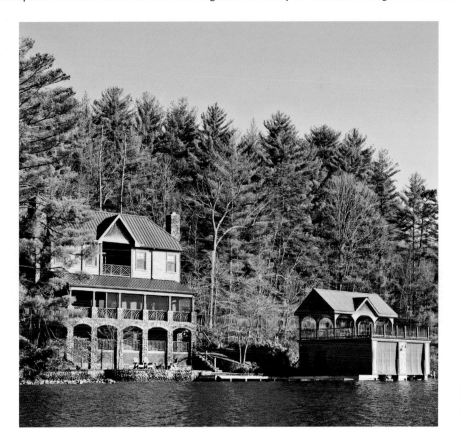

More than basic storage, this boathouse provides a comfortable open-air retreat for casual gatherings. *Courtesy of Harrison Design Associates*

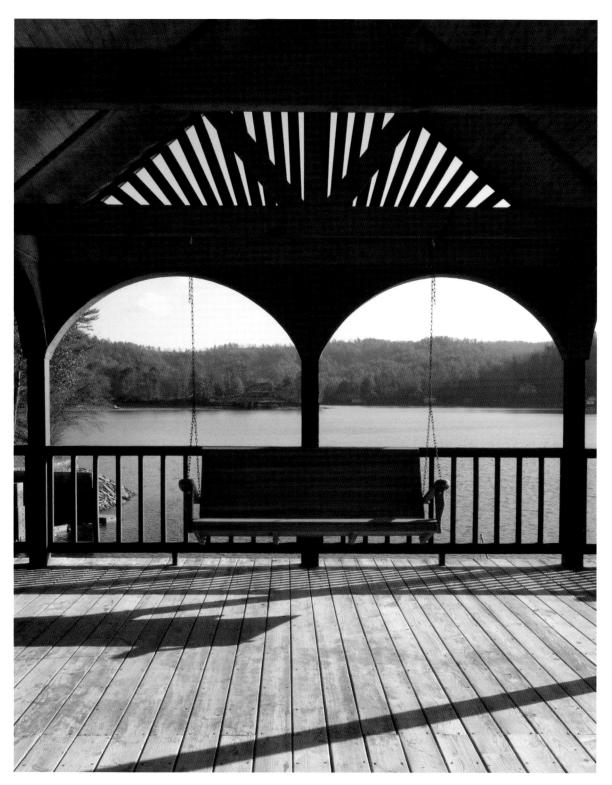

Courtesy of Harrison Design Associates

Jewel Box on the Beach

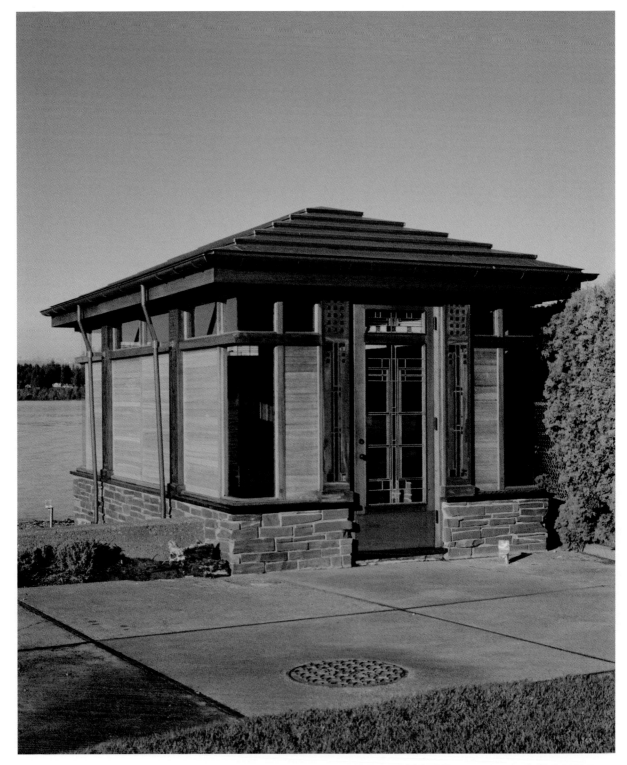

Courtesy of Michael Moore

Many waterfront properties on Bainbridge Island, Washington, traditionally had boathouses that were used to store a small runabout, kayaks, or rowing boats. Relatively few of these structures still exist. The owner's waterfront property on the west side of the Island is one that had a boathouse still standing.

The owners' charge to Chester Carroll Architecture was to reconstruct a boathouse on the site of the existing structure that could be used to store a 14-foot runabout during the winter months. During the summer, the boathouse would be used as a beach cabana for parties and water-related activities.

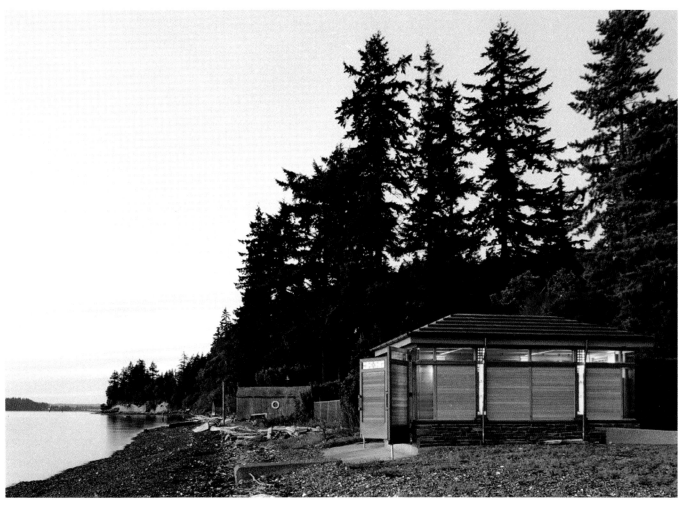

Ideally, the design for the structure would have a timeless quality and last two hundred years with normal maintenance. *Courtesy of Michael Moore*

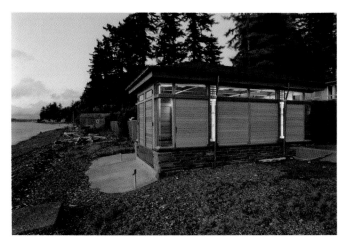

City zoning that would, under certain circumstances, allow these shoreline structures to be rebuilt as long as they did not exceed the footprint and height of the existing structure further complicated the design task. *Courtesy of Michael Moore*

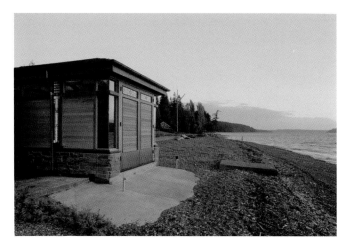

The firm's solution is a craftsman-style, classic northwest wood design with a Japanese influence. The carefully selected structural materials will resist the harsh northwest winter storms and salt spray from Puget Sound. The structural skeleton of the boathouse is expressed throughout with redwood timbers and bronze columns. *Courtesy of Michael Moore*

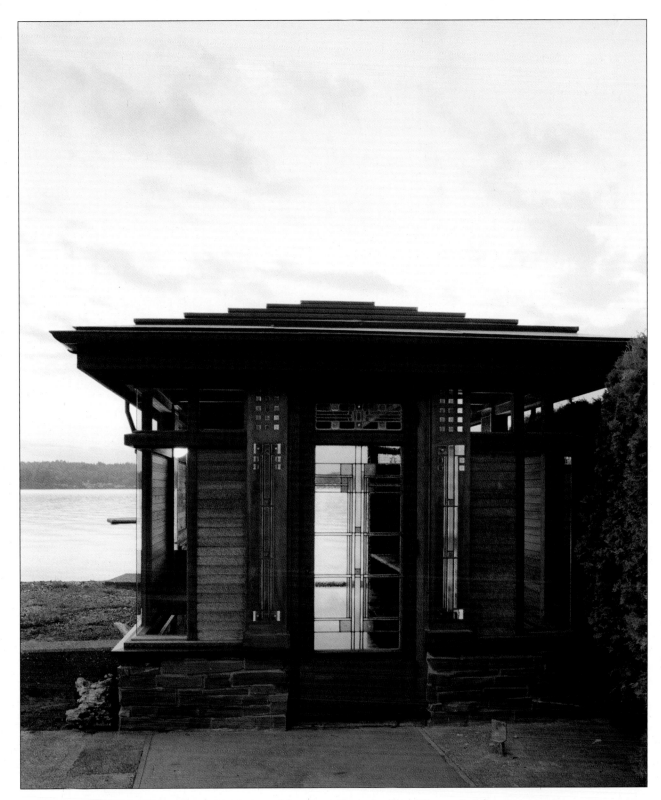

Tongue and grove teak wood is used for the walls and ceiling. The roof of the structure is a Bermuda hip with copper roofing. The structure sits on a black granite sill and stone base of green Vermont ledge stone supported by the original footings of the old boathouse. The floor is laid in a pattern reflecting the roof structure above with a field of green Connemara marble with black granite accents. *Courtesy of Michael Moore*

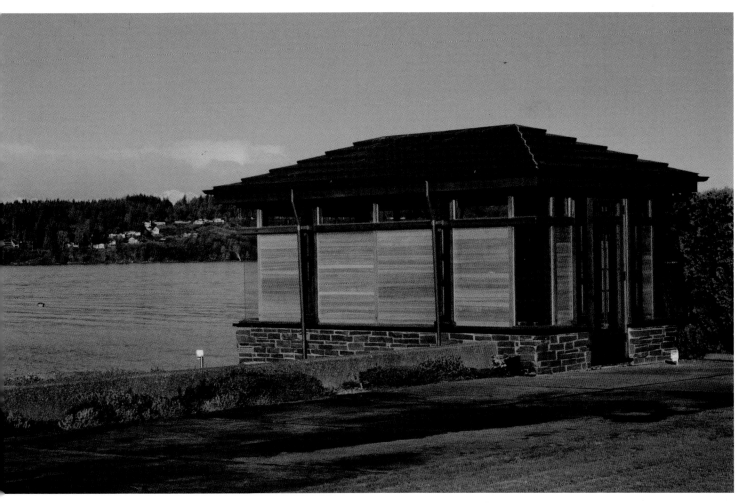

The bronze columns feature a fused glass design in a pattern, reminiscent of Charles Rennie Mackintosh, which is backlighted from within each column. The doors of the boathouse also reflect this pattern in their leaded glass panels. The interior lighting, mitered glass corners, and clearstory window that circumscribe the structure give the illusion that the roof floats above the structure at night and is only supported by the four bronze columns. Copper downspouts battered from the gutters to the stone base with bronze stand off connecting brackets become simple architectural features that add to the building's simplicity and beauty. *Courtesy of Michael Moore*

A bronze sink is mounted in a redwood and teak cabinet with a heavy black granite counter top. The cabinet is hung off the teak wall with custom bronze brackets. *Courtesy of Michael Moore*

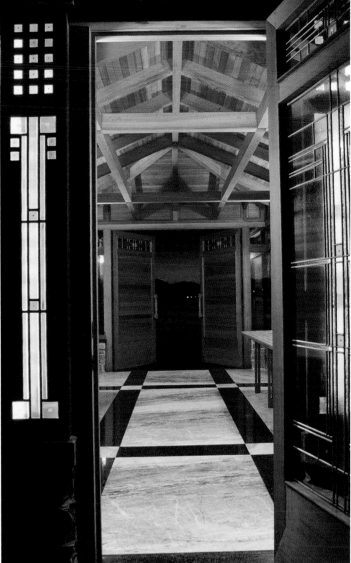

The interior features several finely crafted millwork pieces that complete the facility. *Courtesy of Michael Moore*

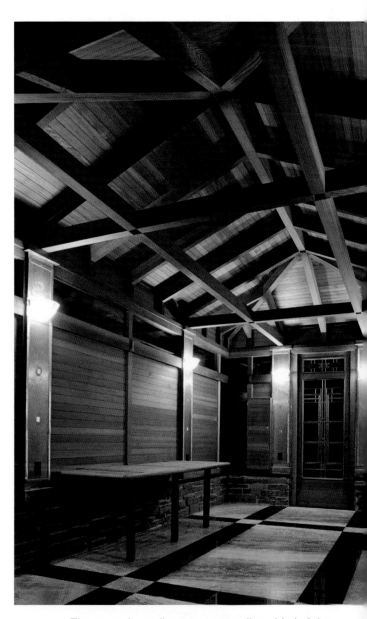

The opposite wall supports an adjustable height counter that can be used as a bench or as a serving counter and will fold out of the way when the boathouse is being used for boat storage. *Courtesy of Michael Moore*

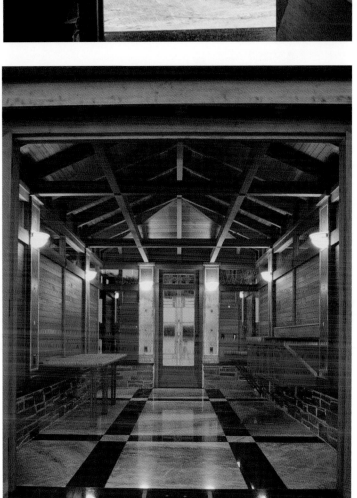

Adjacent to each side of the entry are two matching cabinets one that contains the electrical cabinet and one that can be used to store wine and glassware. *Courtesy of Michael Moore*

Green Boathouse/Studio

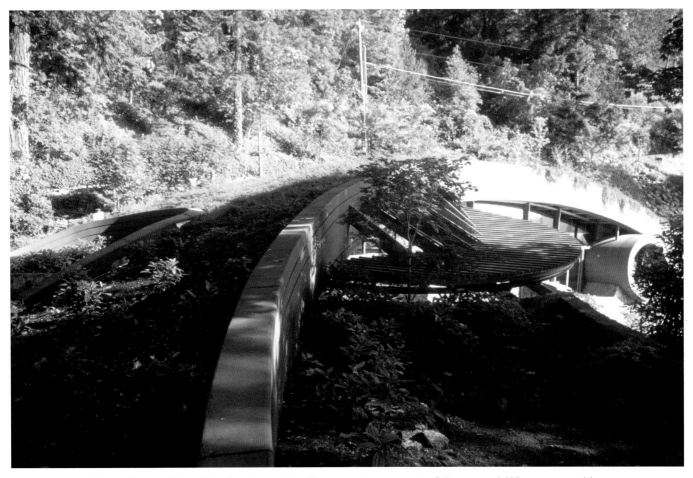

The arcing roofline of the boathouse/studio seems to grow out of the ground. When approaching the building, you can barely perceive it. *Photograph by Robert Oshatz Architect*

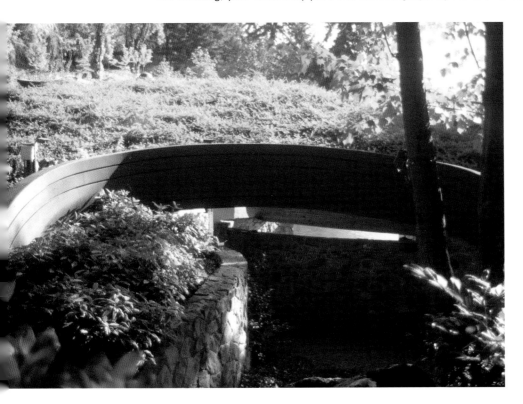

Nestled on the shores of Lake Oswego in Oregon, this boathouse/studio, designed by Robert Oshatz, accommodates a small covered boat stall, a study, and an artist's studio. To reduce its visual impact to the lake, a living green roof was used to effectively bury the structure into the hillside.

Entrance to the structure is made down a ramp, underneath the green roof and between the stonewalls. The building embraces the water with an expansive glass wall that throws a reflection back to the lake but also floods the interior spaces with natural light. *Photograph by Robert Oshatz Architect*

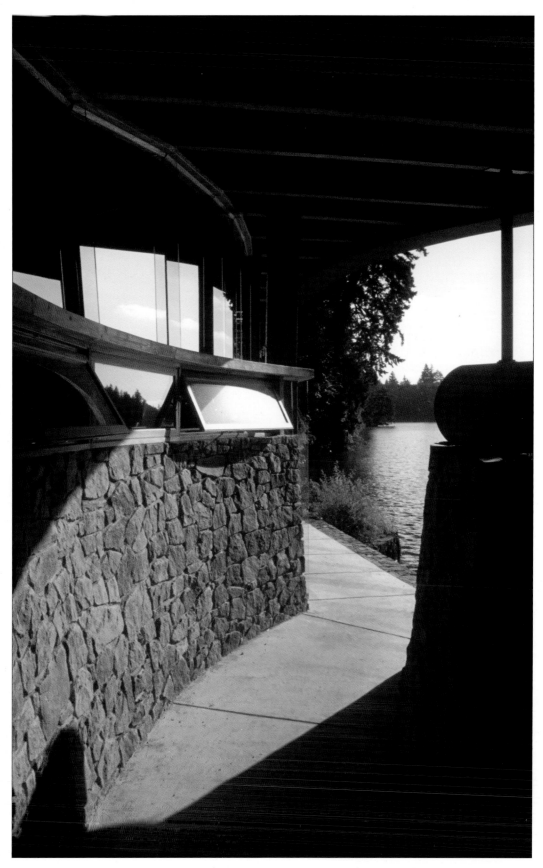

Between the boat stall and the studio, the entry path opens up, giving an open view of the lake. *Photograph by Robert Oshatz Architect*

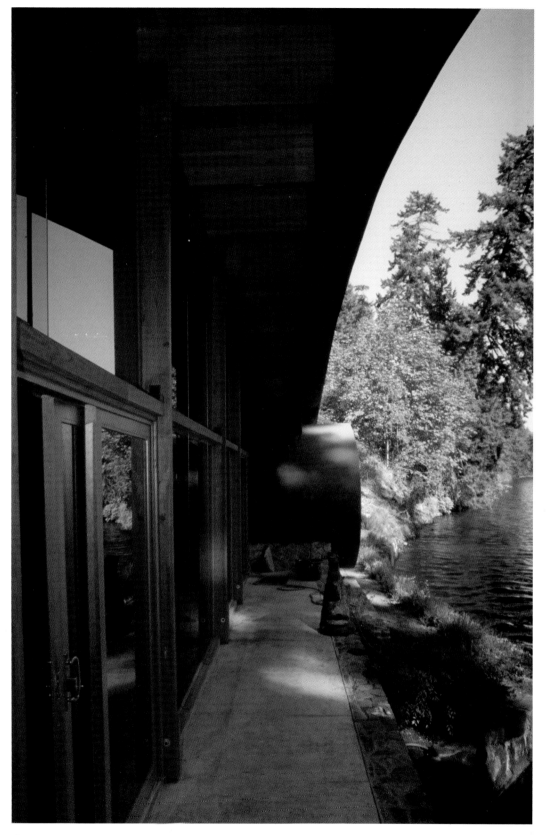

Below the curving roof line and the rhythmically placed glue laminated rafters, the glass wall that embraces the lake is broken by two trapezoidal sliding doors that open into both the studio and the study. The sweeping stucco forms of the structure, which move effortlessly over the glazing, are balanced by the rhythmical placement of the exposed glue laminated rafters. Inside, the radiant floor heating keeps the building at a comfortable temperature during the colder months, while in summer, natural ventilation is achieved through the operable skylights and sliding glass doors that open out to the lake. *Photograph by Robert Oshatz Architect*

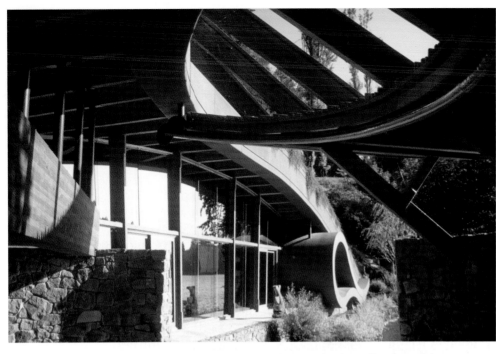

A curving wood roof hangs over the boat stall to protect the boat from the weather. *Photograph by Robert Oshatz Architect*

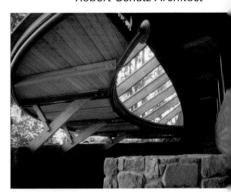

From within the boat stall, the glass wall throws back a reflection of the lake while the fluid form that defines the roof floats above. *Photograph by Robert Oshatz Architect*

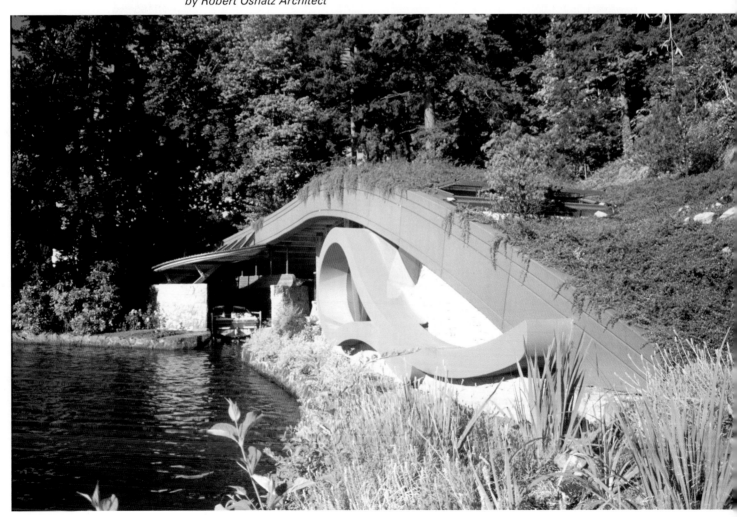

The boathouse/studio appears to disappear underneath the green roof, reducing its visual impact to the lake. *Photograph by Robert Oshatz Architect*

Cape May Boathouse

DAS Architects combined Old World craftsmanship with modern amenities in this certified LEED boathouse with natural and reclaimed materials playing a large part in the design.

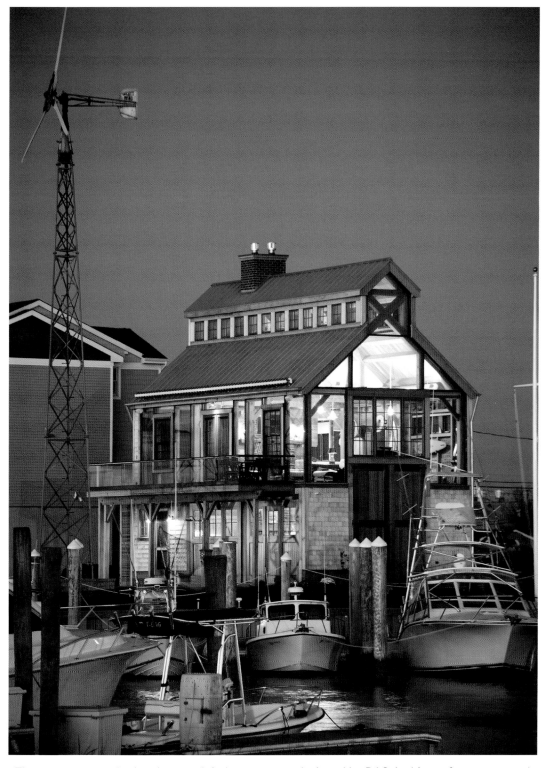

The two-story notched and pegged timber structure designed by DAS Architects features natural cedar trim as well as three custom-made sliding mahogany doors. An existing windmill on the property is utilized to help provide energy to the house. *Courtesy of Peter Paige Photographer*

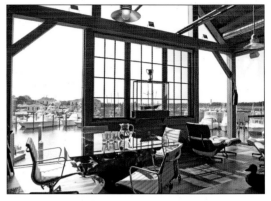

Floors are made of reclaimed oak planks. The whole space is lit with low-voltage lighting that accents the timber structure and the exposed ductwork. The interior is an eclectic mix of modern furniture, such as classic white leather Barcelona loungers, alongside found objects appropriate to the environment, including surfboards, fishing poles, and tackle. *Courtesy of Peter Paige Photographer*

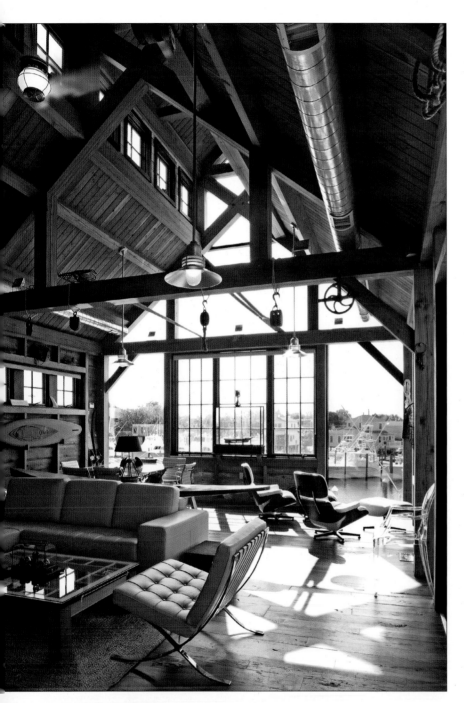

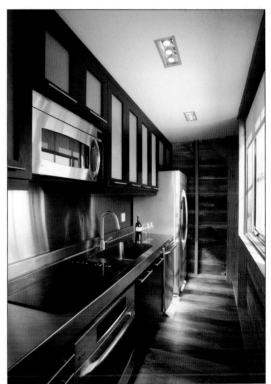

A two-story frameless glass curtain wall lets in natural light as well as providing unobstructed panoramic views of the water. Additional motorized windows at the roofline open to let out heat and keep cooling costs down. There is a fully insulated 6-inch core to the walls that is invisible and provides for energy efficiency. *Courtesy of Peter Paige Photographer*

In addition to the large open living space, the boathouse retreat also features a galley kitchen with custom welded stainless steel counter and sink and a sleeping loft. *Courtesy of Peter Paige Photographer*

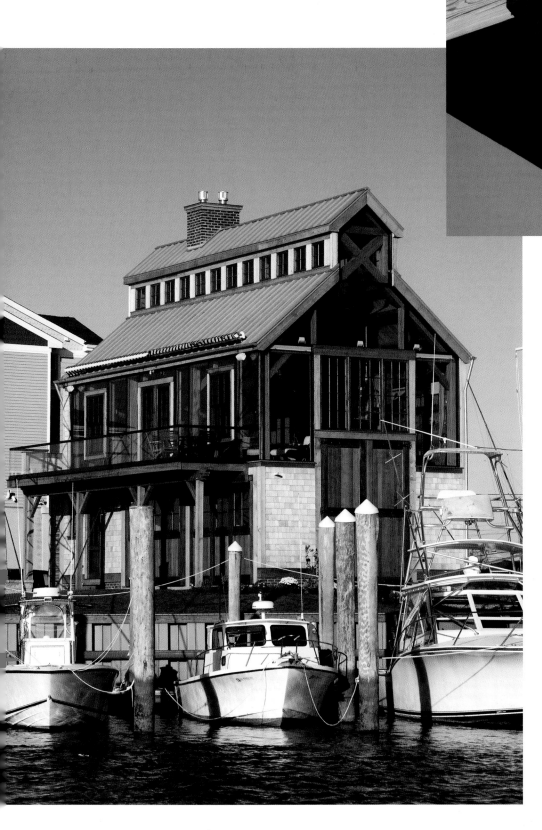

View of boathouse from
Spicers Creek in daylight.
*Courtesy of Peter Paige
Photographer*

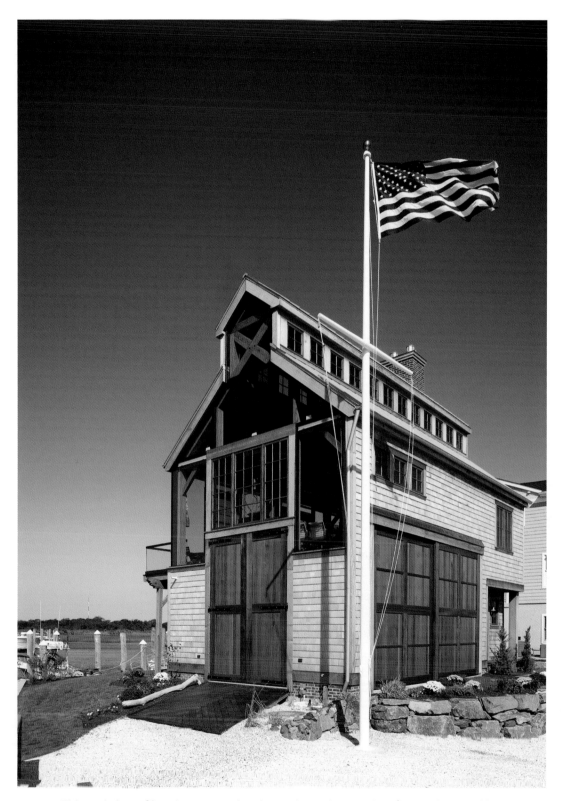

This end view of boathouse exterior shows the mahogany boathouse doors, white cedar shake details and glass curtain wall. *Courtesy of Peter Paige Photographer*

Fieldstone Boathouse

Harrison Design Associates designed a boat-house, which forms a private perch atop a base of rusticated fieldstone from the Appalachians.

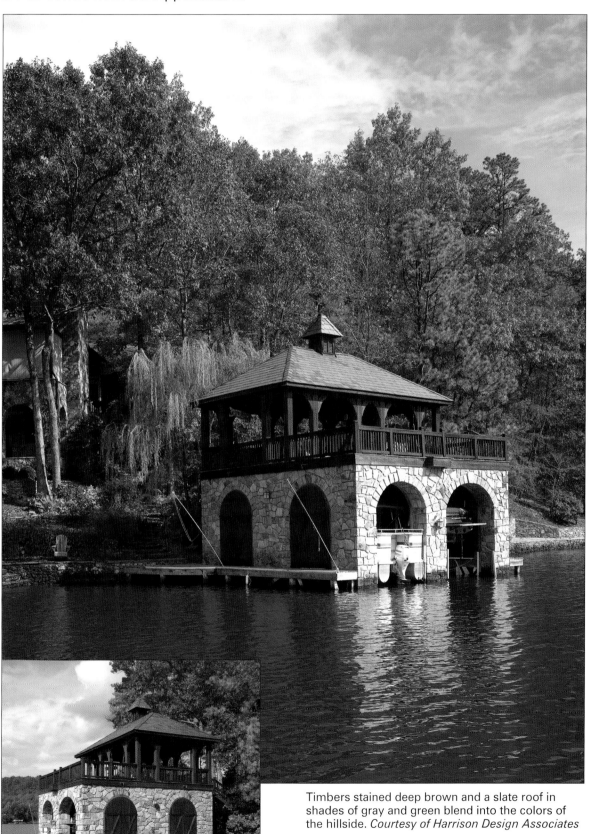

Timbers stained deep brown and a slate roof in shades of gray and green blend into the colors of the hillside. *Courtesy of Harrison Design Associates*

Treemoondus Lodge

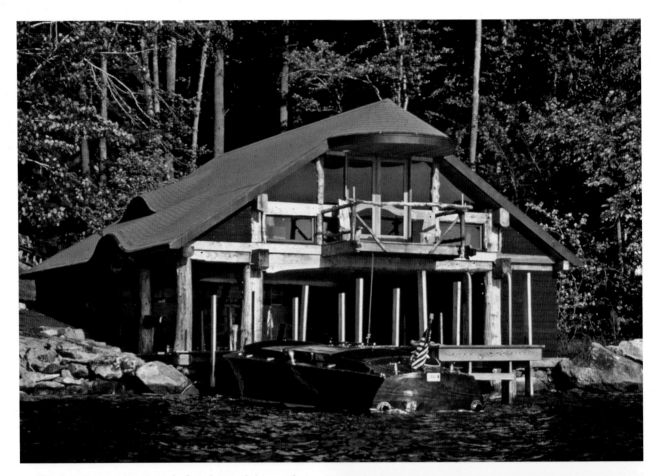

This boathouse can contain four boats. It has a pier and balcony, where one can leap into the water, and two eyebrow windows. *Courtesy of Dave Sellers*

Sellers and Company Architects designed this boathouse as a part of the landscape. The lake was enlarged by dredging out the two boat slips, and the boathouse made from trees cut from the land (think "green"). The entrance on the side has a birch tree with an enormous curved trunk holding up an eyebrow window that looks like a mouth. The roof has an eyebrow window that looks like an eye. The whimsical building is winking at you as the left eye is shut (a line of black shingles).

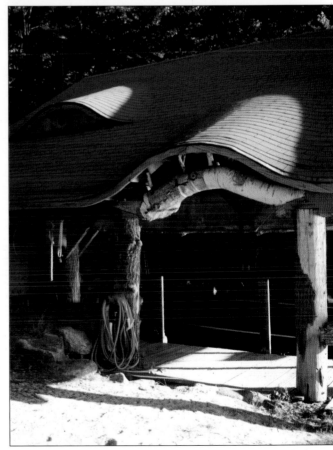

The main eyebrow window uses a birch branch for the arch. It is located to be the nose. The other eyebrow contains a sandblasted eyeball in the roofing shingle pattern. Between this and the shingles, you get the impression that the house is winking at you. *Courtesy of Dave Sellers*

On Golden Pond

Bensonwood Homes has melded the centuries-old craft of framing buildings with heavy timbers with the needs of contemporary buildings. Topped by a standing-seam metal roof and sided with hand-split cedar shakes and wavy-edge skirl siding, this New Hampshire boathouse is frequently visited by loons, moose, and other local wildlife.

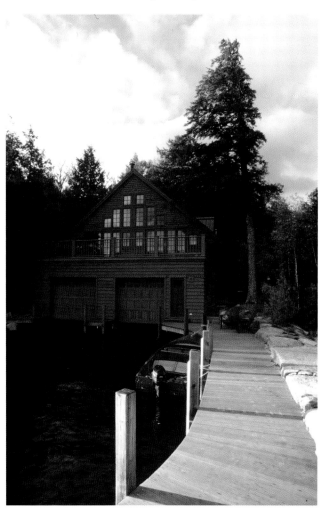

The boathouse is also a guest cottage. *Courtesy of Bensonwood Homes*

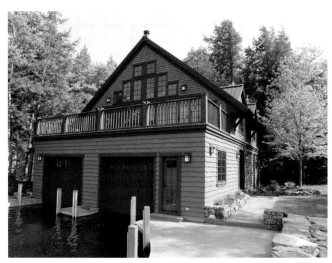

The view from the breakwater. The boathouse stores a collection of canoes and boats at one end, is a garage for cars through the other end, and houses a workshop for boats. *Courtesy of Bensonwood Homes*

Sunset over the lake. *Courtesy of Bensonwood Homes*

Following page:
Two bedrooms and a vaulted ceiling in the great room over the top of this two-bay boathouse, offer beautiful lakeside quarters for guests. *Courtesy of Bensonwood Homes*

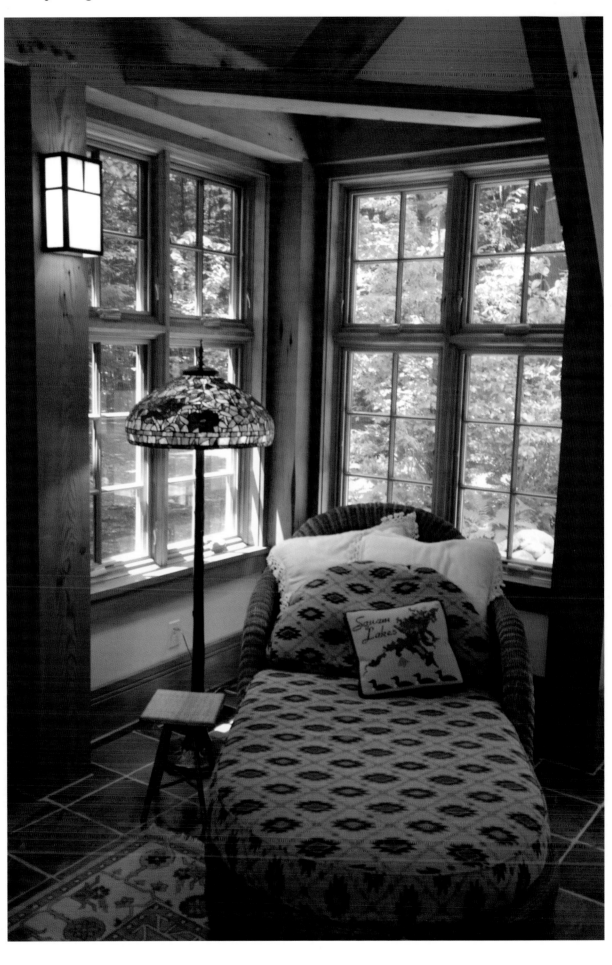

Cottage Boathouse

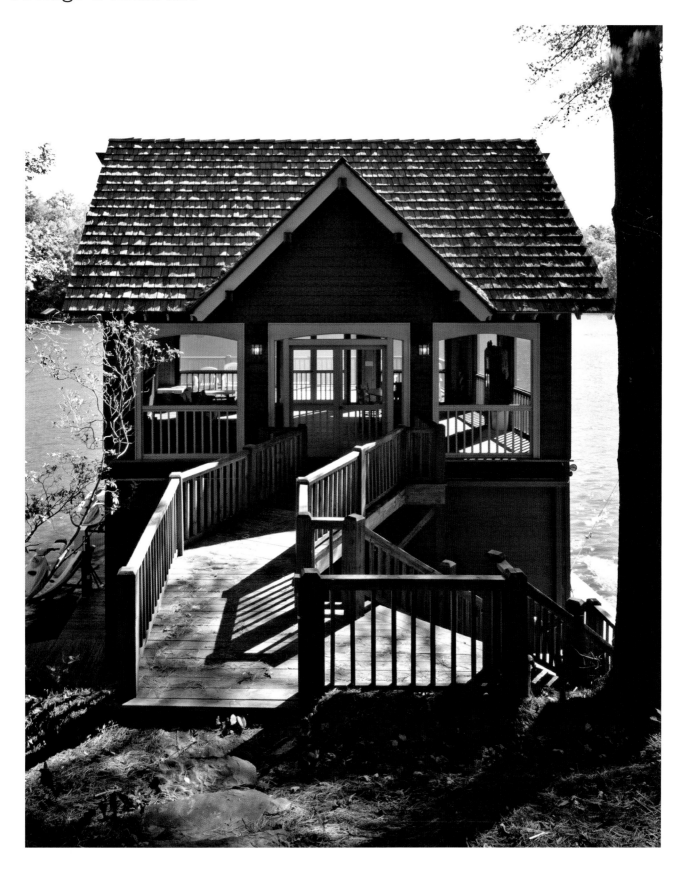

Harrison Design Associates designed a charming cottage-style boathouse. Cottage elements include the painted wood clapboard siding, shake shingle roof, four-over-one window sash patterns, exposed rafter tails, and decorative beams under the gables.

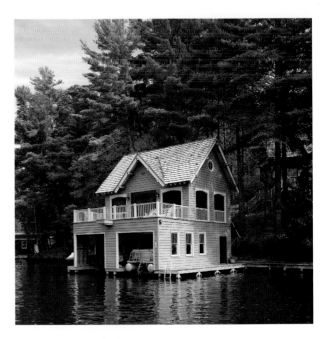

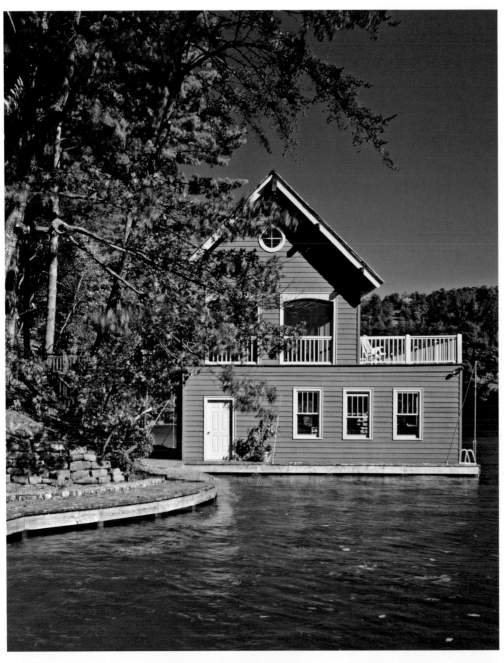

Dug-in Boathouse

Bensonwood Homes designed and built this two-boat, shingle-style boathouse. It is a dug-in boathouse—not right on the shore but 30 feet in—so the prefabricated structure could be assembled quickly on site with a minimal disturbance to the shoreline of the lake.

The excavation was done, leaving an earthen berm. Then interlocking sheet pilings were driven into the earth to form the basin, and the boathouse assembled on dry land. *Courtesy of Bensonwood Homes*

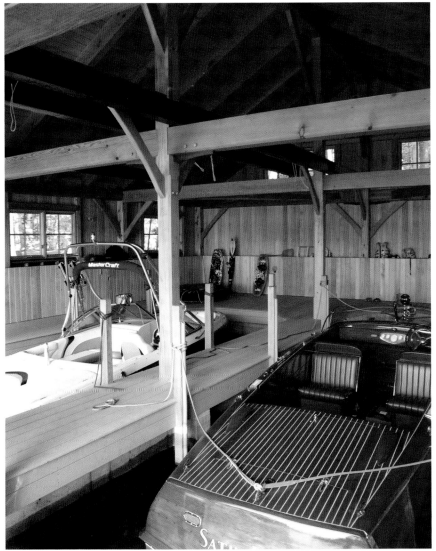

When it was completed, the earthen berm was removed, and the boathouse was married to the lake. With the excavation and on site assembly finished during the winter months, and the pre-fabrication completed in the shop, there was minimal impact to the wildlife. *Courtesy of Bensonwood Homes*

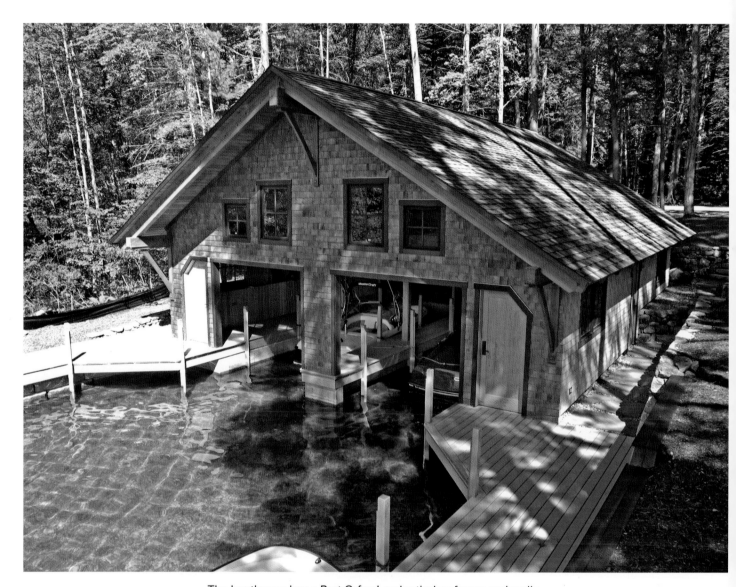

The boathouse has a Port Orford cedar timber frame and walls,
with natural oils to protect against mold, rot and insect infestation.
Courtesy of Bensonwood Homes.

II. Rowing Club, Preparatory School, and University Boathouses

One would sometimes think from the speech of young men that things had changed recently, and that indifference was now the virtue to be cultivated. I have never heard of anyone profess indifference to a boat race. Why should you row in a boat race? Why endure long months of pain in preparation for a fierce half hour that will leave you all but dead? Does anyone ask the question? Is there anyone who would not go through all its costs, and more, for the moment when anguish breaks into triumph, or even for the glory of having nobly lost? Is life less than a boat race? If a man will give all the blood in his body to win the one, will he not spend all the might of his soul to prevail in the other?

—Supreme Court Justice Oliver Wendell Holmes Jr., at his 1886 Yale commencement address.

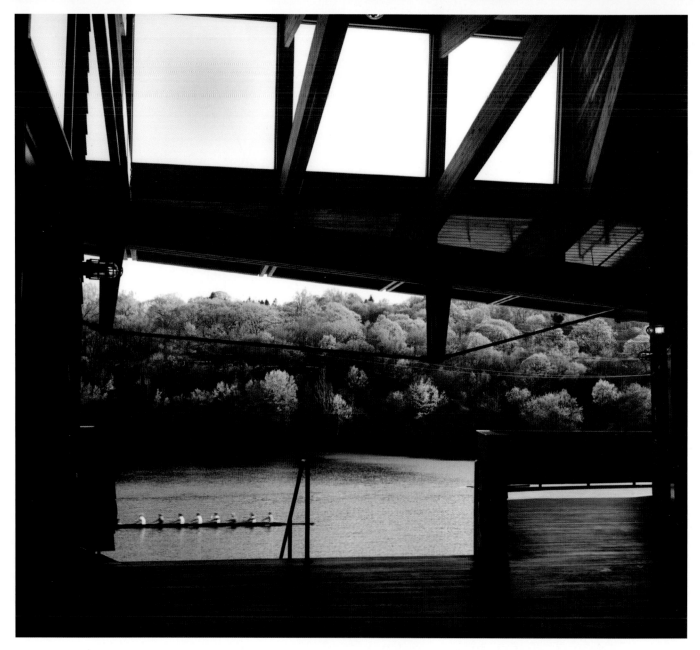

Courtesy of Cervin Robinson

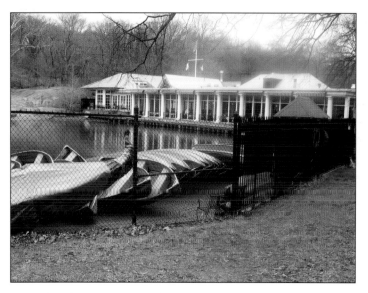

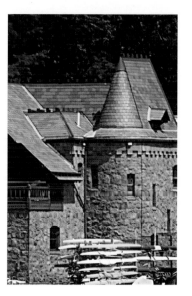

Today, boathouses have a wide range of styles and designs.

Rowing Clubs

By the end of the eighteenth century, ferry men held rowing races on London's Thames River. As these races became increasingly popular, more people became involved in public rowing. Soon the sport came to America, where it was instantly popular. Some engaged in rowing, several thousands watched, and many more lost their money!

Philadelphia's Boathouse Row

Charles II of England gave William Penn a grant of 45,000 square miles in the New World. Calling the area Pennsylvania, Penn sold land to Quakers and other dissenters and established Philadelphia along the Schuylkill and Delaware Rivers. Of course, those early residents used the river for transportation, food, and entertainment. In 1805, the city developed the Fairmount Water Works, the first municipal water works in the country, after a devastating yellow fever epidemic. In 1822, the city built Fairmount Dam diagonally across the river to power the water wheels. The dam changed the river from a tidal stream to a long fresh water lake with a gentle current—a perfect place for rowing. The city then turned the surrounding five-acre site into a public garden, one of the earliest municipal parks in the United States.

As Philadelphia grew, the river and its picturesque setting became a recreational site. Rowing was one of the sports of choice among gentlemen before the Civil War. Men joined rowing clubs, which were beginning to form along the picturesque banks of the Schuylkill River.

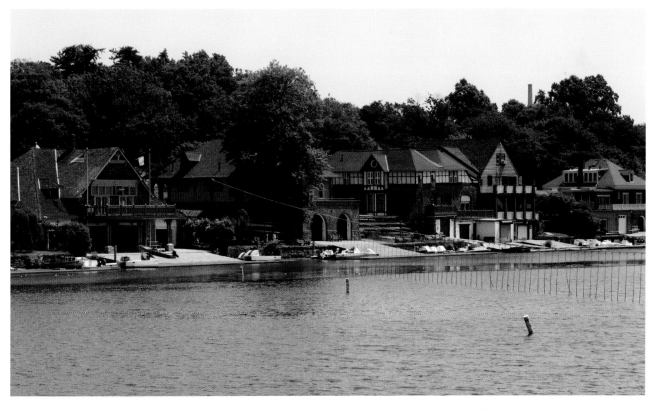

Philadelphia is renown for its Boathouse Row located on the east bank of the Schuylkill River. Each of the ten boathouses has an address on Kelly Drive and belongs to the Schuylkill River, which encompasses several other boathouses along the river. Established in 1858, the Schuylkill navy of Philadelphia is said to be the oldest amateur athletic governing body in the United States.

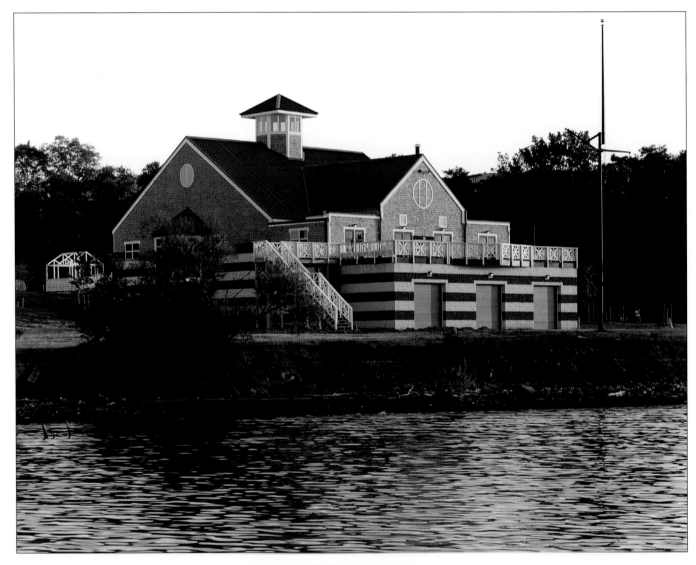

Courtesy of Ayers/Saint/Gross

Although some of the rowing clubs were short-lived, the longer standing ones established the Schuylkill Navy in an effort to promote and control an amateur sport. The city tried to remove the boathouses several times, but the clubs and the Schuylkill Navy brought sufficient pressure to bear that they were allowed to remain. Today, several of the clubs are among the premier rowing clubs in the world while others are also important institutions within Philadelphia society.

Originally, the city favored a Victorian Gothic style for the boathouses. Eventually, the clubs were permitted to erect structures made of various materials (e.g., brick, stucco, and shingle) and styles, ranging from Colonial Revival, to Shingle to Mediterranean. Because of the additions and expansions over the generations, several clubhouses have several designs and many different names. Their architectural diversity makes the boathouses quite unique.

A National Historic Landmark, Boathouse Row was entered onto the National Register of Historic Places in 1987. It hosts several major rowing regattas, where rowers from the boathouses compete at every level, including local clubs, high schools, colleges, summer racing programs, and international events.

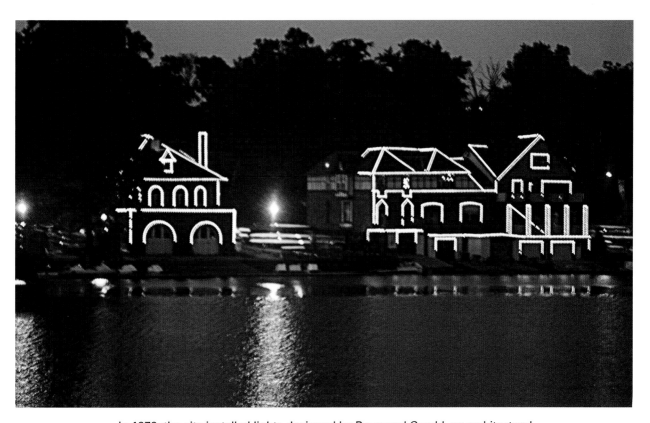

In 1979, the city installed lights designed by Raymond Gerald, an architectural lighting designer. These lights outline each of the boathouses, giving them a fairy-tale appearance; they are on every night during every season.

Founded in 1858, the Schuylkill Navy of Philadelphia is the oldest amateur athletic governing body in the United States. Its rules forbid the acceptance of any wagered money, which helped clarify the differences between professional and amateur rowers. By charter, "its object is to secure united action among the several Clubs and to promote amateurism on the Schuylkill River." Many of its oarsmen have become national and international champions.

The Navy participated in a number of significant functions for the City of Philadelphia. On November 11, 1872, fourteen Navy boats formed a rowing flotilla for the funeral of General George Mead, the victor at the battle of Gettysburg. In 1876, in conjunction with the Centennial Exposition in West Park, the first International Regatta was held—the largest regatta in the country up to that time. On April 27, 1878, the Schuylkill Navy demonstrated rowing in honor of President Rutherford B. Hayes.

Fairmount Rowing Association (# 2 Kelly Drive) was organized in 1870. The Pacific Barge Club built the original one-story rectangular stone boathouse in the year 1860. In 1865 or 1866, the Quaker City Barge Club purchased the northern half of the building (#3). Later, it constructed a single bay, one story stone addition to its half of the boathouse. They replaced the earlier stone boathouse on the site with a two and a half story Georgian Revival building in 1904.

Established in 1861, Pennsylvania Barge Club (#4) joined the Schuylkill Navy in 1865. The present architecture is picturesque Victorian or Eastlake style. The club lost many members in World War II, and the Schuylkill Navy and the United States Rowing Society subsequently occupied the building.

The Schuylkill Navy flag

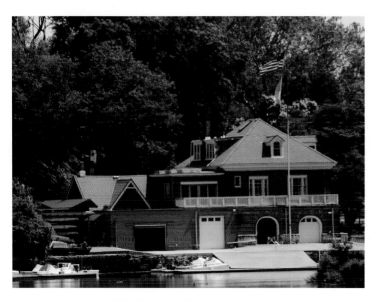

The Fairmont Rowing Association

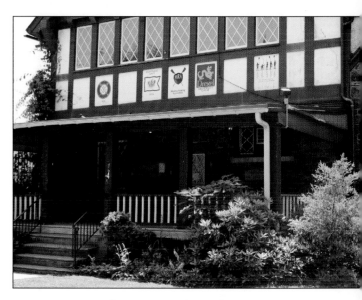

Pennsylvania Barge Club

When the Pickwick Barge Club and Iona Barge Club merged, the Crescent Boat Club (#5) was established. A member of the Schuylkill Navy, it was incorporated in 1874. Its boathouse was completed in two phases: 1871 and 1891.

Founded in 1853, the Bachelors Barge Club (#6) is said to be the oldest continuously operated rowing club in the United States. Today, female rowers outnumber the men, but initially the club's founding fathers were bachelors and members of the Phoenix Engine Company, a volunteer fire-fighting unit that operated in Philadelphia before the city had its own municipal fire fighting capabilities. In 1893, the club constructed its Mediterranean-style brick boathouse on Boathouse Row.

Ten University of Pennsylvania freshmen founded the University Barge Club (#7-8) in 1854. Considered the earliest organized athletics program at Penn, it joined the Schuylkill Navy in 1858 as a founding member. By 1872, the students had left the club and joined the College Boat Club. Constructed in 1871, the semi-attached Second Empire style boathouse was substantially expanded in 1893 to accommodate eight-man shells.

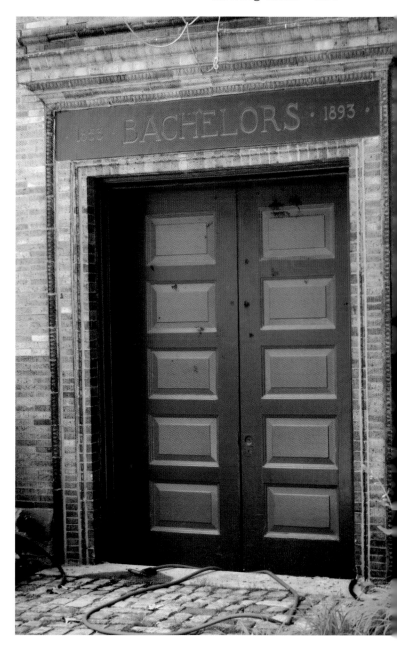

Bachelors Barge Club

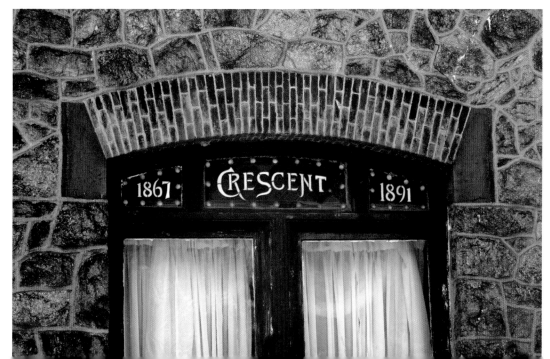

Crescent Boat Club

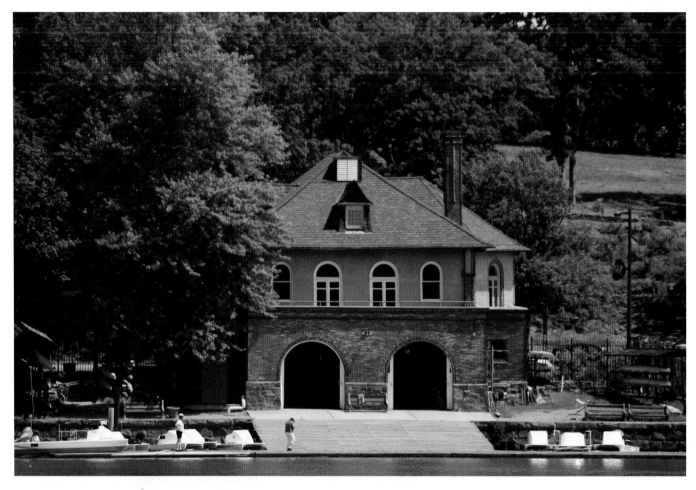

A water view

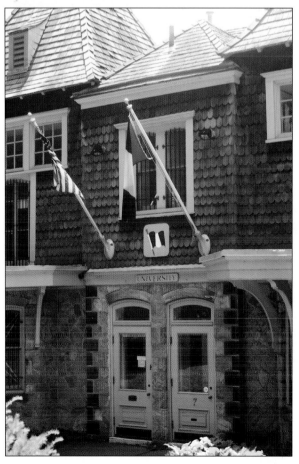

University Barge Club

Seven members of the Minnehaha Lodge of the Sons of Malta organized the Malta Boat Club in February 22, 1860. The club was first housed on a barge on the Delaware River at Smith's Island, before purchasing the Excelsior Club (#9) in 1863. They joined the Schuylkill Navy in 1865. In 1873. Vesper Boat Club and they erected a Victorian Gothic boathouse.

Vesper Boat Club (#10) was founded in 1865 and joined the Schuylkill Navy in 1870. Originally named the Washington Boat Club until 1870, it shared a house with the Philadelphia Barge Club. With Malta, they built a semi-attached ornamental Victorian Gothic building. Since 1883, the clubhouse has been significantly expanded.

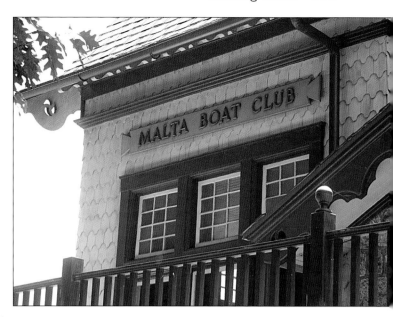

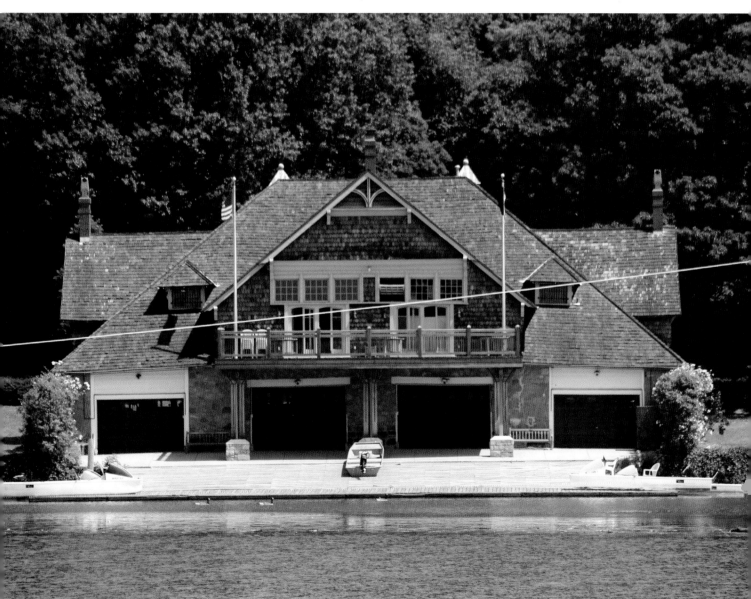

Malta Boat Club

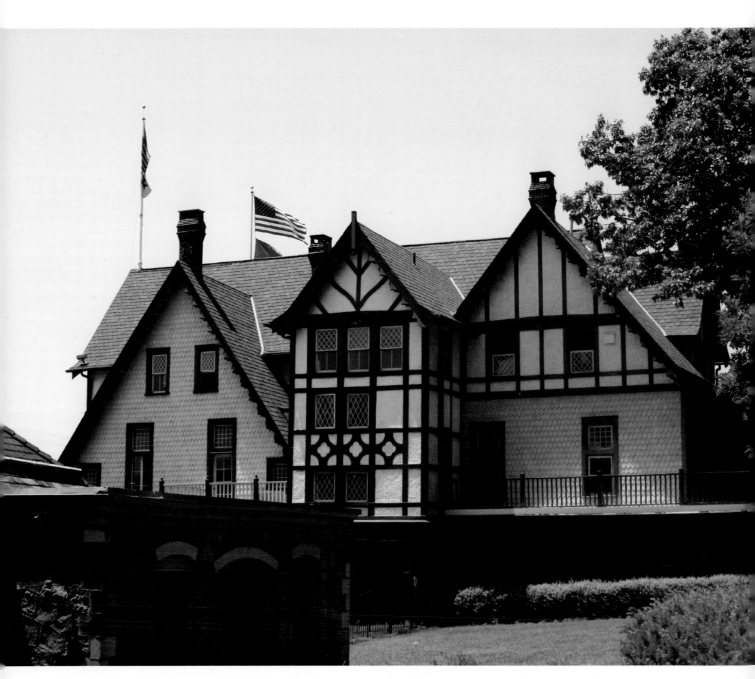

Vesper Boat Club

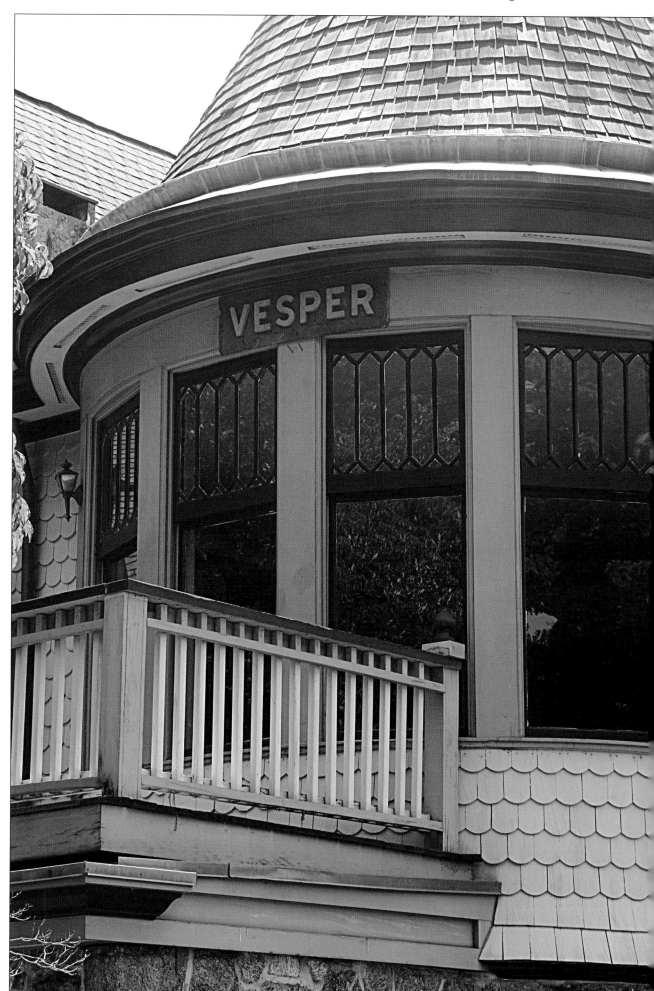

A side view

Penn Athletic Club Rowing Association (#12) dates to 1871 when the West Philadelphia Boat Club was formed. It joined the Schuylkill Navy in 1875. In 1874, unknown architects built the original ornamental Victorian Gothic section; additions were made in 1969 and 1980. In 1924, the club became associated with the downtown Penn Athletic Club and changed its name. John B. Kelly, Sr., helped bring prominence to the club in the 1920s and 1930s.

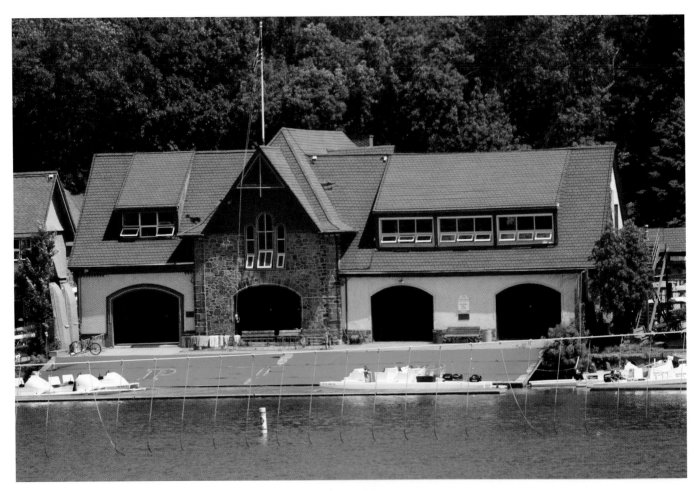

Penn Athletic Club Rowing Association

The Undine Barge Club (#13 Kelly Drive) was organized by twelve Philadelphia gentlemen on May 9, 1856 to provide "...healthful exercise, relaxation from business, friendly intercourse and pleasure, having in view to this end the possession of a pleasure barge on the River Schuylkill." Named after the spirit of babbling brooks in the legend of Undine, the club constructed a simple boathouse in a cove a few hundred yards east of the present boathouse, Oarsmen from around the country come to Philadelphia to train and compete at Undine, home to many national, world, and Olympic champion oarsmen.

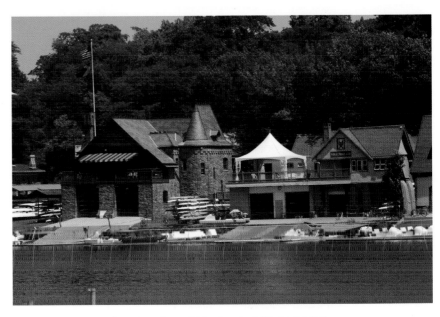

A water view of Undine and Penn Athletic

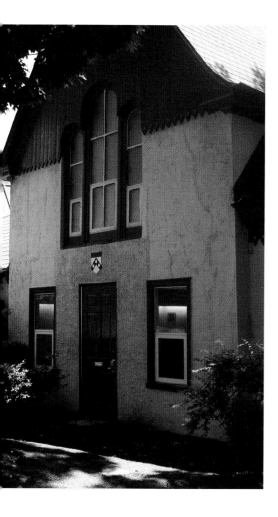

An architectural detail on Undine

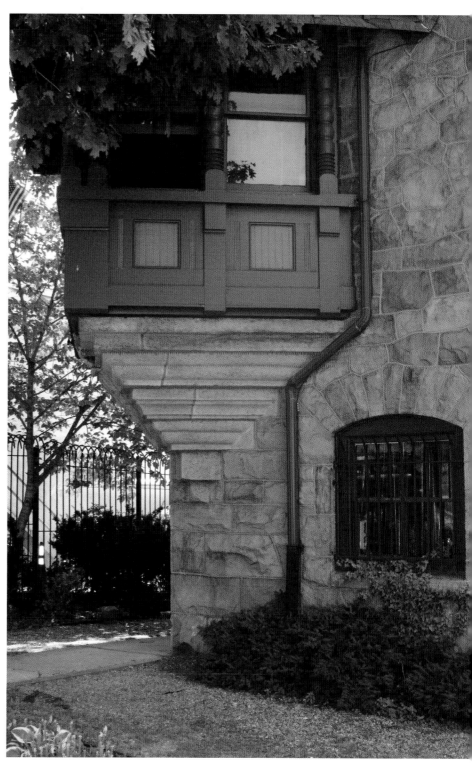

The Philadelphia Girls Rowing Club house (#14) predates the founding of the club in 1938. In 1855, the Philadelphia Skating and Humane Society built a home to provide comfort for skaters and to house a hospital and "apparatus used for rescuing persons from a watery grave." The Philadelphia Girls Rowing Club was organized in 1938. It is the oldest active such club in existence.

Formed in 1897 as the Bicycle, Barge and Canoe Club, Sedgeley Club has become a social organization. They first occupied quarters in Boat House #14 and later obtained permission to build #15 Boat House Row.

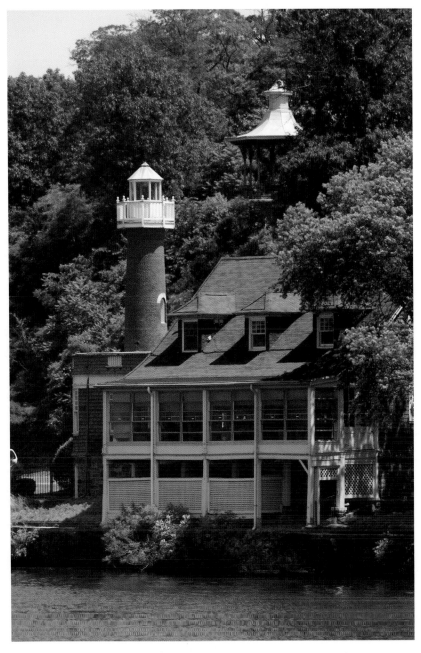

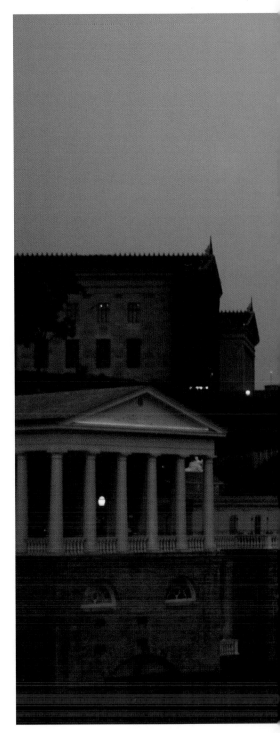

The Sedgeley Club

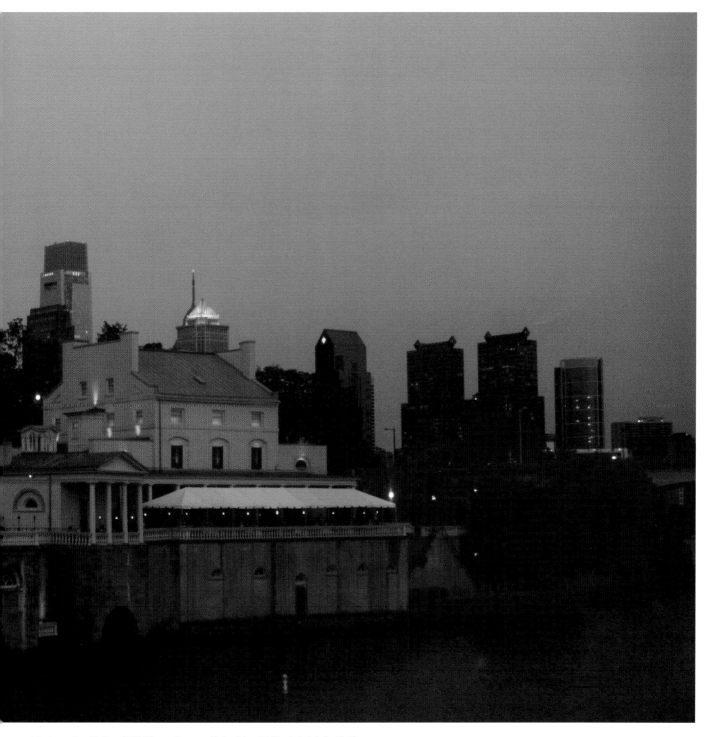

Today, the Schuylkill River is paralleled by Philadelphia's Kelly Drive, which stretches from the Philadelphia Museum of Art to the Twin Bridges near the Manayunk area. Philadelphia's beautiful Fairmount Park and the Water Works border the river.

Cambridge Boat Club

In 1630, the Puritans founded Cambridge, Massachusetts, on the north bank of the Charles River. By the nineteenth century, the Charles River powered many mills and factories and was one of the most industrialized areas in the United States. By the twentieth century, twenty dams had been built across the river. Today, twenty parks, such as the Charles River Esplanade with the Hatch Shell, and natural areas along nineteen miles of shoreline make this river a beautiful place to visit.

In Cambridge, on a bend of the river stands the Cambridge Boat Club (CBC), incorporated in 1909. The boathouse building was originally constructed on the Charles River at Ash Street in Cambridge. Subsequently, the building was moved about a third of a mile upstream to its present location in 1948, when it was necessary to make room for the construction of Memorial Drive. In 1999, the building was renovated, lifted two feet, reinforced with new foundations and a 16-foot addition constructed at the east end.

Today, the CBC is a private, not-for-profit rowing and social club with several hundred members who compete in master's regattas around the world. Club members are also active in various community outreach programs: cleaning up the Charles River, supporting other rowing organizations on the river, and extending free use of its facilities to senior citizens and area-wide charitable organizations.

The CBC first held the Head of the Charles Regatta®, the world's largest two-day rowing event, on October 16, 1965. Today, more than 7,500 athletes from around the world compete in 55 different race events.

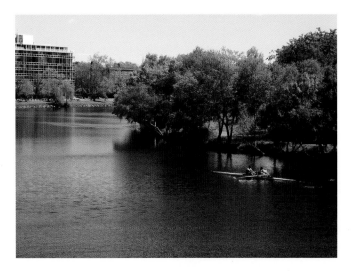

A river seems a magic thing. A magic, moving, living part of the very earth itself—for it is from the soil, both from its depth and from its surface, that a river has its beginning.

—Laura Gilpin

In the heart of Cambridge, at a busy intersection, stands the Cambridge Boat Club.

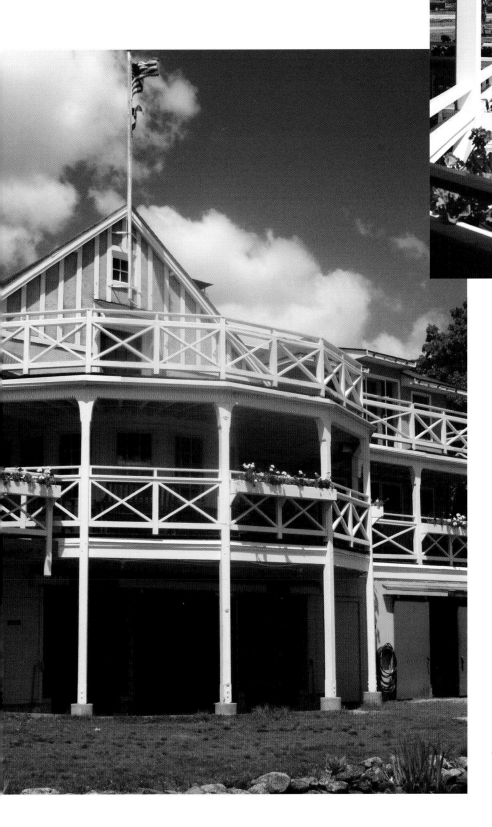

CBC is a private, not-for-profit rowing and social club with several hundred members who compete in master's regattas around the world.

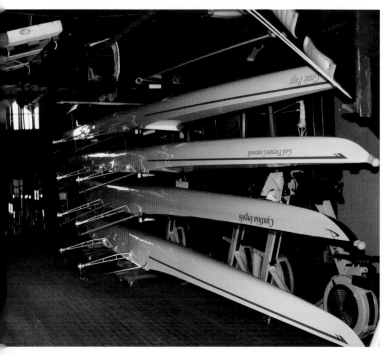

Club members are also active in various community outreach programs: cleaning up the Charles River, supporting other rowing organizations on the river and extending free use of its facilities to senior citizens and area-wide charitable organizations.

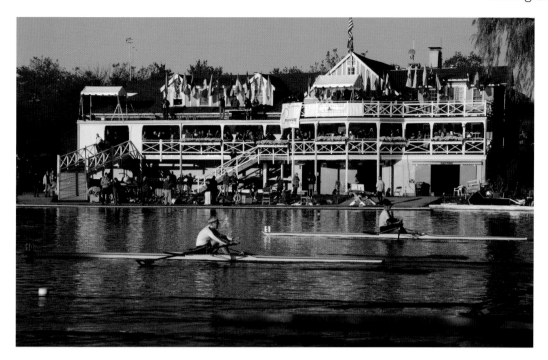

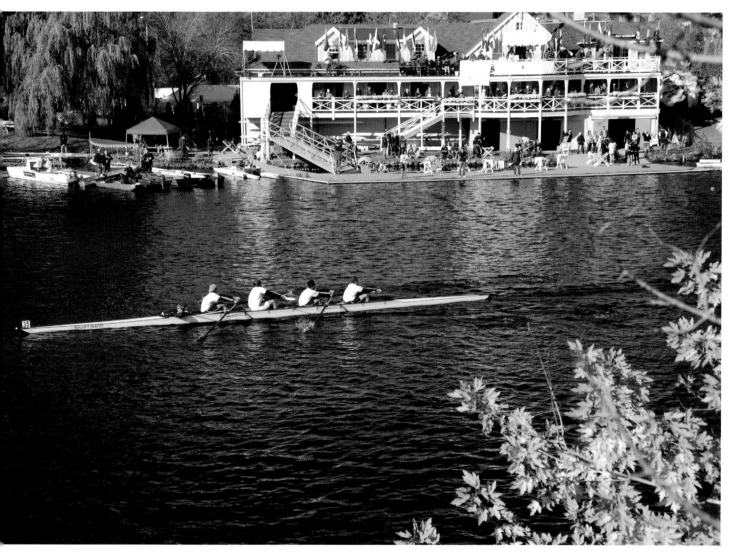

Head of the Charles Regatta® became a two-day event in 1997. It attracts up to 300,000 spectators during the October weekend. *Courtesy of Joan Bowhers*

Baltimore Rowing Club and Water Resource Center

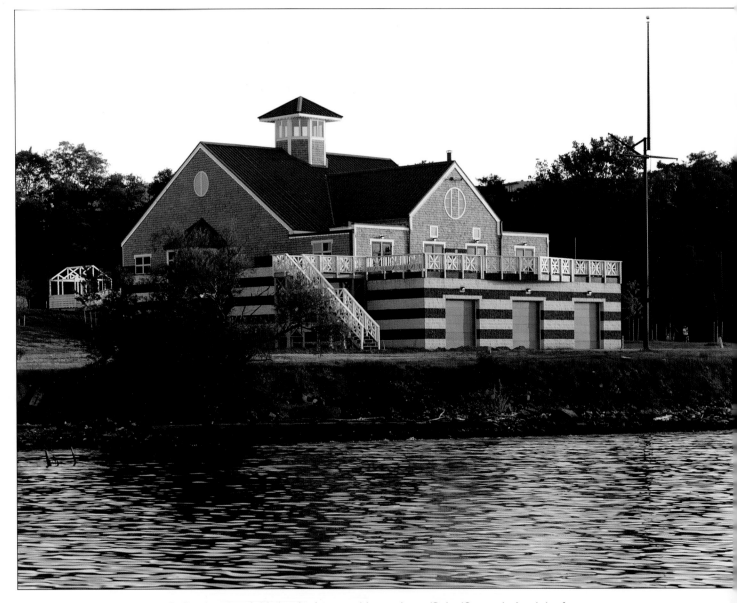

Reflecting the club's beginnings, architects Ayers/Saint/Gross derived the form and imagery of the new building from a study of nineteenth and early twentieth century boathouses on the East Coast. *Courtesy of Ayers/Saint/Gross*

Baltimore has always been known as a community whose lifeblood is its local waterways. A highly popular sport in the region, rowing recruits a large number of its members from numerous local college and universities. The city organized an official rowing club in 1864, which, despite many transitions over the years, has remained a leading competitor in the regional and national rowing sport arena.

In the late 1980s, the Club needed a permanent home befitting its strong history. Located on a sloping hillside affronting the Patapsco River, the new Baltimore Rowing Club and Water Resource Center designed by Ayers/Saint/Gross commands a spectacular view of downtown Baltimore and provides the club with a true sense of place.

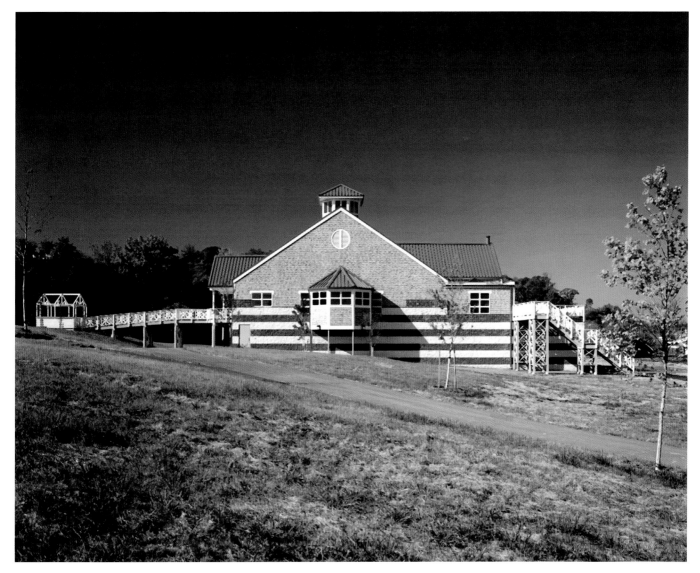

The exterior base is made of black and white rough masonry, on top of which sits a cedar shingle gabled building with a standing seam red metal roof. *Courtesy of Ayers/Saint/Gross*

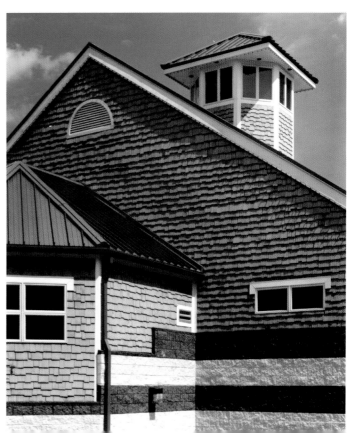

The basement of the building, built of rusticated masonry, grows out of the hillside and contains the large shell storage area. On top of this base is a more traditionally inspired wood frame structure, housing main clubhouse public spaces and various support and athletic facilities. These include classrooms, meeting rooms, catering facilities, function rooms, weight and locker rooms, outdoor viewing areas, and boat storage. *Courtesy of Ayers/Saint/Gross*

The clubhouse level is a sequence of rooms, linked at their centers, that progress from an entrance hall, a top-lighted octagonal trophy room, and a large clubroom, finally terminating in an outdoor deck that projects out toward the water and the downtown skyline beyond. *Courtesy of Ayers/ Saint/Gross*

The interior finishes are deep dark materials and colors consistent with the tradition of the boathouse as a building type. *Courtesy of Ayers/Saint/Gross*

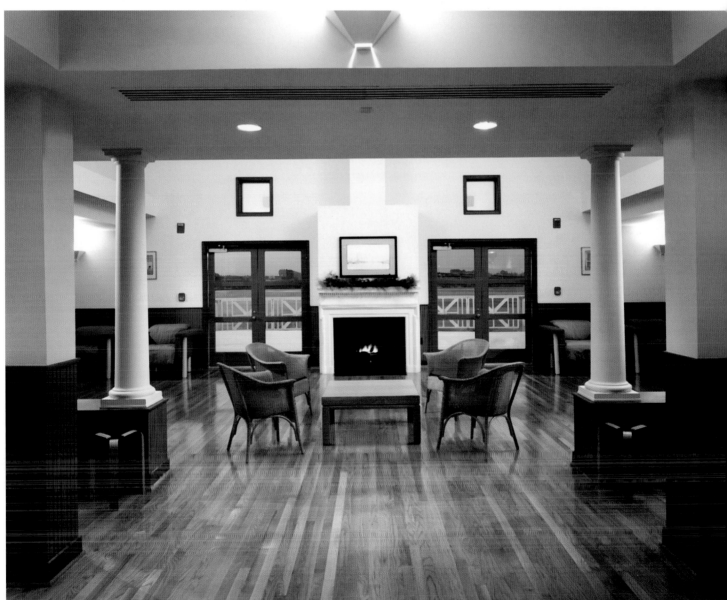

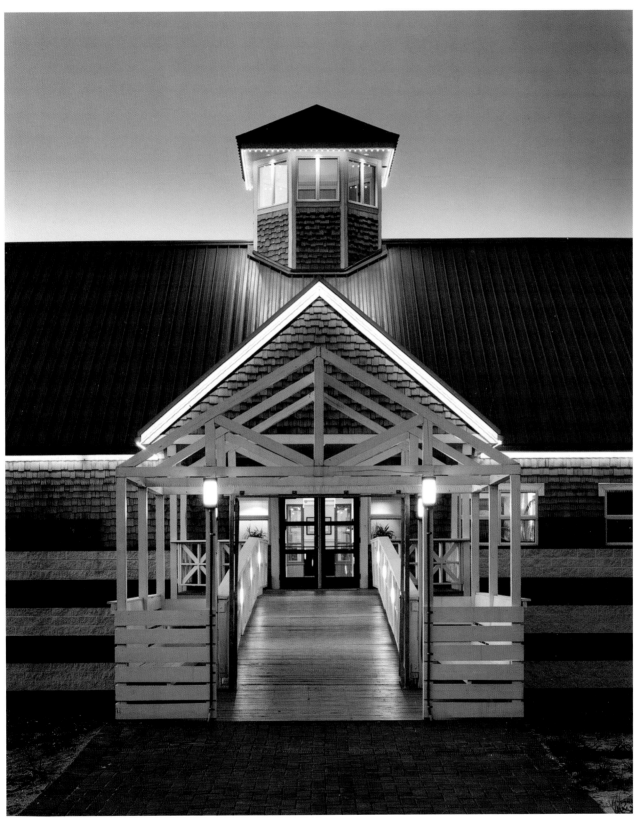

The facility has earned numerous accolades, including a Baltimore Chapter AIA Design Excellence Award and was a feature story in *Architecture Magazine*. In 1990, *Baltimore Magazine* named it the "Best Place to Have a Party." *Courtesy of Ayers/Saint/Gross*

Concord, Massachusetts, Boathouse

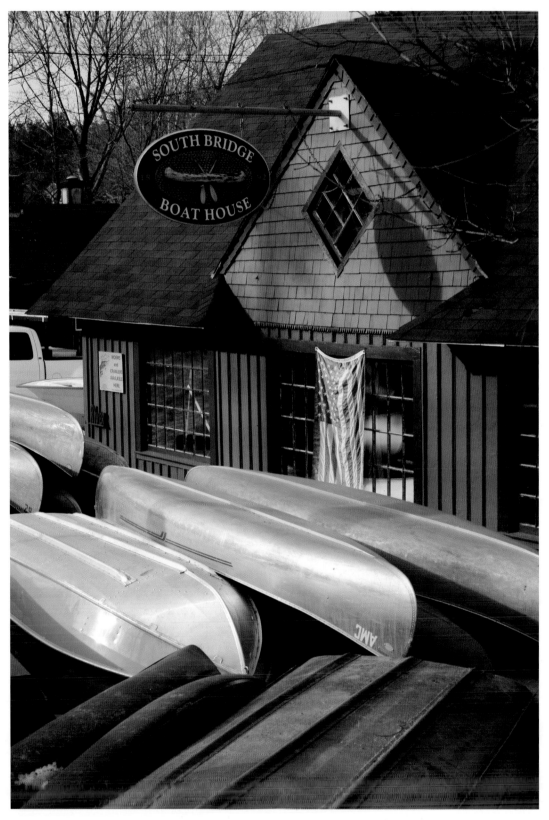

Row, row, row your boat. *Courtesy of Siobhan Theriault*

Many small towns on the water have a boathouse where you can rent boats by the hour. This one in Concord, Massachusetts, allows you to pretend that you're Henry David Thoreau.

Preparatory Schools and Universities

Rowing is a sport for dreamers. As long as you put in the work, you can own the dream. When the work stops, the dream disappears.
—Jim Dietz, Rowing Coach,
United States Coast Guard
Academy

College rowing is one of the few collegiate sports where athletes practice year round and compete during both spring and fall. It is also one of the oldest sports. The Oxford-Cambridge race was first held in 1829; the Henley Regatta began in 1839. Then competitive rowing came to America, and the Yale-Harvard race was introduced on the Charles River in 1852.

Harvard University— Weld Boathouse

Crew has been a major sport for over 150 years at Harvard University. In 1858, the Harvard crew wore miscellaneous attire and caps. In preparing for a big regatta in June, crew members Charles Eliot '53 and Benjamin W. Crowninshield '58 bought six Chinese silk bandannas for teammates to tie around their heads. They particularly liked the crimson one; as a result, crimson became Harvard's official color in 1910.

By 1889, the regatta had become a popular annual event. George Walker Weld, '56 Harvard University, funded the construction of a boathouse in 1889 and bequeathed the funds for the Weld Boathouse, a grander structure designed by Peabody in 1906. When Weld's boathouse opened its doors, young athletes could train in eights, fours, pairs, and singles.

The Weld Boathouse is a well-known Cambridge landmark just a short walk from Harvard Yard. *Courtesy of Janet Smith Photography*

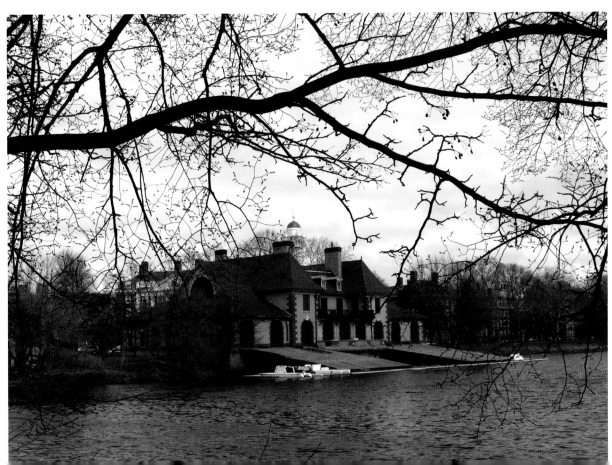

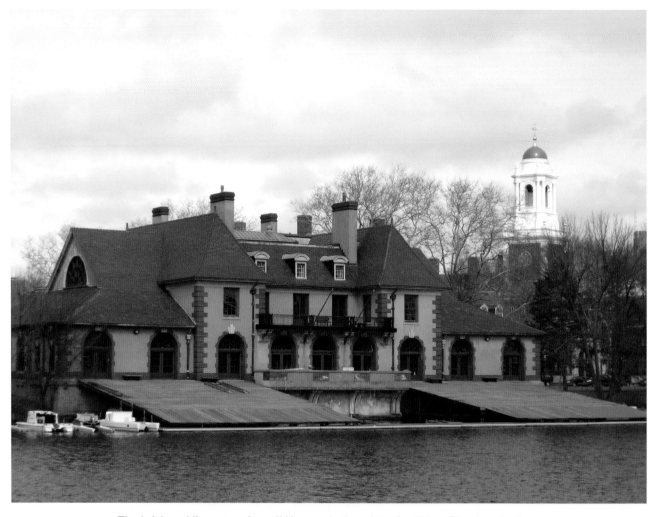

The brick and limestone Lowell House, designed by Coolidge, Shepley, Bulfinch and Abbott, is to the right of the boathouse. *Courtesy of Janet Smith Photography*

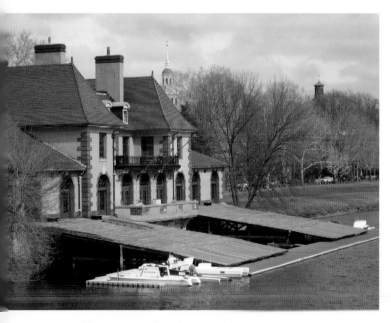

The concrete boathouse with red brick moldings has a slate hipped roof. *Courtesy of Janet Smith Photography*

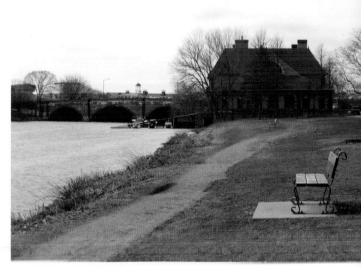

Today the Weld Boathouse houses the Radcliffe and intramural crews and is the center for instruction in recreational and competitive sculling, open to all members of the university. *Courtesy of Janet Smith Photography*

Yale University— Gilder Boathouse

Over the years, Yale crew racing has been a favorite spectator sport in Derby, Connecticut. At the end of the twentieth century, the Yale University rowing crew had a new home—the Gilder Boathouse, a 22,000 square-foot state-of-the-art facility. The building incorporates design features specific to the needs of Yale crew and the requirements of the site on the Housatonic River. Selected through a competition in February 1998, the New Haven firm of Turner Brooks Architects (Turner Brooks and Eeva Pelkonen with help from Michael Curtis, job captain, Susanna Pollman, team) designed the building. Structural engineers include Boston Building Consultants with John Poulin in charge of project; mechanical engineers: BVH and landscape architects: Towers/Golde.

The building negotiates a steep bank on a narrow sliver of site squeezed between the Housatonic River and a busy state highway The facility houses five boat bays, a repair bay, men, women's, and visitors, locker rooms, coach offices, and a ceremonial viewing room. Decks and porches (and the exterior stair) are designed to absorb race day spectators. The shells are unloaded at the upper level parking area and carried down to the docks on a ramp descending along the riverside flank of the building.

At the building's main entrance along the road, one passes through a sliding gate of cast aluminum oars onto a porch that confronts a grand expanding stair connecting with the river and docks below. *Courtesy of Turner Brooks*

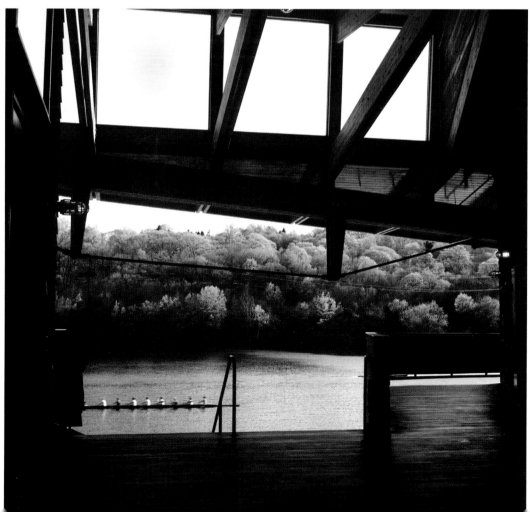

View from entry porch over the public stair that descends to the river level and docks below. *Courtesy of Cervin Robinson*

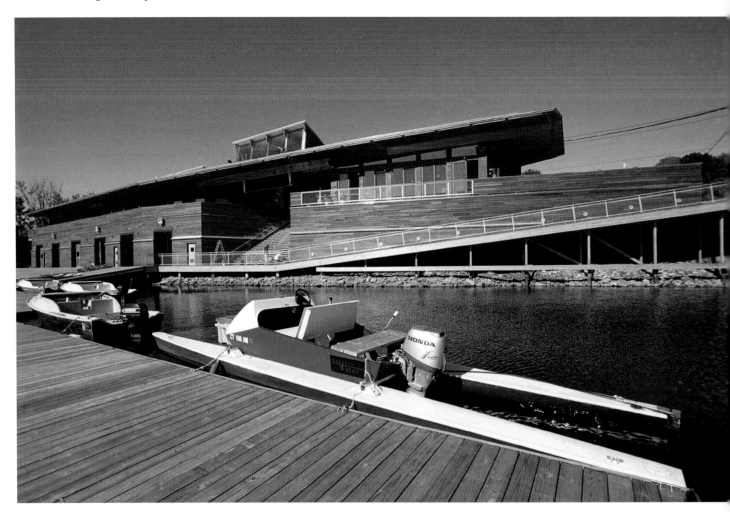

This view over the docks shows viewing room to the right of the public stair with the boat ramp descending below it. *Courtesy of Michael Marsland*

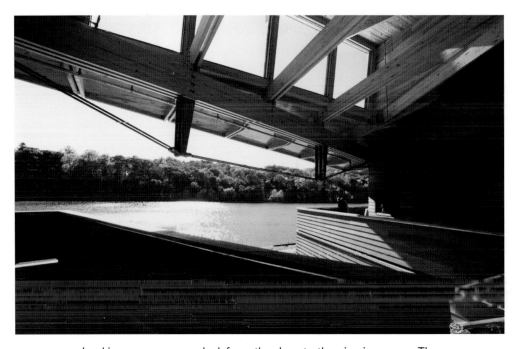

Looking across upper deck from the door to the viewing room. The public stair descends through the gap in the center of the picture to the dock level below. *Courtesy of Michael Marsland*

The locker room has natural lighting from clerestory windows and custom made lockers.
Courtesy of Turner Brooks

The path to the locker rooms looks over the docks and runs parallel to the Housatonic River below.
Courtesy of Michael Marsland

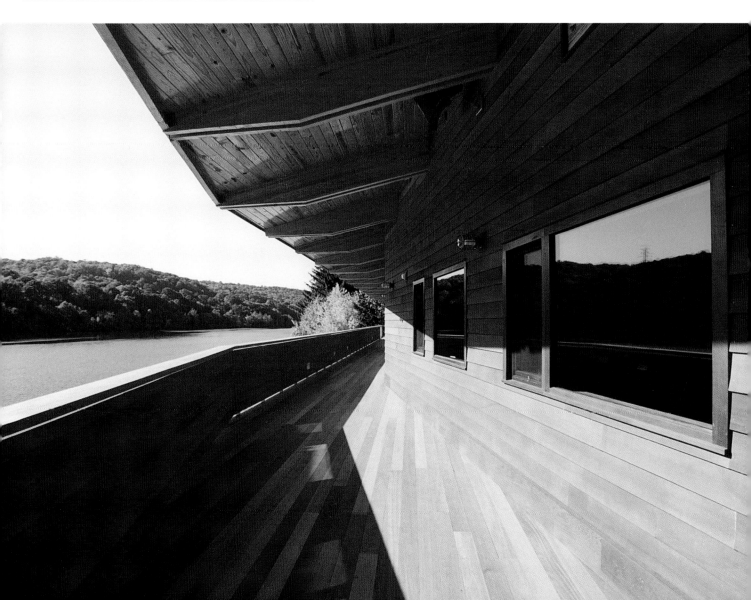

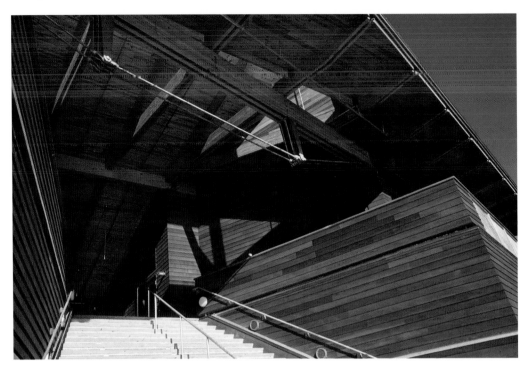

View up the public stairs from dock level. Note "bowstring" truss
carrying roof across the opening. *Courtesy of Turner Brooks*

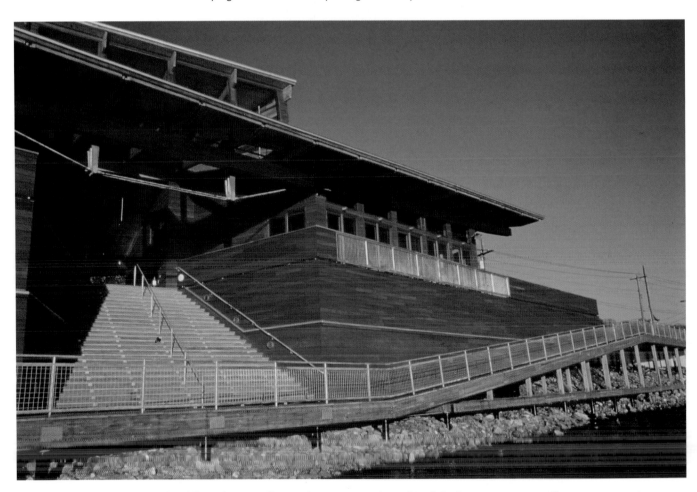

View of public stair ascending under entry porch roof and the boat ramp ascending
along its flank towards the trailer unloading area at road elevation above. The space
housing the stair is illuminated at dusk and acts as a cozy glowing beacon to guide
rowers back to the building after dark. *Courtesy of Richard Cadan*

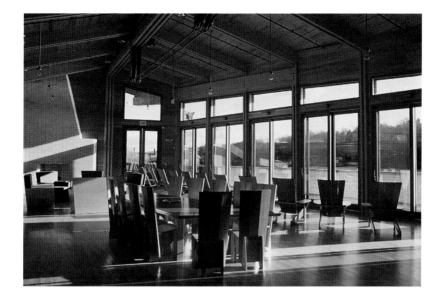

The viewing room looks directly out to the river over the race finish line. Housing an ample supply of generous Adirondack chairs and a trophy case, it is anchored by a large fireplace. This space serves as a multipurpose space for after race gatherings and other special events. *Courtesy of Turner Brooks*

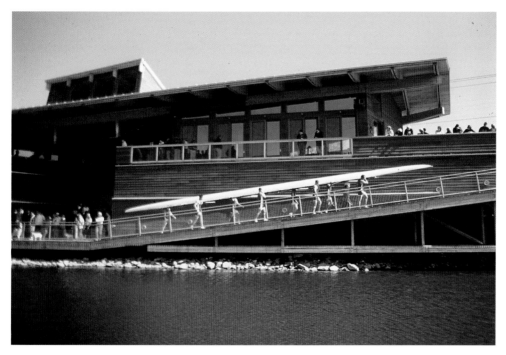

Visiting team carrying shell up the ramp after a meet. Race spectators can be seen crowding the decks above. *Courtesy of Richard Cadan*

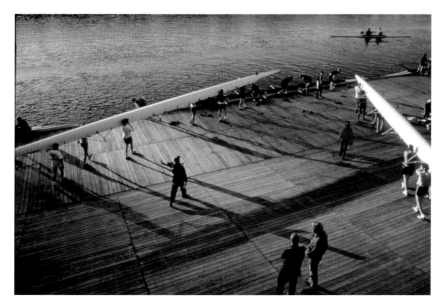

The docks are one-quarter acre in size. *Courtesy of Turner Brooks*

Tufts University— Shoemaker Boathouse

Located on the Malden River in Medford, Massachusetts, the new Shoemaker Boathouse, designed by Peterson Architects for Tufts University, is a gleaming gem on formerly contaminated land. It is the first completed building in River's Edge, a new development that will reclaim brownfield land and will also include office and residential space in several buildings. The development will also create a linear riverfront park for local residents. The boathouse, with benches overlooking the water and interpretive signage outlining the industrial history of the site, will be a part of the park. The modern structure responds to solar and view conditions and considers the proposed architecture of the development.

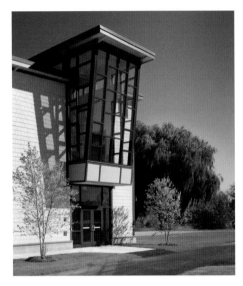

A spectacular glazed landing over the entry looks back to the western approach to the building and will also relate to structures planned for the future of the site. *Photo by Edua Wilde*

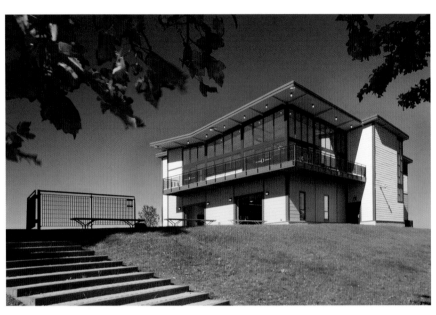

The 9,000 square foot building includes two boat bays to accommodate the university's mix of eights, fours, pairs and single sculls and contains storage for the different types of oars for those boats. *Photo by Edua Wilde*

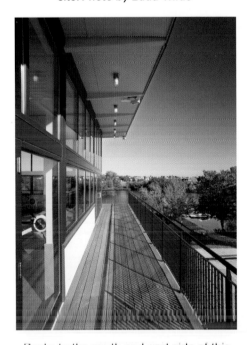

Decks to the south and east side of this space also respond to the views. The coaches' office, off of the club room, features interior glazing that allows it to share the sweeping views of the site. *Photo by Edua Wilde*

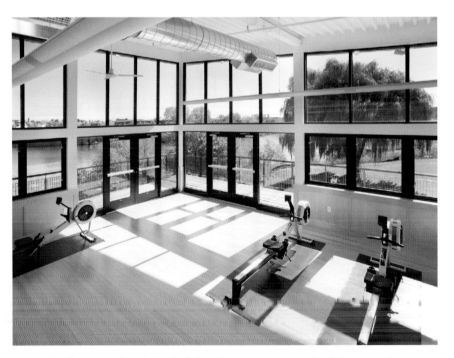

On the upper level, the building features a dramatic club room that overlooks the river. This room will accommodate ergometers and other training equipment but can also be set up to host meetings, dinners or other functions. *Photo by Edua Wilde*

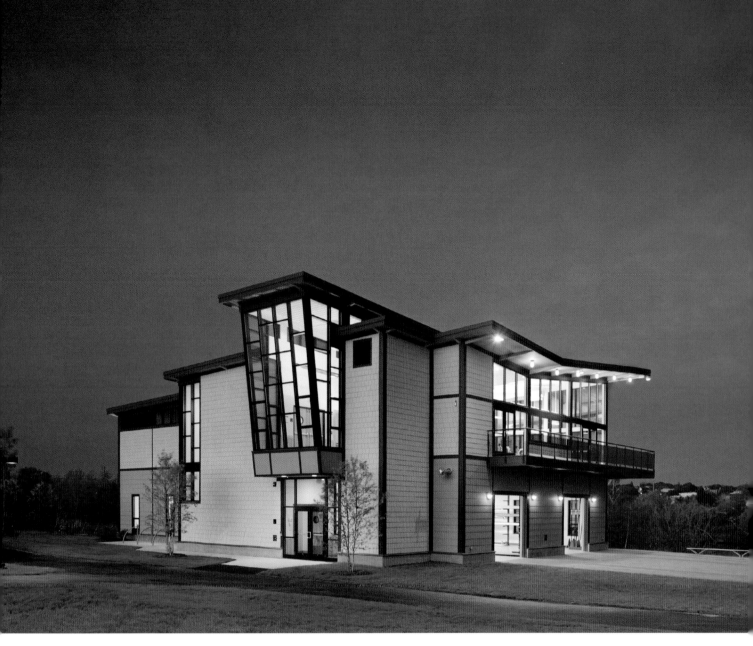

Glazing of entry and the multifunction room highlight the spatial relationship of the public spaces of the building. Bathrooms, storage, and changing rooms occupy the more enclosed building area to the north. *Photo by Edua Wilde*

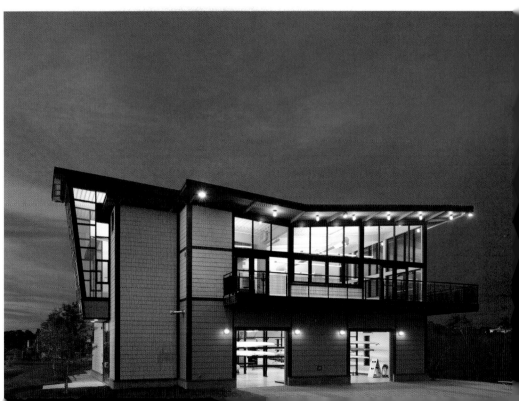

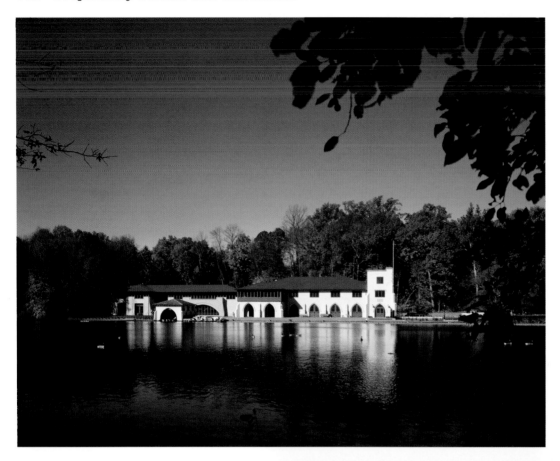

The remodeled boathouse tower, with stairs sweeping up to a lofty sky lit anteroom on the second floor, is not only the dominant visual element of the complex but also its primary entryway. *Courtesy of the Frances Loeb Library, Harvard Graduate School of Design: Nick Wheeler photographer*

Princeton University— C. Bernard Shea Rowing Center

ARC/Architectural Resources Cambridge designed and completed the addition and renovation to the C. Bernard Shea Rowing Center at Princeton University.

The new boathouse unifies the historic Class of 1887 Boathouse with a spacious modern addition, creating a striking presence on the north shore of Carnegie Lake.

The project includes a 13,500 square-foot addition to the existing 20,000 square-foot structure. *Courtesy of the Frances Loeb Library, Harvard Graduate School of Design: Nick Wheeler photographer*

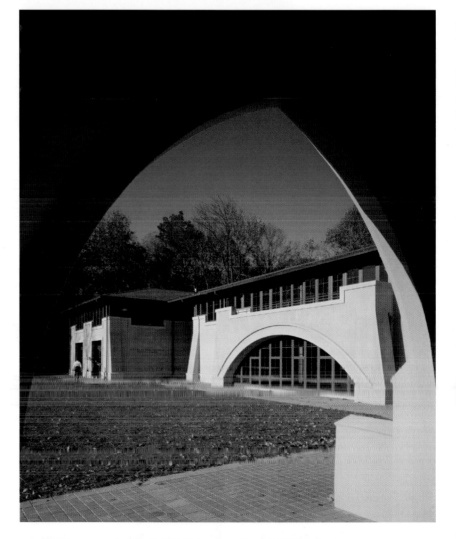

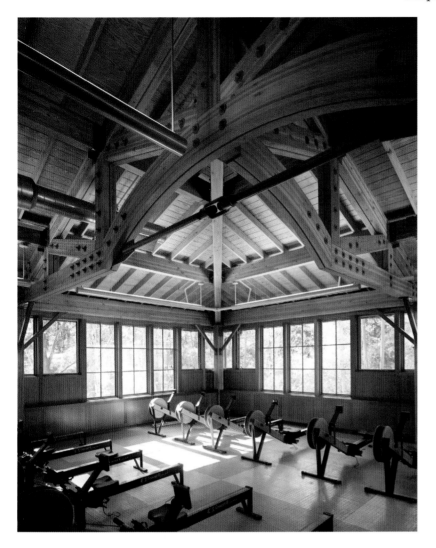

Below:
The new construction sits back from the edge of Lake Carnegie to both protect the lake during construction and reduce the visual impact of the addition from the bridge on Washington Road. The design respects the roof forms and massing elements of the old boathouse. The low arch —reminiscent of the Washington Road Bridge—frames the view of the lake from the ground level rowing tank. *Courtesy of the Frances Loeb Library, Harvard Graduate School of Design: Nick Wheeler photographer*

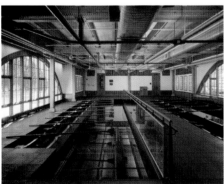

The new complex, renamed the C. Bernard Shea Rowing Center, features state-of-the-art facilities and equipment. It includes a new 16-person rowing tank, one repair bay, seven boat bays, and four large workout spaces. The renovation not only improves heating and ventilation systems, but also facilitates accessibility for the disabled. Other features include a restored clubroom, spacious locker rooms, offices for the coaching staff, and a two-bedroom apartment. *Courtesy of the Frances Loeb Library, Harvard Graduate School of Design: Nick Wheeler photographer*

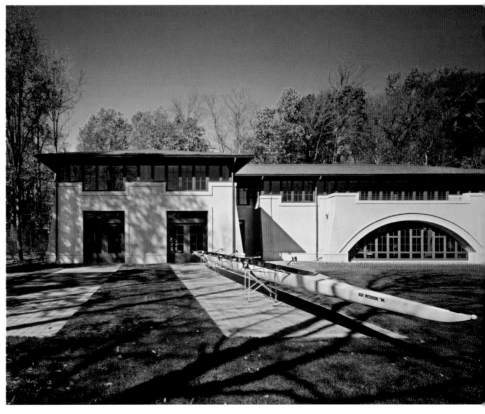

Episcopal High School of Jacksonville— Walton Boathouse and Riverside Activity Center

Sited among statuesque live oaks on 18 acres along the Arlington River in Jacksonville, Florida, the Walton Boathouse and Riverside Activity Center at Episcopal High School is home to the school's crew team. Designed by Peterson Architects, the activity center also contains a multifunction clubroom and a bleacher-style outdoor classroom. Reflecting the colors of its site, the building is comprised of a central mass clad in textured, colored concrete block, flanked by wood-clad volumes on each end.

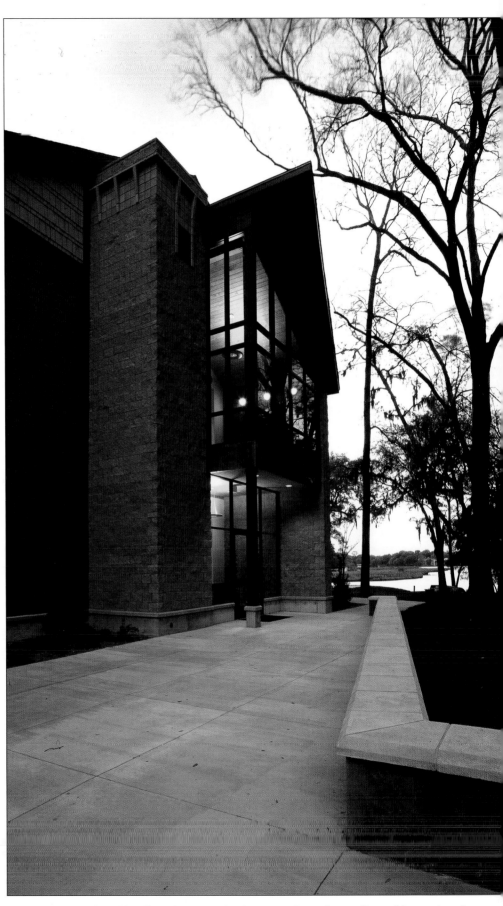

The glazed landing above marks the entry. A seating wall provides a place for students to meet and wait for their rides. *Photograph by Antony Rieck*

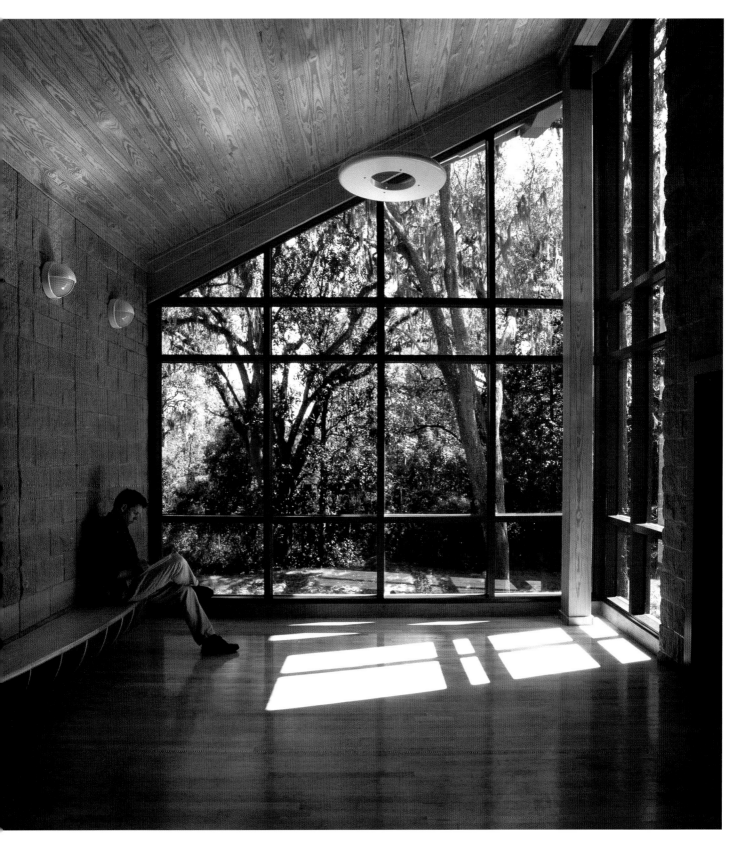

The dramatic fully glazed landing looks back on the entry plaza. It includes a built-in, boat-shaped, maple bench. The columns here and throughout the building relate to the trees outside. Floor and wainscot are maple. *Photograph by Antony Rieck*

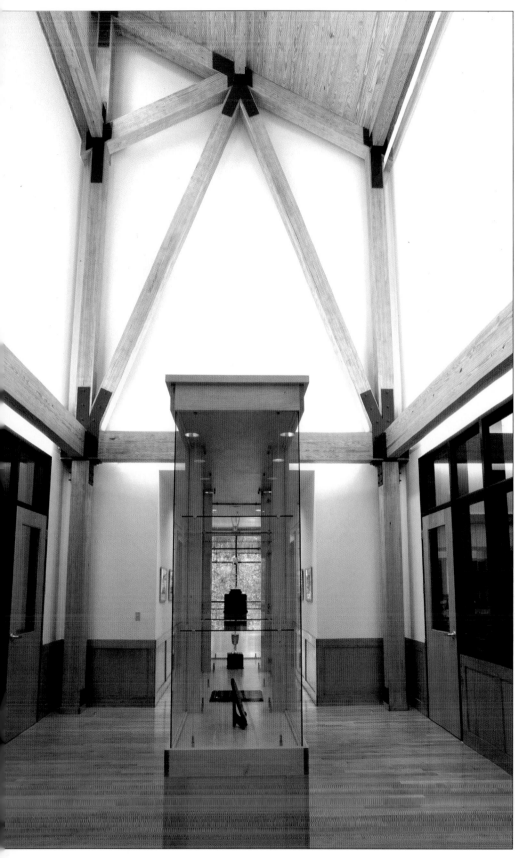

The trophy room has glazed walls opening into the club and cardio rooms. From this location, at the center of the building, one can see outside in all four directions and through the striking 30-foot high clerestory above. *Photograph by Antony Rieck*

The trophy room features dramatic space with lighting hidden behind the beams and in the top of the trophy case. *Photograph by Antony Rieck*

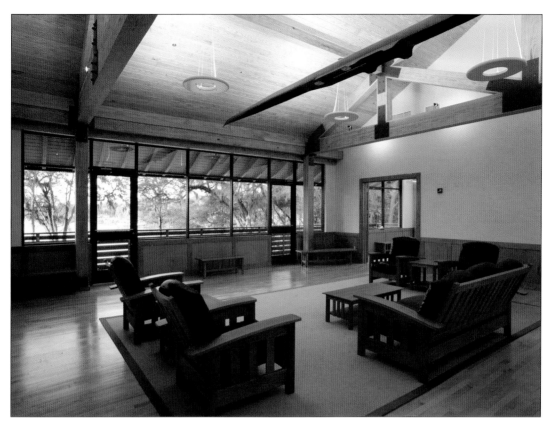

The clubroom features exposed structure and decking. *Photograph by Antony Rieck*

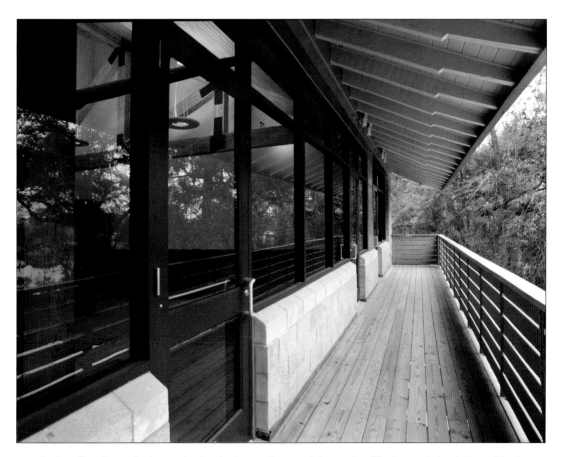

A sixty foot-long deck overlooks the boat plaza and the water. *Photograph by Antony Rieck*

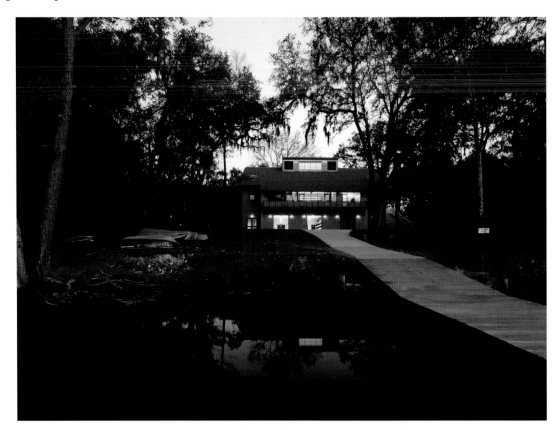

The boat bays illuminated at dusk. *Photograph by Antony Rieck*

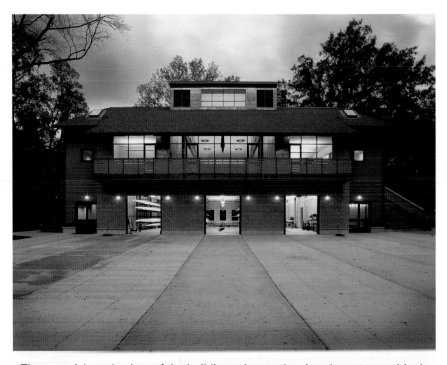

The materials and colors of the building relate to the site: the concrete block to the sandy soil, trim to the brown of the tree trunks, olive siding to the leaves and silver green shingles to the Spanish moss. *Photograph by Antony Rieck*

University of Washington—Conibear Shellhouse

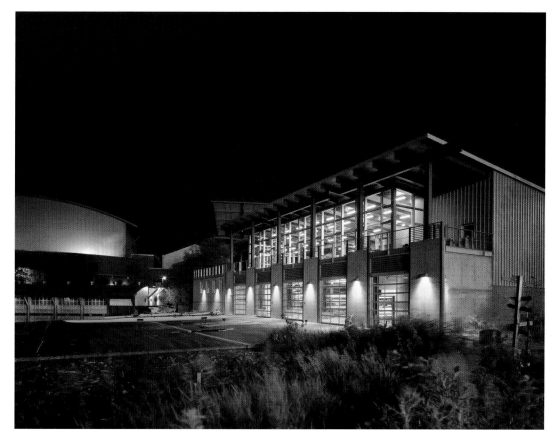

The site, once on the edge of a city dump, is now surrounded by newly restored wetlands with pathways linking to existing nature walks. The original shell bay structure of retaining walls was retained for shoreline permit reasons. *Courtesy of Nic Lehoux*

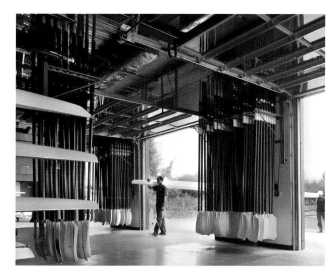

The rowing teams are located at the water's edge with shell bays opening directly to the launch docks. *Courtesy of Nic Lehoux*

Rowing at University of Washington (UW) began in 1901, when the first class day race was held. The first intercollegiate competition for UW was held in 1903, when UW defeated California, marking the first interstate collegiate regatta west of the Rockies.

In 2005, The Conibear Shellhouse was reopened after a major expansion and renovation. The University of Washington Department of Intercollegiate Athletics (ICA) and the Miller|Hull Partnership designed an expansion and renovation of the existing Conibear Shellhouse and associated facilities that provide the university with a center to their "athletic village by the lake." Situated on the west shores of Lake Washington, the resulting 48,000 square-foot facility houses three programs: the men's and women's rowing teams, dining and athlete academic services. Each program element maintains its identity within Miller|Hull's overall design.

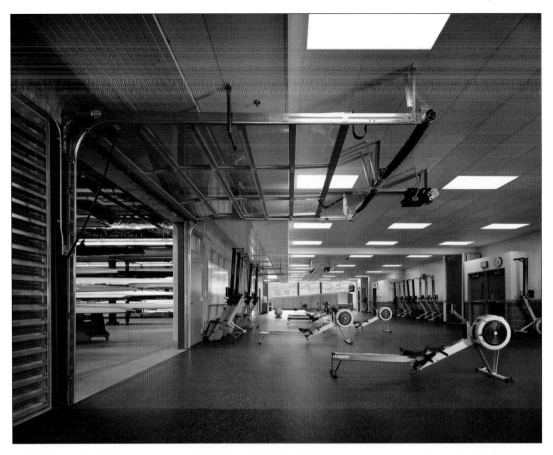

Behind the shell bays are the team training areas and locker rooms. Team training functions need lots of air movement. Cool outside air is pulled by stack effect through the shell bays into the team training areas. Chimney shafts in the building create the stack effect. There is no air-conditioning. The crew area has is own lower level exterior entrance and courtyard. *Courtesy of Nic Lehoux*

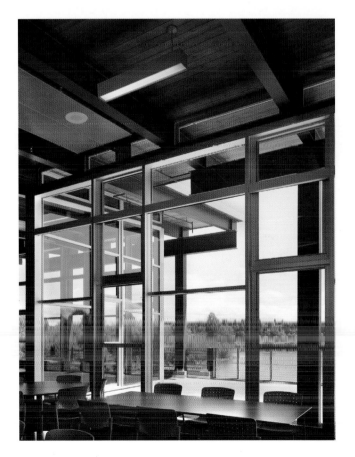

The dining room, student lounge and lecture room occupy the main level. The dining area, with room to accommodate 250-plus student-athletes, features 18-foot floor-to-ceiling windows and opens to the lake. The glazing system incorporates vertical lift operable windows spaced regularly around the perimeter. Again, the strategy is to use natural ventilation chimney shafts augmented by mechanical air when needed. Connected to the dining hall is a 2,500 square-foot deck that spans the entire east wing of the building and boasts breathtaking views of Lake Washington. *Courtesy of Nic Lehoux*

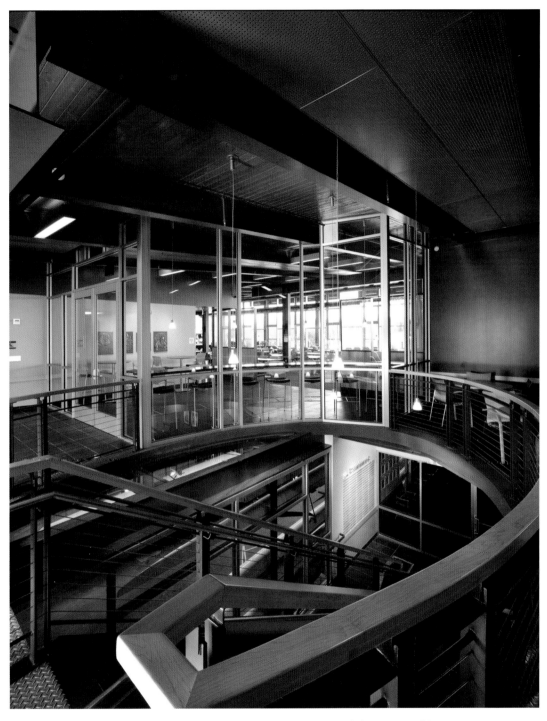

A large stair connects up to the lobby and dining room with
views into the shell storage bays. *Courtesy of Nic Lehoux*

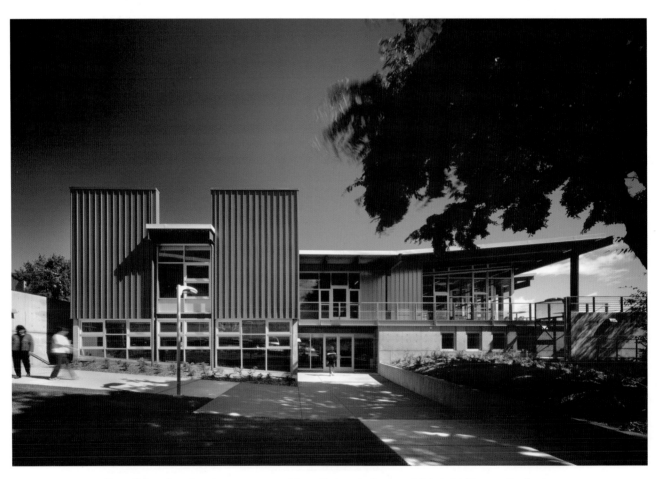

Part of the plaza is a lawn area used heavily by students, which is built over the locker rooms below grade. The exterior deck is also used for dining. The student academic program is housed in its own two-story form. Study lounges, tutoring spaces, computer labs and faculty offices are located within it. *Courtesy of Nic Lehoux*

Boston University— DeWolfe Boathouse

BU's new boathouse was designed to replace the university's original facility on the Charles River in Cambridge, Massachusetts. ARC/Architectural Resources Cambridge designed the handsome boathouse to meet the future needs of a rowing program that produced a women's national championship the year of the groundbreaking. The boathouse was completed in October 1999, in time to serve its traditional role as the starting line on the thirty-sixth year of the Head of the Charles Regatta.

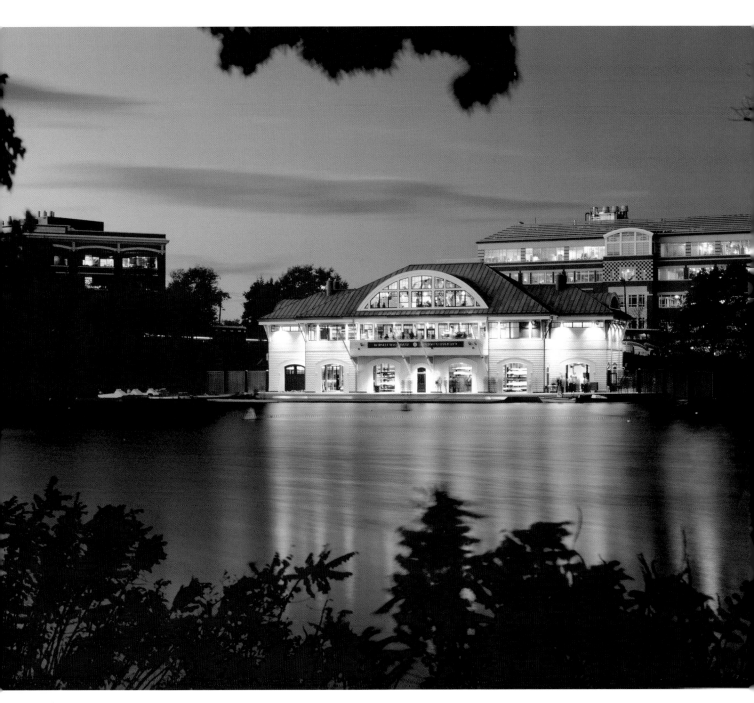

The boathouse is the focal point of views from the main campus, on the other side of the river and, in turn, presents sweeping views of the BU campus with the Boston skyline in the background. *Courtesy of John Horner Photography*

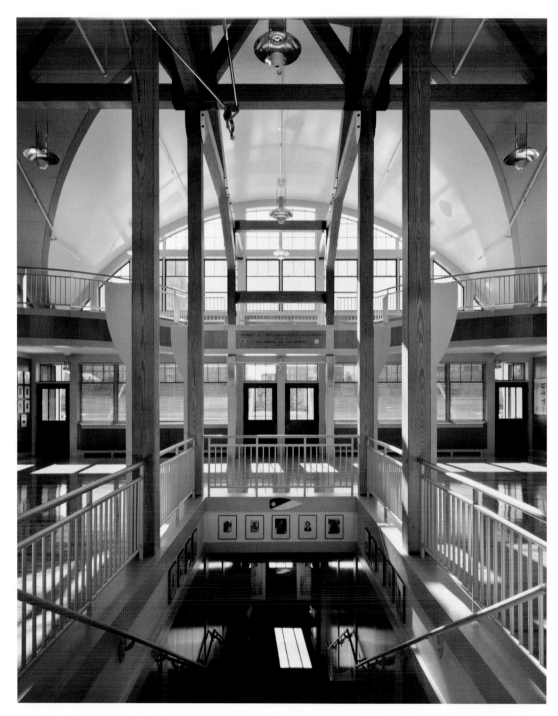

The structure houses five-boat bays, a repair bay, land training facilities with
ergometers and weight training rooms, 200 lockers, an expanded dock area, and
support facilities including a team room and coaches office. *Courtesy of the Frances
Loeb Library, Harvard Graduate School of Design: Nick Wheeler photographer*

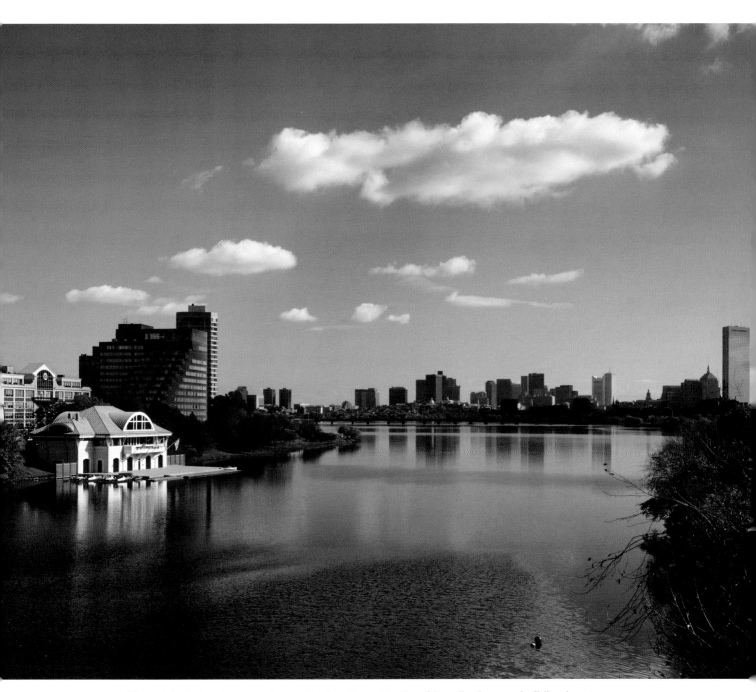

The original structure was immediately adjacent to the sidewalk; the new building is set back creating a public plaza at the entry that both highlights the boathouse's presence on Memorial Drive and increases pedestrian safety. *Courtesy of the Frances Loeb Library, Harvard Graduate School of Design: Nick Wheeler photographer*

Phillips Exeter Academy Saltonstall Boathouse

Located on the Squamscott River, the Saltonstall Boathouse, completed in 1990, was designed by ARC/Architectural Resources Cambridge. The two-story, wood frame boathouse is located in the Historic District of Exeter, New Hampshire, and only a brief walk from downtown.

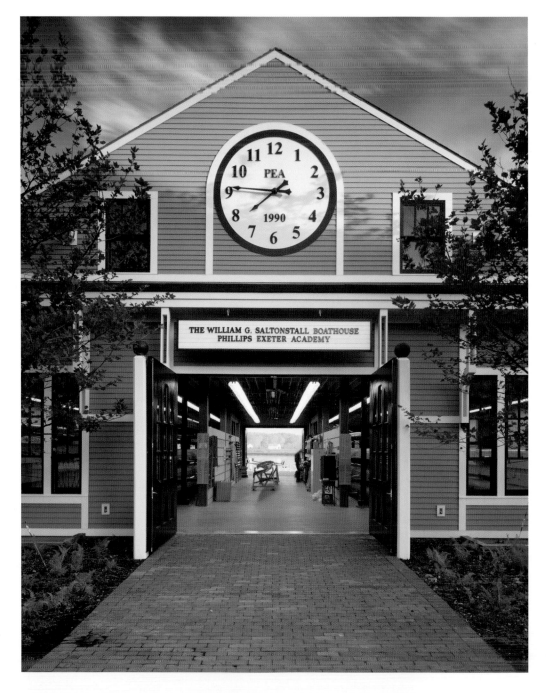

The boathouse is wood framed with a red cedar clapboard exterior. *Courtesy of the Frances Loeb Library, Harvard Graduate School of Design: Nick Wheeler photographer*

The central bay opens on both the water and street sides to facilitate loading boats for away races and movement of visiting teams' boats to the water for competitions held at home. *Courtesy of the Frances Loeb Library, Harvard Graduate School of Design: Nick Wheeler photographer*

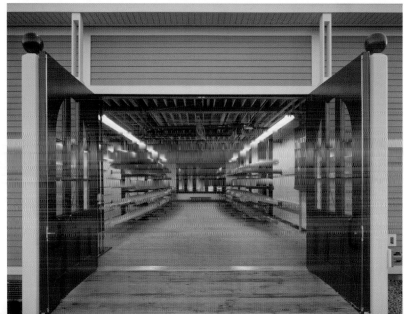

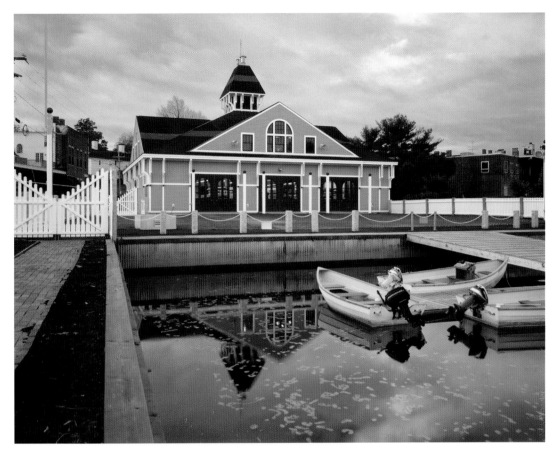

It blends with the character of the existing structures within the surrounding historic district. *Courtesy of the Frances Loeb Library, Harvard Graduate School of Design: Nick Wheeler photographer*

It incorporates two 23-foot- wide boat storage bays, flanking a 13-foot-wide work bay. The second floor includes a rowing machine facility, clubroom, trophy space, and lockers for 144 rowers, 72 boys and 72 girls. *Courtesy of the Frances Loeb Library, Harvard Graduate School of Design: Nick Wheeler photographer*

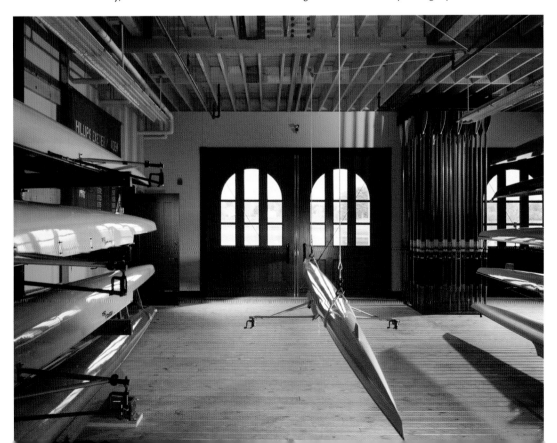

St. Paul's School—Crumpacker Boathouse

For many years, the St. Paul's School crews rowed out of two nearly identical boathouses located sixty feet apart in the woods on the shore of Little Turkey Pond. The two structures were aligned with two "boat clubs" at the school, Shattuck and Halcyon. Peterson Architects has designed a state-of-the-art facility that brings the two existing buildings together as a unified structure.

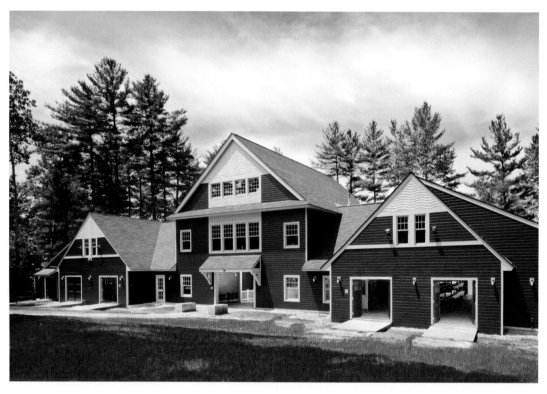

The Crumpacker boathouse provides St. Paul's with a new facility that manages to unify the program while still acknowledging its unique history . The layout acknowledges the identity of the two original clubs, with red doors on the Halcyon side of the building and blue on the Shattuck side. *Photo by Edna Wilde.*

Opposite page, bottom: Upstairs, a grand new function room, with exposed glu-lam trusses and a deck, looks out to the pond. This Great Room includes a fireplace and a trophy case and provides a place to display over a century's worth of plaques memorializing the winners of the Shattuck/Halcyon races. *Photo by Edua Wilde*

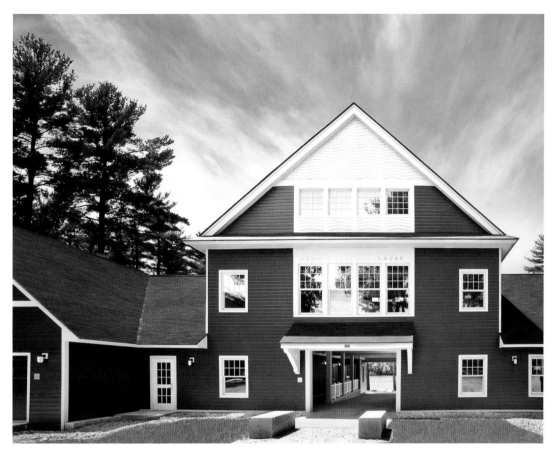

The new structure contains a central passageway that widens as you approach the pond, which compresses the perspective and seems to pull the water closer. On the lower level, the facility provides the coaches' offices and improved and expanded toilet facilities. A new boat bay was added to the north side of the facility, maintaining the symmetry of the two original boathouse structures. A new dry-pipe fire sprinkler system was also added. *Photo by Edua Wilde*

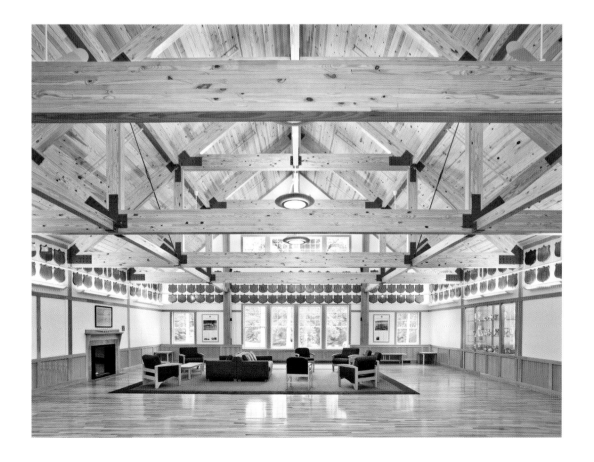

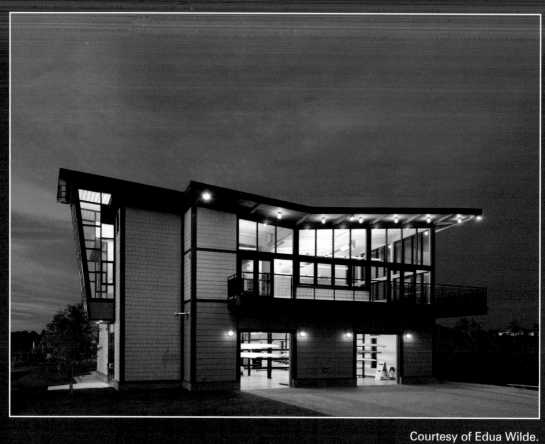

Courtesy of Edua Wilde.

Resources

Founded in 1969, **ARC/Architectural Resources Cambridge** is a nationally recognized architectural, planning, and interior design firm. It has built its design practice by responding to the needs and concerns of its clients. ARC's success is directly related to the importance it places on its client's unique goals and objectives. Its building and spaces are designed to meet the needs of each user in a functional and efficient manner; blend historical, geographical, and architectural context while clearly reflecting the building's designated and perceived purposes; promote sustainability and environmental responsibility; and achieve budget and schedule objectives. With an emphasis on innovative and sustainable design, the firm has garnered more than seventy awards from a wide range of professional organizations and publications.

Five Cambridge Center,
Cambridge, MA 02142
617.547.2200
www.arcusa.com

Ayers/Saint/Gross is an internationally recognized planning and design firm with a staff of over 140 employees located in Baltimore, Maryland, Washington, D.C., and Tempe, Arizona. Since the firm's founding in 1915, its primary focus has been the design of environments that support the creation and dissemination of knowledge and culture, primarily for academic clients and the communities that surround higher education institutions. The firm is organized into seven studios that specialize in campus planning, academic buildings, student life facilities, cultural facilities, town planning, landscape architecture, and 3D visualization/graphic design for clients across the United States and abroad.

1040 Hull Street, Suite 100,
Baltimore, MD 21230
410.347.8500
baltimore@asg-architects.com
www.asg-architects.com

Bensonwood Homes' history begins with the history of building in New England. The durable, honestly crafted buildings framed in heavy timbers and held together by mortise-and-tenon joinery were the dominant form of construction in America until the late 1800s. In 1974, Tedd Benson observed these remarkable structures — many of which had stood for more than two centuries — and reasoned that the ancient craft of timberframing could be made viable again with modern tools and would yield great benefits in durability and beauty. Today, Bensonwood Homes is acknowledged as a premier builder of energy-efficient homes and related structures. Their timberframe construction shows off the "wooden bones" of the structure.

6 Blackjack Crossing,
Walpole, NH 03608
877.203.3562 • 603.756.3600
info@bensonwood.com

Chester Carroll Architecture is dedicated to two simple philosophies: 1. "Design Matters." Design creates the image, comfort and functionality of the spaces we live work and play in daily. 2. "Design is Fun." The design process should be one of the most enjoyable processes that architectural clients can have.

120 Madrone Lane, North Suite 201,
Bainbridge Island, WA 98110
206. 842.1775
bill@chestercarroll.com

DAS Architects is a full-service architectural and interior design firm nationally recognized for unique hospitality, commercial, and private residential projects. Its dominance in the marketplace results from innovative, cost-effective work that consistently exceeds its clients' most demanding expectations. DAS offers a broad range of services including planning, site, and building analysis, project management, theme development, and procurement of furnishings and specialties.

Suite 100, 8 Penn Center
1628 JFK Boulevard
Philadelphia, PA 19103
215.751.9008
info@dasarchitects.com

Since its founding in 1991, award-winning **Harrison Design Associates** has been dedicated to creating high-end custom residential homes, town homes, and specialty commercial projects that are inspired by the best of traditional architecture. From Georgia to California, the firm shares a singular belief that a handcrafted house is a work of art; it is an enduring investment and a place to express the individuality of the families that will live there. Its team of over 85 professionals creates an array of distinctive ancestral homes and public buildings through the thoughtful study and application of classical proportions and detailing.

3198 Cains Hill Place, NW, Suite 200,
Atlanta, GA 30305
404.365.7760
info@harrisondesignassociates.com

The design reputation of the **Miller|Hull Partnership** is based on simple, innovative, and authentic designs. Since its inception in 1977, the firm has pursued a rigorous logic in its design approach in the belief that architectural programs are best solved directly and efficiently. Throughout the firm's history, Miller|Hull has received over one hundred seventy design awards and has been published in numerous national and foreign design journals. Miller|Hull's design philosophy centers around two essential architectural ideas: one is to use a building's structure to create a significant place within a site, and the other is to be sensitive to climate and to respond to environmental demands with the form of the building. These ideas evolve from an appreciation of the extraordinary beauty of the natural environment and have allowed Miller|Hull's projects to have an unusually clear fit to their surrounding context.

Polson Building, 71 Columbia-Sixth Floor,
Seattle, WA 98104
206.682.6837
jamesr@millerhull.com

Robert Harvey Oshatz, Architect, states that his relationship with his clients is based on a mutual understanding that architecture is the synthesis of logic and emotion. "The architect is the client's artist, creator, logician of an evolving aesthetic structure; a designer of not only the visual but also internal space. My commitment is to interrupt the individual poetic sense of each building site with my client's functional, emotional and spiritual needs. The challenge is to translate that spirit into architectural poetry. When an emotional idea is taken to its logical conclusion, a structure reflecting the client's dream and fantasies is brought into reality."

PO Box 19091,
Portland, OR 97219
503.635.4243
robert@oshatz.com
www.oshatz.com

Founded in 2001, **Peterson Architects** is an award-winning firm based in Cambridge, Massachusetts. Working across the country, the firm is dedicated to providing innovative and high quality design services to a range of institutional clients. Its skills and experience are broad, and the firm has developed considerable expertise with certain project types, particularly boathouses and rowing tanks. Each project it designs is unique, dealing with its own specific issues and conditions. The firm does not possess a design formula or agenda. Its goal is to create beautiful buildings and spaces while tending to issues of program, budget, site and the environment.

1132 Massachusetts Avenue,
Cambridge, MA 02138
617.354.2268
jpeterson@peterson-architects.com
www. peterson-architects.com

Sellers and Company Architects specializes in artistic, highly crafted architecture that makes you laugh, is green as turtles, uses local materials and craftspeople, and lasts for thousands of years. Patch Adams and the Gesundheit Hospital is a major client and partner in building clinics in El Salvador, Peru, Africa and the main hospital in West Virginia. Current work is in California, Connecticut, New Hampshire, Colorado, and West Virginia. Their shop, the Temple Of Dindor is a hub for making all the difficult and challenging aspects of their work from doors to onion domes.

PO Box 288,
Warren, VT 05674
802.496.2787
dave@sellersandcompany.com

Brigitte Shim and Howard Sutcliffe are partners as well as collaborators. They have created a firm, **Shim-Sutcliffe Architects,** and a life around their shared passion for architecture, landscape, and furniture. Their interest in the construction and fabrication of buildings, sites, and their intersections has forced them to question fundamental relationships between object and ground, building and landscape, man and nature. Although their backgrounds and sensibilities are very different, their similar education and architectural journeys together offer a rich starting point for their work.

441 Queen Street East,
Toronto, Ontario, Canada M5A 1T5
416.368.3892

Turner Brooks Architect is an architectural firm dedicated to offering the highest quality design services for institutional, commercial, and residential projects. Their work is known for its successful response to different site conditions, programs, and budgets. Their emphasis is on innovative design and ecologically sound solutions.

A graduate of the Yale School of Architecture, principal Turner Brooks enjoys a national reputation for the excellence of his designs, which have been widely published both in international architectural journals and in the popular press such as *Architectural Record, Progressive Architecture, Architectural Digest 100 Architects* (a special issue celebrating the world's foremost architects), and *Global Architecture*. He has been invited to lecture on his work throughout the United States and abroad. He has taught at the Yale School of Architecture since 1991, where he is currently a professor adjunct.

319 Peck Street,
New Haven, CT 06513
203.772.3244
turner@turnerbrooksarchitect.com

Head of the Charles Regatta®
2 Gerry's Landing
Cambridge, MA 02138
P. O. Box 380052,
Cambridge, MA 02238
617.868.5048
schoch@hocr.org

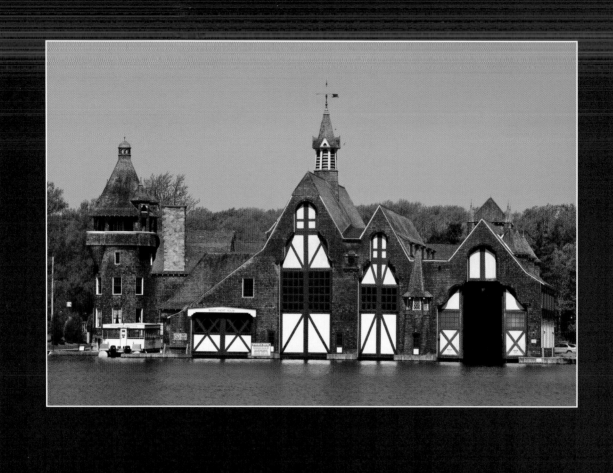

Index

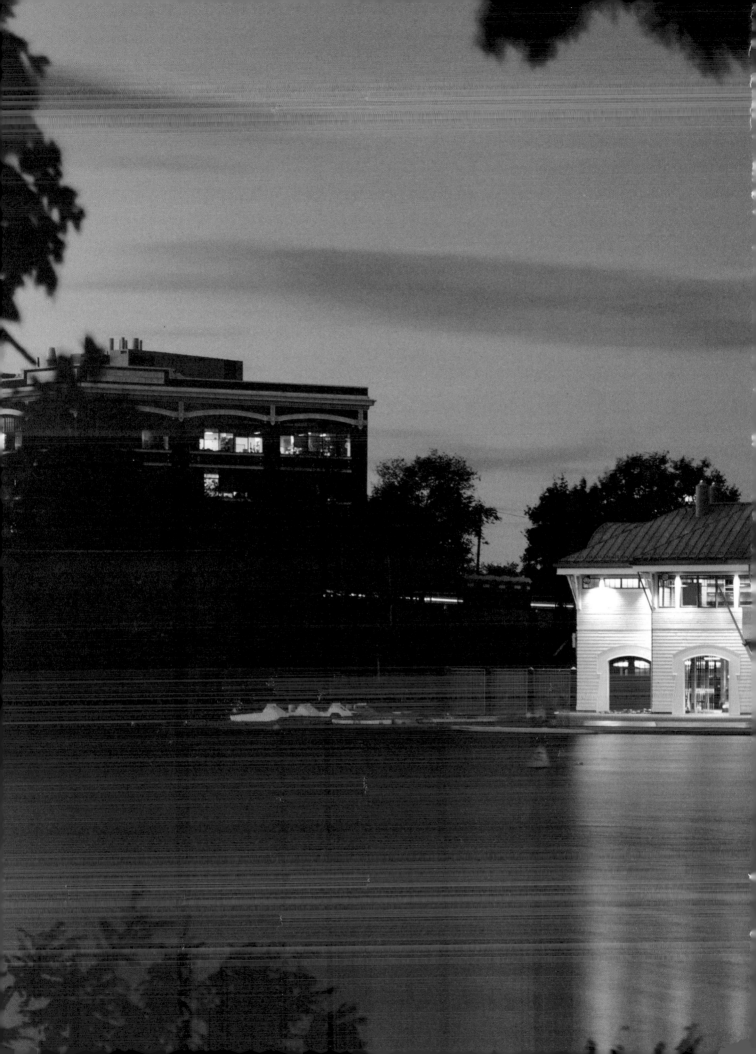